MW01119070

LIBERTY
IN
TROUBLED
TIMES

A LIBERTARIAN GUIDE TO
LAWS, POLITICS AND SOCIETY
IN A TERRORIZED WORLD

JAMES WALSH

SILVER LAKE PUBLISHING
LOS ANGELES, CALIFORNIA

Liberty in Troubled Times
A Libertarian Guide to Laws, Politics and Society
in a Terrorized World

First edition, 2004
Copyright © 2004 by Silver Lake Publishing

Silver Lake Publishing
3501 W. Sunset Boulevard
Los Angeles, CA 90026

For a list of other publications or for more information, please call
1.888.638.3091. Outside the United States and in Alaska and Ha-
waii, please call 1.323.663.3082. Find our Web site at
www.silverlakepub.com.

Library of Congress Catalogue Number: Pending

Walsh, James
Liberty in Troubled Times
A Libertarian Guide to Laws, Politics and Society
in a Terrorized World
Includes index.
Pages: 344

ISBN: 1-56343-778-3
Printed in the United States of America.

Author's Note

I don't mean this book to be a legal treatise. Or an elegy about the suffering related to 9/11. Or a political diatribe against any elected official or party. Instead, I hope that this book will serve as a kind of primer for how people can think critically about liberty issues in a world that's more risky every day.

America's great strength is that it assumes its citizens are intelligent adults, who can make up their own minds about what they want from their government...and what they need in their own lives. Sometimes Americans don't act like they're up to this standard of behavior and thought. But I believe that crises often bring out the best in people; and I think the troubles that America has faced since 9/11 will shock its people into thinking about the importance of the American social contract.

There's another point that shapes this book. I believe strongly that the familiar American political dynamic of liberal-versus-conservative is no longer relevant. The new dynamic will be something closer to liberty-versus-statism. The sooner that Americans get past the old terms and get comfortable with the new ones, the more useful our public debates will be.

And, finally, I've written this book thinking about all of the ridiculous B.S. that I've heard in the last several years ascribed to the word *libertarian*. If I'm at all successful, maybe that word will start to carry a more consistent meaning.

—James Walsh, Los Angeles (Spring 2004)

Contents

Liberty/Statism
Replaces Liberal/Conservative

Why should this book stand out from all of the other big-idea treatises on 9/11, al Qaida and the War on Terrorism?

Before the 9/11 attacks on the World Trade Center in New York and the Pentagon near Washington, D.C., debates over the meaning of liberty in the United States seemed silly and academic. Most Americans assumed that liberty and political freedoms were givens in the most powerful and wealthy country in the world.

The attacks changed that.

First, Americans joined the ranks of people around the world who faced the prospect of being killed without notice at their work or even in their homes because of who they are.

Second, the U.S. federal government did what governments do in times of trouble: It ditched its rational, libertarian foundations and grabbed as much power as it could.

The second change is more dangerous than the first; it's al Qaida's lingering effect—more insidious than the hijacked planes.

Power grabs by governments are nothing new. In his *Historical Review of Pennsylvania*, Benjamin Franklin famously wrote, "They that can give up essential liberty to obtain a little temporary safety deserve neither liberty nor safety."

1

Americans made just such a trade-off after 9/11. In more than two years since the attacks, there were no similar terrorist actions on American soil. The military, civilian law enforcement agencies, corporate America and individual citizens stepped up their efforts and attention to prevent further attacks.

But the power grab that the federal government made in the weeks after the 9/11 attacks was particularly troubling because of its complexity and scope. Conspiracy nuts can be excused for their paranoid excitement because the Feds seemed so *ready* to step in.

And that stepping certainly makes the debate over liberty less silly. To be really effective, though, it needs to find some new focus.

Americans are used to political debates that contrast liberal and conservative philosophies—or the Democrat and Republican parties. Those were the choices that defined U.S. politics for most of the 20th Century. And they became so familiar that most Americans were lulled into a sleepy ignorance about the workings of their republic.

After World War II, the U.S. Congress effectively ceded its power over war, peace and foreign policy to the president and its power to decide issues of race, gender, religion, culture and morality to the Supreme Court. Why did Congress cede its powers? Because congressmen are politicians—and politicians would rather not make difficult decisions on war, peace, race, religion, morality, culture and gender. Such issues divide people deeply. They can cost a politician his office. Better for him to hand the hard calls over to judges, appointed for life, who never face the voters.

That handing-over began the slippery slope toward statism. It made a lot of assumptions about shared beliefs: that the federal government was the best mechanism for serving citizens; that federal courts of law were the best places to resolve political disputes; that America was a rich and peace-loving country. These assumptions had worked well enough to see America through two World Wars and they still worked in a Cold War. But the end of the Cold War in the 1990s started an unraveling of these assumptions.

The Old System Undone

Al Qaida's suicide terrorists finished it.

Now, with a hole in lower Manhattan where the World Trade Center used to be, repairs just concluding at the Pentagon and long lines at most airports, Americans are stepping back and asking more fundamental questions about their country and the world.

Republican-versus-Democrat doesn't mean anything any more; libertarian-versus-statist is the more timely debate.

This book will consider the libertarian-versus-statist debate in various ways, from various angles. At the start, though, it's useful to define roughly each perspective.

Libertarians believe that liberty is about *fundamental rights*: the right to own property, the right to practice religion as they wish, the right to assemble, to speak freely, to participate in government. In short, these freedoms mean that no person can be a slave—or a tyrant...and that government should follow *laissez-faire* guidelines whenever possible. Libertarians believe that self-ownership is essential to human dignity and that self-ownership limits what any person or state can force a citizen to do.

Statists believe that liberty is about *quality of life*. They believe that fundamental freedoms include the freedom from hunger, from illness, from discomfort and even from unhappiness. Most importantly, they believe in a powerful central government—a powerful state—that delivers quality of life to its people. Statists call their wide-ranging, materialistic freedoms "positive rights," a misleading term that has caught on in many circles.

It's misleading primarily because it leads some people to call libertarian fundamental freedoms "negative rights."

There are several reasons for this misled response.

Being a libertarian is difficult—intellectually, politically and emotionally. It means accepting limits on what the government can and should do for its citizens, even down-and-out citizens. It means trust-

ing—not cynically, but honestly—that private-sector charitable institutions will offer social services to people that statists would prefer the government to offer.

And, perhaps most importantly, it requires rationalism...a flinty reserve that doesn't grab at cheap sentiment or emotion.

On the other hand, troubled times encourage emotional reaction and statism. This has been true dating back to democracy's early times in ancient Athens and Rome. In those places, war or civil unrest would result in constitutional tyrants taking control of the government. In theory, these tyrants were supposed to give up their power as soon as the crises abated; in practice, they rarely did.

In 21st Century America, the statists have followed that course. In November 2001, weeks after the World Trade Center and Pentagon were attacked, a poll run by National Public Radio and the Kennedy School of Government at Harvard University found that 66 percent of Americans approved of "searching people who are Arab or of Middle Eastern descent to see if they might be involved in potential terrorist activities." A Zogby International poll taken at about the same time found that 77 percent of Americans supported government video surveillance of public places, 62 percent supported random roadblock searches of vehicles and 61 percent supported government monitoring of people's mail.

Americans were afraid. And they were willing to give the state extraordinary power to track down terrorists. They were willing to let the tyrants rule.

Less than a year later—in the late summer of 2002—the fear had subsided. Zogby International repeated its poll and found that tolerance of state intrusions had declined: support for video surveillance of public places remained about the same, but only 49 percent supported random roadblock searches of vehicles and only 35 percent were willing to let the government monitor mail. And a follow-up of the NPR/Kennedy School poll also found fewer Americans willing to target

people for special scrutiny based on nothing more than Middle Eastern heritage.

This is the natural ebb and flow of public opinion. But, in a republic, the ebb and flow is supposed to be counterbalanced by sturdier political philosophy. In a terrorized world, libertarianism is America's best hope for that counterbalance.

John Locke's Idea of Liberty

Starting with the English philosopher John Locke, classical liberals (of which libertarians are a subset) have described *liberty* mainly in terms of the primary functions of governments. To them, a government has the authority to:

- legislate public rules and revise them to meet changing circumstances;
- adjudicate disputes arising under these rules; and
- enforce these rules when necessary against those who violate them or who resist their resolutions.

For Locke, these three powers are needed to remedy certain "defects" of human nature (including greed, impatience and fear). And the remedy of these defects was the reason that people enter a "social contract" to create a political society.

Statists embrace the social contract enthusiastically. They use it as the justification for all kinds of coercion. Libertarians accept the social contract carefully, with careful eyes kept on the compromises that *every* contract requires.

America was founded by people who had reservations about the social contract. Thomas Jefferson accepted that political society was necessary—but was seriously concerned that it always seemed to gravitate toward tyrannies of either kings or democratic majorities. That's why Jefferson was adamant about protecting "fundamental" and "inalienable" rights.

To say certain rights or liberties are *fundamental* means they have absolute priority over other political values; they can't be sacrificed or traded for other rights. These fundamental rights can't be given up—not to satisfy the preferences of democratic majorities, not to enhance security, not to improve economic efficiency, not to achieve fashionable notions of social justice.

Libertarian doctrine usually holds that limits on one person's fundamental liberties are to be imposed only to protect and maintain another person's basic liberties. In the legal aphorism: *Your right to swing your fist ends at my nose.*

This is a strict standard—and it's what Jefferson believed. He wasn't alone, either. His contemporary Roger Sherman (geographically and temperamentally as different from Jefferson as possible) wrote in a draft bill of rights from 1789:

> The people have certain natural rights which are retained by them when they enter into Society, such are the rights of Conscience in matters of religion; of acquiring property and of pursuing happiness & Safety; of Speaking, writing and publishing their Sentiments with decency and freedom; of peaceably assembling to consult their common good, and of applying Government by petition or remonstrance for redress of grievances. Of these rights therefore they Shall not be deprived by the Government of the United States.

Post-9/11 Americans need to rediscover people like Roger Sherman. To do that, they'll have to relearn how they think about politics and public life. It may be tempting—and easy—to think of libertarians as the new version of conservative Republicans and statists as the new version of liberal Democrats.

That's not right.

Some conservative Republicans believe in minimal government and governmental coercion of citizens; these relative few share beliefs with libertarians. But many conservative Republicans are ambitious

statists, with designs on forcing their version of freedom and quality of life on fellow citizens. They're willing to use the state to coerce people into behaving a certain way—just like the politically-correct American liberals who want to tell people how to think.

Statists can be either right- or left-wing. Their politics aren't important; their desire to control the mechanics of government are. And statists seem to be more numerous than libertarians. They're attracted to public service and public life—which makes sense, given their interests and ambitions. Spend an evening watching television news programs, listening to (non-sports) talk radio or reading opinion magazines, and you're likely to find dozens of statists for every libertarian.

Finally, being a libertarian is tough because it requires developing and using your own good judgment. And that can be a lonely thing. As UCLA law professor Eugene Volokh has written:

> A sense of perspective—an ability to recognize the true magnitude of the harms against which you rail, and to compare it sensibly to other matters, especially the countervailing benefits that have come about together with these harms—is intellectually and practically important.

That sense of perspective is the best way for a libertarian to honor the liberties that are the foundation of the free world.

The brilliant federal court Judge Learned Hand, writing that judges should not try to invalidate legislation offensive to their "personal preferences," concluded with the oft-quoted line:

> For myself, it would be most irksome to be ruled by a bevy of Platonic Guardians, even if I knew how to choose them, which I assuredly do not.

And, separately, Hand warned:

> Liberty lies in the hearts of men and women. When it dies, no constitution, no law, no court can save it.

The aim of this book is to examine American liberty in its various forms and uses during troubled times. In crises, when Platonic Guard-

ians seem most appealing, liberty is most precious. Perhaps, from this examination, readers will be able to draw a pragmatic understanding of libertarian political philosophy.

That will do more good and prevent more terrorism than a parade of random roadblocks.

This book stands out from others about the aftereffects of the 9/11 attacks because it's about *the* essential American value—liberty. There are no easy emotional appeals in this book...only the bright light of rational debate.

If you're a libertarian, the arguments in this book will make sense, on a gut level if nowhere else. If you're not a libertarian, consider this book a primer on an extreme philosophy.

Part One:
Freedoms and Rights

1 Speech

How far does the 1ˢᵗ Amendment extend in a country roiled by terrorism? Does it give people with poor judgment freedom from harsh response when they say stupid things?

Early 2003 saw America's hard-won notions of free speech translated into tempests over t-shirts in suburban high schools and shopping malls.

In February 2003, Bretton Barber—a high-school student in Dearborn Heights, Michigan—wore a t-shirt to school featuring President Bush's picture and the words "International Terrorist." Barber claimed that he was protesting U.S. policy in Iraq. The school asked him to turn the t-shirt inside out or go home. He went home.

Six weeks later, the American Civil Liberties Union filed a lawsuit on behalf of the young heir to Noam Chomsky. The ACLU alleged that Barber's constitutional rights had been violated by Dearborn High School.

Good thing Barber didn't bring a gun to school.

Barber had refrained from wearing the anti-Bush t-shirt to school since February; but he told local media that he felt vindicated by publicity over his protest. "The shirt was meant to emphasize the message 'no war' and I feel that I've been successful in getting that

message out," he said. "I think it's especially important for students who may be asked to fight at some point, to have the right to say how we feel."

Michigan is home to one of the largest concentrations of Arabs outside the Middle East and Dearborn has a flourishing community of Iraqi exiles. That community generally supported the U.S. military action to oust Saddam Hussein.

About the same time that Barber was calling in air support from the ACLU, an Albany, New York-area lawyer and self-styled political activist was agitating in a local mall. Stephen Downs and his adult son Roger walked around wearing t-shirts sporting the phrases "Peace on Earth," "Give Peace a Chance" and "No War With Iraq."

At one point, when the father and son were eating in the mall's food court, a security guard approached and asked that they take off their t-shirts. The son complied; the father refused, claiming a 1st Amendment right to wear the t-shirt. He argued with the security guard that the words on the shirt were not offensive or obscene and were as innocuous as a Christmas card.

The security guard called the police. The police asked Downs to leave the mall; he claimed the right to remain. The police arrested Downs and charged him with trespassing. (Few suburban mall rats realize that the places are private property—and that management is free to ban speech, clothes and behavior as it pleases.)

Local political activists mobilized to protest Downs's arrest. The next day, 150 people turned up at the same mall, wearing t-shirts with anti-war slogans. The mall's management saw trouble on the horizon and asked the local district attorney to drop the charges.

The History of Freedom of Speech

The freedom of speech is not a matter of legal or political interpretation—it is described in explicit detail at the top of the American Bill of Rights:

> Congress shall make no law...abridging the freedom
> of speech, or of the press; or the right of the people
> peaceably to assemble, and to petition the Govern-
> ment for a redress of grievances.

This essential liberty was not new to the founders. It traced back to England's *Magna Carta* and certainly played a central role in John Locke's notions of liberalism (more on Locke and liberty in Chapter 6).

On a mechanical level, freedom of speech includes not only the right to utter or to print, but the right to distribute, the right to receive, the right to read and freedom of inquiry, freedom of thought and freedom to teach. As the Supreme Court has noted, "Without those peripheral rights, the specific rights would be less secure."

To a libertarian, almost everything that's important to the social contract flows from freedom of speech. It's a requisite to an efficient marketplace. It's a necessary result of self-ownership. It's an element of both privacy and property rights—less specific and clear freedoms.

If there is any individual liberty right that would seem to be inviolate, it's freedom of speech. But, even in the U.S., statists have been trying to erode it since it was made law. And they usually use the cover of war to do this eroding.

John Adams was the first president to attack the 1st Amendment. A man particularly bad at accepting criticism, Adams pushed through Congress the Alien and Sedition Acts in 1798; the latter made it a crime to criticize the government.

A bitter debate was raging at the time between the Federalists, Adams's party and the Republicans, led by Thomas Jefferson. The countries of Europe were at war and Adams wanted the United States to take a series of military measures that would effectively put it in a state of undeclared war with France. The Republicans opposed these measures. The Federalists accused the Republicans of treason.

Against that backdrop, Adams drafted the Alien and Sedition Acts. The Alien Act allowed the president to deport any noncitizen he judged dangerous to the "peace and safety" of the United States.

The Sedition Act prohibited publication of "false, scandalous and malicious writings" against the government or the president with intent to bring them into contempt or disrepute. Any aggressive criticism of Adams, his policies or his administration was deemed unlawful. This law didn't sit well with American voters, who turned out Adams at the next election. The Federalist Party unraveled soon after.

The Supreme Court never had the chance to rule on the constitutionality of the Sedition Act, which expired by its own terms on the last day of Adams's term of office. Jefferson, who succeeded Adams, pardoned all those who'd been convicted under the Sedition Act.

The Same Mistake, Again

Nearly 120 years later, America had another president whose aversion to criticism was so strong that he tried to carve away at the 1st Amendment. When the United States entered World War I, President Woodrow Wilson harrumphed that the goal was to "make the world safe for democracy." Many Americans doubted this, believing instead that the goal was to protect investments that American companies had made in Europe—which was destroying itself in a slow-moving war of attrition.

Wilson, a thin-skinned and arrogant man, had little patience for such dissent. On one occasion, he warned that disloyalty "must be crushed out" of existence. His administration drafted and pushed through Congress several laws, including the Espionage Act. These laws—though not as far-ranging as Adams's Sedition Act—made certain sorts of dissenting speech illegal.

During the course of World War I, aggressive statists in the federal government prosecuted more than 2,000 people for their opposition to the war and the draft; and federal judges were disappointingly quick to hand out punishment.

And the Supreme Court was no braver. In a series of decisions through 1919 and 1920, it illogically upheld the convictions of people

who had agitated against the war and the draft—including Eugene Debs, who received nearly a million votes as the Socialist Party candidate for president in 1920.

Strangely, the Supreme Court ruled that sending Debs to federal prison for speaking out against U.S. participation in the war was not a violation of the 1ˢᵗ Amendment.

From 1920 to 1923, the federal government released from prison every person who had been convicted under the Espionage Act. A decade later, President Franklin D. Roosevelt granted all of them amnesty, restoring their full political and civil rights. Over the next half-century, the Supreme Court overruled its World War I decisions, admitting that people who'd been imprisoned or deported for dissent had been punished for speech that should have been protected.

Actions As Speech

As the statist effort to erode the 1ˢᵗ Amendment ebbs and flows with the times, it sometimes looks for interesting niches in which to operate. In the 1990s and 2000s, one of those niches has been the ongoing debate over whether actions—flag burning, cross burning, standing in front of abortion clinics—that have a political aspect constitute protected speech.

In April 2003, the U.S. Supreme Court released a split-decision in *Virginia v. Black, et al.*, a constitutional free-speech challenge to a Virginia statute that banned Klan-style cross burnings that were specifically designed—as proved by "prima facie evidence"—to intimidate some group of people.

The ironically-named Barry Elton Black, a leader of the Ku Klux Klan in Virginia, had been arrested and convicted under the state law for organizing a cross burning that a trial court determined was designed to intimidate blacks in the Richmond area. Black appealed the conviction on the grounds that the state law was an unconstitutional limit on his freedom of political speech.

Sandra Day O'Connor wrote the decision for the majority:

In this case we consider whether the Commonwealth of Virginia's statute banning cross burning with "an intent to intimidate a person or group of persons" violates the 1st Amendment. We conclude that while a State, consistent with the 1st Amendment, may ban cross burning carried out with the intent to intimidate, the provision in the Virginia statute treating any cross burning as prima facie evidence of intent to intimidate renders the statute unconstitutional in its current form.

So, the Virginia law was unconstitutional and, in the narrow confines of the legal decision, Black's cross burning was the equivalent of constitutionally-protected speech.

Through her tenure on the Supreme Court, O'Connor has been known for her nontraditional logic. In this decision, she convinced three colleagues to make two contradictory points at the same time: First, Virginia's cross-burning ban was "unconstitutional on its face"; and, second, that it *might* be constitutional if its "prima facie evidence" provision were applied in a manner consistent with traditional American judicial practice.

Three other justices, led by David Souter, agreed with O'Connor but straightened out her crooked logic. They ruled that all cross-burning bans—not just Virginia's—had to be judged unconstitutional. Cross burning symbolically expresses political views that, though obnoxious, fall squarely within the 1st Amendment's protection and can't be singled out for restriction. This was the closest thing to a libertarian line in the ruling.

O'Connor's eccentric reasoning illustrates how tenuously even the most basic rights and liberties apply to judicial decisions. It also encourages statist follies like the ongoing efforts to pass laws banning burning of the American flag.

In late March of 2003, as the first waves of American planes bombed Baghdad and anti-war protest reached its height, Utah Senator Orrin Hatch collected five more cosponsors for his bill to amend the constitution to allow Congress to ban flag burning.

The Hatch amendment read: "Congress shall have the power to prohibit the physical desecration of the flag of the United States."

"Of course, it's disturbing to see such an important symbol of our country desecrated, but those who burn it will not be breaking any laws by their actions if the flag amendment passes," Hatch said. "If it is enacted, the amendment would simply authorize but not require Congress to pass a law protecting the American flag."

In other words, his amendment would send a message to potential flag burners.

The 2003 bill was the third in eight years drafted by Hatch—who'd made a flag-burning ban something of a personal mission. The first two had lost overwhelmingly on the floor of the U.S. Senate.

One of the groups that had opposed Hatch's earlier attempts was Veterans Defending the Bill of Rights. One of its main spokesmen was Gary May, a professor at Southern Indiana University who'd served in the Army during the Vietnam War.

In 2003, May still saw no reason to amend the Constitution. "Even offensive speech is part of what we fought and sacrificed for and we ought to be careful of taking steps that would have the effect of limiting that freedom," he said.

Hatch anxiously pointed out that his bill *had* to involve a constitutional amendment because the U.S. Supreme Court had declared the Federal Flag Protection Act unconstitutional in 1989. (That law had been passed to rebuke the high court for overturning a man's conviction under a Texas flag-burning prohibition.)

The cross-burning case and the flag-burning amendment are more closely related than they might seem at first glance. Sandra Day O'Connor's uncertainty and Orrin Hatch's certainty both focused on manners and social etiquette rather than liberty and freedoms.

Frederick Douglass, a leading figure in the American abolitionist movement, wrote that people who want a free democracy to be polite "want rain without thunder and lightning." And he was right.

The worst ill-mannered, racist, flag-burning American should expect his freedom of speech to remain sacrosanct. In fact, he or she probably needs it protected more than a better person. And it's the liberty that should be inviolate, not the fabric symbol that represents the liberty.

Manners over liberty is a foolish choice that some people make. It's insidious. And it's a choice for statism. Liberty first, then manners—that's the libertarian order.

Freedom of Speech Protects Dissent

In early 2003, a bumbling administrator at a community college in Orange County, California, warned instructors against discussing the Iraq war in class unless it was directly related to the subject they were teaching. The warning caused an immediate uproar and complaints about an attack on academic freedom.

In a inter-department memo, Irvine Valley College Vice President of Instruction Dennis White wrote that, although he understood the depth of opinions held by instructors both in favor of and against the war, discussing those views in class would be "professionally inappropriate if it cannot be demonstrated to this office that such discussions are directly related to the approved course materials."

President Glenn Roquemore stepped into the fray and said White had acted after receiving reports from counselors that at least three students—including one with a fiancé in the military—became distraught after instructors expressed anti-war opinions in their classes. "I believe his memo was really meant to say, 'Please talk to me before you enter into a conversation with your students, unless it's in the context of a political science class,'" Roquemore said. "We have to remember these students are graded on attendance, they pay their

money, they're enrolled in class; in essence, they're a captive audience."

Some students claimed that the memo was the latest attempt by administrators to muzzle free speech at the college. But others said they agreed with White's memo. "There are teachers who are just haranguing Bush and his strategies," said one member of the student Senate. "There are a lot of teachers who are making a lot of comments, and the students are kind of upset because it's distracting."

Restrictions on free speech aren't limited to suburban community colleges. At the same time Irvine Valley College was clamping down on anti-Bush rants, Harvard Law School was considering a speech code of its own.

For months, Harvard's Black Law Students Association and some faculty members had been pressing for a speech code that would punish offending students and professors. The delicate sensibilities of the future advocates had been offended by a series of racial incidents—including one student's use of the word "nig" in an on-line course notebook, a professor's defense of that student and another professor's comment that feminism, Marxism and black studies had "contributed nothing" to legal studies.

Alan Dershowitz—perhaps Harvard Law's best-known professor—opposed any kind of speech code and spoke up at a contentious "town meeting" on the subject:

> When I hear blacks saying "I want more blacks," or
> liberals saying "I want more liberals," that doesn't seem
> like diversity; that sounds like self-serving pleading.

Dershowitz's comments brought a rebuke from Randall Kennedy, another well-known Harvard Law professor—who supported the speech code. Kennedy reprimanded Dershowitz for using the sort of insensitive language and tone that upset many students.

Again, the foolish choice of manners over liberty.

Free Speech Without Tears?

But that's not the dumbest mistake related to free speech.

The most foolish mistake is the impression that free speech means a person can speak without consequences. The U.S. Constitution protects speech for exactly the opposite reason. It protects speech so that there can be free markets for ideas—and everything else; it protects free speech for the intemperate response as well as the ill-advised pronouncement.

The proposed Harvard Law School speech codes stumbled on this mistake. More memorably, in 2002 and 2003, celebrities like the actor Tim Robbins and the music group the Dixie Chicks did, too. They made provocative political statements and then played hurt and confused when people responded angrily.

But celebrity actors and singers can be expected to seek controversy to keep their names in the press. What's shocking is how many Americans who should know better make the same mistakes.

Francis Boyle, a professor at the University of Illinois, was a very public critic of the Bush Administration. He wrote and circulated a Draft Impeachment Resolution Against President George W. Bush; and he spoke out stridently against the military actions in Afghanistan and Iraq. In his Draft Impeachment Resolution, Boyle mentioned Bush's "violating the 1st Amendments rights of the free exercise of religion, freedom of speech, peaceable assembly, and to petition the government for redress of grievances."

In a speech against military action in Afghanistan, Boyle wrote: "Let me conclude by saying that we still have our 1st Amendment rights, despite [John] Ashcroft's best efforts."

Fair enough sentiment—but one which a reasonable person should expect to generate some angry response from defenders of the Bush Administration.

Boyle didn't seem to see it that way. He was apparently shocked that students and other faculty members in Champaign ridiculed

him—in writing and conversation—as a mediocre mind greedy for press clippings. His response was to send an e-mail that implied he would report names of people he felt were "Boyle bashing" to the Equal Employment Opportunity Commission and the Department of Justice as part of a discrimination complaint he was making. (Boyle claimed he'd experienced workplace discrimination after he'd stated that parties that Illinois graduate students held on St. Patrick's Day were "completely sacrilegious." Then, he claimed, he started getting anti-Catholic e-mails.)

In the e-mail, Boyle wrote that his complaint "could create problems for people dealing with a Character and Fitness Committee who want to be admitted to the Bar somewhere." This was a threat directed at his own law students!

About the same time, New Jersey poet laureate Amiri Baraka was reaping some serious anger that he'd sewn with his words.

One of Baraka's recent poems, "Somebody Blew Up America," suggested that Israel had advance knowledge of the 9/11 attacks. The poem contained several incendiary passages, including:

> Who knew the World Trade Center was gonna get
> bombed?
> Who told 4000 Israeli workers at the Twin Towers
> To stay home that day
> Why did Sharon stay away?
> . . .
> Who know why Five Israelis was filming the explo-
> sion
> And cracking they sides at the notion.

The poem went on to insult several high-profile black leaders, including Clarence Thomas, Colin Powell, Condoleeza Rice and Ward Connerly.

Connerly fired back in a column, comparing the poem's "hate-infused, Jew-bashing, hip-hop-like lyrics" to "the rantings of a teen-aged, wannabe gangsta-rapper."

Denounced as anti-Semitic and anti-American, the poem prompted the New Jersey legislators to consider abolishing the poet laureate position.

Baraka told a local newspaper that—if the bill to abolish the state's poet laureate position passed—he would sue legislators for slander and defamation. Apparently, he was being serious.

Conclusion

An important part of having liberty is understanding the consequences that follow choices. A terrible result of statist erosion of American liberties is that few people connect liberty with consequences.

Hollywood celebrities may be the worst offenders—they want to be praised for their "courage" to speak out on issues of the day and, at the same time, they want none of the risks of those who say something meaningful.

If there are no risks, where's the courage?

2 Religion

After 9/11, religion may replace race as the hot-button issue in American public life. Self-appointed experts screech about "constitutional protections" of the government from religious influence. In fact, the U.S. Constitution does the opposite—it protects religion from the state. Why the confusion?

In late February 2003, the U.S. Court of Appeals in San Francisco affirmed a controversial ruling that reciting the words "under God" in the Pledge of Allegiance in public schools violated the U.S. Constitution.

In June 2002, a smaller panel of the same court ruled the pledge unconstitutional by a 2-to-1 vote, a decision assailed by George W. Bush and condemned by the U.S. Senate in a 99-to-0 vote. The decision was stayed pending the possibility of review by a larger panel of judges. The February decision was that review.

Judge Alfred Goodwin, who wrote the majority opinion, made it clear that the ruling applied only to use of the Pledge of Allegiance in public schools. Goodwin wrote that in the setting of a public school, the pledge was inherently "coercive" to children and violated the constitutional ban on government establishment of religion.

The Supreme Court had invented the "coercion test" in a 1992 ruling, *Lee v. Weisman*, which held "unconstitutional the practice of including invocations and benedictions." In that case, the Supreme Court held that the prayers "bore the imprint of the state and thus put school-age children who objected in an untenable position."

Back in California, Judge Goodwin wrote:

> The school district's policy...places students in the untenable position of choosing between participating in an exercise with religious content or protesting.... The coercive effect of the policy here is particularly pronounced in the school setting, given the age and impressionability of schoolchildren.

The suit challenging the pledge had been filed by Michael A. Newdow, a Sacramento doctor and anti-religion activist. Newdow argued that the pledge had traumatized his daughter, an elementary school student. (He made this claim, even though his daughter's mother—who had primary custody of the child—indicated they had no problems with school prayer.)

Even though reasonable people considered him a grandstanding jerk, Newdow had standing to bring the case. In a March 2003 opinion article published by the Los Angeles *Times*, he wrote:

> One day I was looking at the money in my hands, and I noticed, as if for the first time, the words "In God we trust" on every coin and every bill of every denomination. "What's this?" I wondered.
>
> I don't trust in God. I'm an atheist. Don't I count as an American? Isn't ours the country that holds itself out to the world as the beacon of religious liberty? Isn't there something in the Constitution that says that the government can't take sides in a religious debate?

Disingenuous (Newdow wasn't a new convert to aggressive atheism...he'd been an activist for years). Pedantic. Wrong.

Antireligious activists often claim, weakly, that their constitutional objections are not to religion in general but to religion in public life. This is often a pretext for antireligious bigotry. And, even a pretext, it's ignorant on several levels. First, "public life" is not the same thing as government; government should be only a small piece of public life. Second, the U.S. Constitution doesn't say anywhere that religion must be kept out of public life—and even out of government institutions or policies.

What the Constitution says is that the U.S. government can't establish an official religion. All religions (including the rejection of religious belief) are supposed to have equal footing in terms of public institutions and public policy.

The History of Establishment Clause

A common misconception about libertarianism is that it's inherently antireligious. Secular. That's not so. Even a pure libertarian can be devoutly religious and support religion in public life. In fact, the most devoutly religious American *should* support most of the limited-government beliefs of liberty. Statist efforts to manage religion, either by banning it or requiring it, usually erode religion's metaphysical integrity. The best relationship between state and religion is respectful distance.

America's founders knew this. They—and rationalists of all sorts at that time—were focused on protecting religion from government, not government from religion. They had vivid experience with states trying to co-opt religion in order to shore up their authority.

The United States enjoys freedom of religion because of a small phrase in the Constitution that says, "Congress shall make no law respecting the establishment of religion."

In 1786, the Virginia House of Burgesses (as the state legislature was called at that time) passed a statute written by Thomas Jefferson, supported by James Madison, declaring that no one should be dis-

criminated against because of religious belief nor compelled to join any particular church. This statute was a model for the 1st Amendment to the Constitution.

In 1788, the document became official upon its adoption by the required number of states. Some of the states were concerned that by giving authority to a federal government primarily to defend against foreign countries, not enough protection was given for the protection of the citizens against the government itself.

The Bill of Rights was added to the Constitution because people feared that without its specific guarantees, the federal government might trample on their freedoms.

The 1st Amendment protected ordinary citizens against the limitation of Congress on the freedom of religion, speech and assembly. The wording, as to religion, is a model of brevity and clarity:

> Congress shall make no law respecting an establishment of religion, or prohibiting the free exercise thereof....

It says that Congress shall do nothing that could be seen as a national endorsement of a particular religious creed.

The founders never intended that government officials police against the religious expression of Americans. They simply wanted to ensure that the government did not force any particular religion on the people. Indeed, Jefferson once remarked:

> We have solved, by fair experiment, the great and interesting question whether freedom of religion is compatible with order in government and obedience to the laws. And we have experienced the quiet as well as the comfort which results from leaving every one to profess freely and openly those principles of religion which are the inductions of his own reason and the serious convictions of his own inquiries.

The libertarian approach to religion is to trust every person to find his or her own metaphysical beliefs...and reconcile those beliefs with citizenship. This is a serious and mature expectation of reasonably intelligent people.

Prayer at School

But not everyone is mature and serious. In March 2003, the Clark County, Nevada, School District was staring at a federal lawsuit over a policy that could allow benedictions or invocations at school graduation ceremonies.

District board members back-pedaled as fast as they could—they approved a notice of intent to replace the old policy.

The old policy had been deemed unconstitutional by school district attorneys and the Nevada Attorney General's Office. Still, in February 2003, a majority of board members voted to keep it in place.

That led to a lawsuit from the American Civil Liberties Union. The complaint asked the federal court for a declaration that the district regulation was unconstitutional and for an injunction to prevent enforcement of the regulation.

Prayer in public schools is generally allowed—provided that it happens outside the classroom and is initiated by students, not by school officials.

ACLU attorney Allen Lichtenstein said his organization supported a student's right to pray as an individual. What the ACLU opposed, he said, was a district policy that he claimed violated the separation of church and state by allowing school-sanctioned prayer. Numerous rulings from both the U.S. Supreme Court and the Ninth Circuit Court of Appeals were clear on that issue, Lichtenstein said.

"You're talking about a captive audience at a graduation ceremony," Lichtenstein said. "The constitutional problem is still the same."

CLARK COUNTY GUIDELINES FOR INVOCATIONS OR BENEDICTIONS

Old Policy

"High school commencement exercises may include an invocation and/or benediction under the following conditions:

- The decision to include an invocation and/or benediction at a high school graduation exercise must be voluntarily agreed upon by a majority of the graduating senior class, with the advice and counsel of the school principal.
- The invocation, benediction, if used, shall be given by a student volunteer."

New Policy

School officials may not mandate or organize prayer at graduation or other extracurricular activities or select speakers for such events in a manner that favors religious speech such as prayer. Where students or other private graduation speakers are selected on the basis of genuinely neutral, evenhanded criteria and retain primary control over the content of their expression, however, that expression is not attributable to the school, and, therefore, may not be restricted because of its religious (or antireligious) content. To avoid any mistaken perception that a school endorses student or other private speech that is not in fact attributable to the school, school officials may make appropriate, neutral disclaimers to clarify that such speech is not school sponsored.

The George W. Bush White House was determined not to let groups like the ACLU prevail on the prayer-at-school issue. Just a month prior to the Clark County lawsuit, Education Secretary Rod Paige sent a letter to all state education departments advising them of a provision within the federal No Child Left Behind law of 2001, requiring school districts to certify in writing that they did not have policies that interfere with "constitutionally-protected prayer."

This was the Bush Administration's two-part approach: To emphasize the constitutionality of every student's right to pray and to vilify opponents as those interfering with constitutional protections. In effect, the political strategy was to turn the constitutional-protection argument against those usually making it—the no-prayer advocates.

"Public schools should not be hostile to the religious rights of their students and their families," Paige said. "At the same time, school officials may not compel students to participate in prayer or other activities."

There were a few gray areas, though. For one, to what extent was so-called student-initiated prayer permissible at a public school event like graduation or a sporting match? That was something federal circuit courts had split over. The Bush Administration guidelines implied that that type of activity had to be permitted.

Religious Diversity

After the 9/11 attacks, there was considerable concern among left-wing civil rights activists in the U.S. that Americans would respond with bigotry...or even violence...toward Muslims. And there were a few egregious instances of violence. But, in all, the response was calm enough to cause some optimism. Maybe Americans were up to the mature expectations of the libertarian foundations of the country.

Sophomoric atheists are likely to win small legal victories but do a slow burn as they lose the larger argument about religion in the public arena. In January 2003, the Pew Global Attitudes Project was perplexed to report that its research indicated a continued importance of religion in American life. Nearly six in 10 Americans said that religion played a "very important" role in their lives. This was roughly twice the percentage of self-avowed religious people in Canada (30 percent) and an even higher proportion when compared with Japan and Europe.

Many anti-religion groups used these numbers as a point of departure to complain about the evangelical trends in American Christian churches—and then draw a line to the faith-based organizations (FBOs) that the Bush Administration encouraged as a private-sector mechanism for providing many social services.

These trends aren't inherently troubling, but they do suggest that religion will become a bigger issue in American "public life" in the 2000s and beyond. From the libertarian perspective, "public life" includes actions and agreements that are part of the social contract. *That* means many things, including work.

According to the Equal Employment Opportunity Commission (EEOC), complaints of religious discrimination rose 21 percent between 2001 and 2002. Although religious discrimination claims made up less than 10 percent of all workplace discrimination complaints in the U.S. during that period, they were rising at the fastest rate.

The politicization of religious issues that followed the 9/11 attacks may have something to do with these trends—but there are other, more general, demographic explanations. An aging population and a booming immigrant community both make it more likely that religious diversity will be an issue for years to come.

Banishing religion from public life was never supposed to be the American way. Tolerance for a variety of religion is.

Generally, employers are obligated to reasonably accommodate employees with religious needs, just as they are required to do for the disabled, as long as it doesn't cause undue hardship to the company. Under federal law, Title VII of the Civil Rights Act of 1964, workers are entitled to practice, exercise and discuss religion in the workplace without the threat of retribution.

One EEOC spokesman has said that a general rule of thumb for companies might be: "If the religious expression, whether it be different clothing, displaying some sort of religious paraphernalia or praying at lunchtime, isn't hurting the business and not disrupting the office culture, it should be allowed."

The key part of that statement is "not disrupting the office culture." That means no proselytizing; and it means no extreme or offensive religious practices.

Evangelical religions often make proselytizing an essential practice. This conflicts with libertarian philosophy and life-style; simply said, the libertarian belief in self-ownership doesn't mix well with aggressive religious recruiting. There's a communitarian aspect to some ministries that slips into authoritarian regimes.

Faith-Based Organizations

During his January 2003 State of the Union address, George W. Bush asked Congress to approve $600 million over three years for drug and alcohol treatment run by FBOs.

His guests for the speech included Tonja Myles of the Set Free Indeed Program at Healing Place Church in Louisiana and Henry Lozano of Teen Challenge California. Bush held up the Set Free Indeed program as a model, calling its work "amazing."

Bush's political allies on the American right have made much of faith-based organizations as a viable alternative to the delivery of social services. They've appealed to libertarians by arguing that FBOs can be a private-sector version of public-sector agencies.

But the hand of the state is corrupting—with conflicting interests and scores of unintended consequences. At best, FBOs are a mixed proposition. Some anti-religion groups objected to the explicit religions of the groups Bush championed. Several pointed out indignantly that Set Free Indeed's Web site contained the statement:

> We believe that recovery begins at the Cross.... We
> rely solely on the foundation of the Word of God to
> break the bands of addiction.

That's an explicitly religious statement. Is it proselytizing? Hard to say.

Internet Web sites don't convey proselytizing very well.

In May 2001, an executive with Teen Challenge told Congress that the group hires only Christians. John Castellani, its president, said—in what he may have intended as a witticism—that some Jewish participants complete the drug treatment program as "completed Jews," evangelical Christian jargon for converting to Christianity.

That sounds more like proselytizing.

A libertarian, even a pragmatic one, should begin to question state funding of the programs if they proselytize teenagers who are trying to kick drug habits. Ownership of self for young people in that position is often tenuous and easily exploited.

In March 2003 testimony to the House Financial Services Subcommittee on Housing and Community Opportunity, Douglas W. Kmiec—the Dean at the Catholic University of America's School of Law—attempted to explain how FBOs work.

Kmiec said:

> ...it has been a profound misunderstanding of the nature of our Constitution's protection of religious liberty that, in the past, often led to the erection of artificial barriers, and therefore, deprived our government of the services of many who dedicate their lives, as a matter of religious conviction, to the well-being of others.

Kmiec was talking about proposed regulations that applied to eight Department of Housing and Urban Development (HUD) programs that—working through faith-based organizations—promoted home ownership, supplied emergency and other shelter, created housing opportunities for those with AIDS, awarded community development grants or involved young people.

Each program stated clearly that:

> Explicitly providing that funds supplied directly to an FBO may not be used to support inherently religious activities, such as worship, religious instruction or proselytization....

No current or prospective beneficiary of a government funded service could be discriminated against on the basis of religion or religious belief....

Kmiec added:

[T]he regulations ensure that FBOs can retain their independence, allowing for example the continued use of a religious organizational name and not banishing the inclusion of religion in the organization's "definition, practice and expression," so long as that is continued without government funding.

This is constitutional. Does it pose an administrative responsibility that must be carefully observed in application? Yes. Supreme Court case law requires reasonable assurance that direct government funding is employed for secular purpose. It does not require that a religious organization forsake religion to participate.

Kmiec went on to explain that principles of non-establishment and non-endorsement meant an FBO should conduct privately-funded religious activities separately from the secular services funded by HUD. And existing regulations required that sort of separation.

On the other hand, if HUD funds were provided for "acquisition construction or rehabilitation" these must be for structures that were either wholly secular or—if mixed-use—government funding could not be more than the pro rata secular portion.

Kmiec concluded:

[T]he HUD regulations eliminate a variety of constitutionally unwarranted regulations of the past that categorically excluded religious organizations.... These prior regulations were odious. They did not advance freedom of religion so much as freedom from religion, which stands the constitutional protection on its head.

That sums up the misconception.

His outrage was a fair critique of the separation-of-church-and-state mania that occupied American public policy from the 1970s to 1990s.

Conclusion

The 9/11 attacks were born of religious intolerance. The desperate bigotry of groups like al Qaida underscores the importance of religious freedom in the developed world. But religious freedom is not the same thing as antireligious bigotry.

Surely, freedom of religion must allow freedom from religion. It's every citizen's right to have faith...or not to have faith. But that doesn't mean that all mentions of religion must be absent from public life. The separation of church and state was designed to protect churches—not the state.

Those who scream against any form of religious expression in public discourse overestimate the virtue of the state and the public sector. They are not inherently altruistic.

Despite their occasional lapses, churches usually are.

All of this having been said, so-called faith-based organizations are a problematic proposition. These FBOs purport to do public work in a private-sector way. Libertarians may be drawn to them as a kind of privatization; but FBOs require scrupulous management to avoid conflicts between their service of God and of mammon.

In the end, it's probably better to reduce the mission of the state, so that FBOs aren't necessary. Their structures and resources—human and financial—are better applied to an old-fashioned mission: charity.

3 Privacy

There's no right to privacy in the U.S. Constitution. But most reasonable people agree privacy is a fundamental liberty. How does a libertarian square this inconsistency?

Ellen Griswold was Executive Director of the Planned Parenthood League of Connecticut. The League operated a clinic in New Haven—where Griswold was arrested in November 1961 for violating a Connecticut law that stated:

> Any person who uses any drug, medicinal article or instrument for the purpose of preventing conception shall be fined not less than fifty dollars or imprisoned not less than sixty days...or be both fined and imprisoned.

The case quickly became a test for how the U.S. would deal with contraception. And—as often in cases related to sex or death issues—the constitutional issues were a little off point. Griswold was found guilty and fined $100. The case was appealed through federal channels to the U.S. Supreme Court.

There, William O. Douglas wrote the landmark decision *Griswold v. Connecticut*, which—in 1965—made contraception legal in America.

However, for the sake of this discussion, the controversy over contraception isn't important. The philosophy behind Douglas's decision is. Specifically, he wrote:

> ...the State may not, consistently with the spirit of the 1st Amendment, contract the spectrum of available knowledge.
>
> ...In other words, the 1st Amendment has a penumbra where privacy is protected from governmental intrusion. ...Various guarantees create zones of privacy. The right of association contained in the penumbra of the 1st Amendment is one.... The 3rd Amendment, in its prohibition against the quartering of soldiers "in any house" in time of peace without the consent of the owner, is another....

Douglas noted that the 4th and 5th Amendments were defined in an earlier Supreme Court decision as protection against state invasions "of the sanctity of a man's home and the privacies of life."

Justice Arthur Goldberg, agreeing with Douglas, wrote separately:

> The Court stated many years ago that the Due Process Clause protects those liberties that are "so rooted in the traditions and conscience of our people as to be ranked as fundamental."
>
> In determining which rights are fundamental, judges are not left at large to decide cases in light of their personal and private notions. Rather, they must look to the "traditions and [collective] conscience of our people"....

This matter of "fundamental rights" is hugely important to libertarians, since they focus so tightly on rights.

Goldberg then discussed the rarely-mentioned 9th Amendment to the U.S. Constitution. That amendment protects other fundamental rights, which exist alongside the rights specifically named in the first eight amendments. The 9th Amendment reads:

The enumeration in the Constitution, of certain rights, shall not be construed to deny or disparage others retained by the people.

In more than 200 years since the U.S. Constitution was ratified, privacy has emerged as the chief one of those "other rights."

The 9th Amendment was almost entirely the work of James Madison. It was introduced in Congress by him, and passed the House and Senate with little or no debate and virtually no change in language. Madison drafted it to quiet fears that a bill of specifically enumerated rights could not be sufficiently broad to cover all fundamental rights—and that the specific mention of some rights would be interpreted as a lack of protection for others.

In sum, the 9th Amendment supports the view that the personal liberty protected by the 5th and 14th Amendments from infringement by the federal government or the states is not restricted to rights specifically mentioned in the first eight amendments.

Although Douglas and Goldberg represented the majority opinion of the Court, not everyone agreed with them. Justice Hugo Black was especially opposed:

> "Privacy" is a broad, abstract and ambiguous concept which can easily be shrunken in meaning but which can also, on the other hand, easily be interpreted as a constitutional ban against many things other than searches and seizures.

> ...I get nowhere in this case by talk about a constitutional "right of privacy" as an emanation from one or more constitutional provisions. I like my privacy as well as the next one, but I am nevertheless compelled to admit that government has a right to invade it unless prohibited by some specific constitutional provision.

>If these formulas based on "natural justice," or others which mean the same thing, are to prevail, they

require judges to determine what is or is not constitutional on the basis of their own appraisal of what laws are unwise or unnecessary. The power to make such decisions is, of course, that of a legislative body.

Black was right. There is no "right to privacy" described in the U.S. Constitution. This fact surprises many people. But it also doesn't mean as much as it seems. The power of America's founding documents comes from more than just a list of rights.

What the Constitution does provide are some specific protections against government search and seizure of body and property that—taken together—create an inference of something called, variously, a "zone of privacy" or "right created by Constitutional penumbra."

Penumbra is a fancy word for shadows. And privacy issues raised by lawsuits like *Griswold* invariably seem to exist in those shadows.

Privacy from State Snooping

The state can violate zones of privacy in a number of ways—from prohibiting use of birth control for married adults to forcing families to let soldiers live in their homes. But, in the wake of the 9/11 attacks, the invasion of privacy that concerned most Americans was domestic surveillance aimed at preventing future acts of terrorism.

Totalitarian regimes spy on their own citizens frequently; free states aren't supposed to. The privacy-versus-security issues facing libertarians in America fall between those two extremes. How they work out as the War on Terrorism proceeds will indicate whether the United States ends up a little closer to a free state...or a little closer to a totalitarian regime.

Is there a role for domestic intelligence in a liberal democracy? And, if so, can the liberal democracy avoid political abuses and acquire the information necessary to protect citizens' lives and property?

There is a fair amount of U.S. legal precedent that helps answer these questions.

The 1986 federal appeals court decision *Handschu v. Special Services Division, New York City Police Department* limited domestic intelligence collection activities—surveillance—to circumstances in which:

> specific information has been received by the Police Department that a person or group engaged in political activity is engaged in, about to engage in or has threatened to engage in conduct which constitutes a crime.

But the most useful guide came almost a hundred years before *Handschu.*

The phrase "right to privacy" became common after a 1890 *Harvard Law Review* article co-written by future U.S. Supreme Court Justice Louis Brandeis. The point of the article was that states should allow some form of financial relief to people whose private affairs were exploited financially by others. The Supreme Court of Georgia, in granting damages to a man whose picture had been used in a newspaper advertisement without his consent, wrote that "A right of privacy in matters purely private is...derived from natural law."

Brandeis popularized the term in his analysis—and support—of the Georgia court's decision.

Years later on the Supreme Court, Justice Brandeis dissented from the decision *Olmstead v. United States* and summarized the principles underlying the Constitution's guarantee of privacy:

> The protection guaranteed by the [4th and 5th] Amendments is much broader in scope. The makers of our Constitution undertook to secure conditions favorable to the pursuit of happiness. They recognized the significance of man's spiritual nature of his feelings and of his intellect. They knew that only a part of the pain, pleasure and satisfactions of life are to be found in material things. They sought to protect Americans in their beliefs, their thoughts, their emotions and their sensations. They conferred, as against

the Government, the right to be let alone—the most comprehensive of rights and the right most valued by civilized men.

This right to be left alone became one of Brandeis' most well-known legal concepts. But this right and the right of privacy were fluid things—which makes them tough to define. Brandeis admitted the difficulty:

> The scope of the constitutional right of privacy is determined by evolving social norms, not by legal logic. It is determined by politics and social movement contestation, even if judges don't recognize this fact or admit it to themselves. We often think that fundamental rights should reflect basic values that do not change over time. In fact it is quite the opposite.

This approach was consistent with Brandeis's belief that the U.S. Constitution was a living document that each generation should interpret for itself. In his time, this was considered the progressive view. However, in the 2000s, political progressives don't like the fact that heavy interpretation allows for a pendulum-swing away from liberty—including privacy—and toward statist notions of security.

Libraries As Privacy Battleground

The USA Patriot Act (much more on this in Chapter 18) was a big part of the pendulum-swing away from privacy after 9/11. And one of the first groups to raise questions was librarians.

At a March 2002 meeting of the American Library Association, requests for borrower records under the Patriot Act were a hot topic. The librarians complained that they had started getting the requests immediately after the Act became law in late 2001—but they couldn't reveal who made the requests or what specific information was requested; and, worse still, weren't even supposed to keep track of Patriot Act requests.

Spokespeople from the White House, Justice Department and FBI all insisted that the number of library information requests was much smaller than groups like the ALA made it seem. The Feds suggested that the librarians were exaggerating the problem to make political points.

The federal government—especially the FBI—had long had uneasy relations with librarians. In 1987, the ALA received a call from a librarian in New York who said that two FBI agents had come into the branch and asked staff about what citizens of "hostile sovereign nations" were reading. The Association publicized the call as what it thought was an outrageous example of invasion of privacy.

But, in the weeks after the story broke, the ALA received calls from libraries around the country that had received similar visits. At that time, as later, the Feds implied that the ALA was exaggerating the scope of the inquiries.

So, which is the truth: Are the librarians a group of hysterics who exaggerate matters...or do federal agents routinely trample on the privacy rights of Americans? Because the erosion of liberty can be such a slippery slope, it's sometimes the safest bet to side with the hysterics.

Until the Patriot Act, book purchases and library records had been protected from law enforcement searches in ways that other records were not. Librarians had been fighting against government searches since the end of World War II; they'd lobbied successfully for statutes in 48 states and the District of Columbia prohibiting librarians from releasing lending information without proper legal authority.

There weren't specific statutes protecting book sales records; but most courts had required that law enforcement agents show a "compelling need"—a higher legal standard than usual—before they'd issue search warrants for bookstore records.

The Patriot Act trumped all of these state laws. It gave law enforcement agents the option of subpoenaing library records as they would any other information; and it made subpoenaing any other

information easier. It allowed the FBI and other agencies to make broad requests for information—for example, a list of all books checked out by all noncitizens. Librarians believed that these sorts of requests added up to a massive invasion of hard-won privacy rights.

When the Patriot Act was signed into law, the FBI knew that it would have to assure librarians that it would use its new powers judiciously. The Bureau sent Michael Woods, the head of its National Security Law Unit, to a January 2002 ALA meeting. Woods outlined what the FBI would ask of librarians and how the librarians should respond to such requests; and he assured his audience that the days of badge-flashing and demanding records were over.

Still, many of the librarians didn't trust the FBI's claim that it would handle its new powers responsibly. This wasn't necessarily much of a promise. One of the problems with the Patriot Act was that a search could be legal—and still trample privacy rights.

The ALA pointed out another reason for concern. Public libraries are a major source of public access to the Internet. After home and work, libraries make up the third most common place where Americans go on-line. Over 95 percent of libraries offer some form of Internet access; and one study of Internet usage by the U.S. Department of Commerce showed that a growing number of people were using library computers for personal use instead of places like work, where many companies monitor employee usage.

Through most of 2002, the libraries fought hard to keep the Patriot Act in the news. But the Feds used the Act craftily; specific information requests could be made secretly. As a result, the debate remained largely theoretical; there were few individual anecdotes to stir up outrage. The issue stayed in the news for a while—media outlets critical of the Bush Administration were particularly interested—but mainstream interest faded.

This is too bad. Privacy rights are difficult to defend precisely because their erosion happens quietly, at the hands of eroders who look and act like reasonable people.

A libertarian questions so-called "hate crime laws" because they penalize certain thoughts or beliefs, so a libertarian has to question unrestricted state access to library records. Books and periodicals are the tools by which a person develops thoughts or beliefs. To read books on Nazism doesn't make someone a Nazi; to read books on bombs doesn't make one a terrorist.

Technological Threats to Privacy

In early 2003, word began to circulate that the state of Oregon was considering the feasibility of requiring global positioning system (GPS) technology to be installed in all vehicles registered in the state. The goal: The state tax agency could track and record how many instate miles residents drove. This, in turn, was part of a proposal to switch the basis for vehicle taxes from fuel purchased to miles driven.

The proposal was supposed to be more fair to poorer people who drove older, less-fuel-efficient cars. But cheating spouses all over Oregon got nervous.

GPS technology has been a boon to millions who don't want to get lost; but others are turning to the technology to track people and keep an eye on them.

A network of 24 geosynchronous satellites broadcasts signals received by GPS devices. Using triangulation, the satellites help the devices gain a fix on their location anywhere on Earth. The devices not only indicate direction and speed at which a vehicle or person is moving, they also track the precise addresses it has visited. Employers who suspect workers are misusing company vehicles or suspicious spouses can use the devices as a surveillance system.

When you start to think of these uses of technology, you begin to see the potential privacy issues.

Facial recognition software is another technology advance with major privacy impacts. For example, everyone who attended the 2001 Super Bowl in Tampa, Florida, was photographed upon entering.

Images of the face of every person going in were compared against the faces of known felons and terrorists.

The 100,000 people at the game (counting spectators and workers) were not told this was happening. In the weeks that followed, officials at Tampa Stadium boasted about how well the system had performed—and a major backlash ensued. Political activists decried the process as a massive invasion of privacy.

According to Howard Safir, the former commissioner of the New York City Police Department:

> I don't think it was an invasion of privacy. The fact is you have no expectation of privacy when you enter into a public event in which there's 100,000 people. And we live in a dangerous world, and the use of photo imaging and comparing computer images of people entering to known terrorists is a great way of protecting the public.
>
> I don't think it's spying. ...people go through magnetometers when they go through airports. They put their luggage through x-ray machines. You go to casinos in Las Vegas or Atlantic City you're constantly under surveillance. But you're in a public place. If you want privacy, then you should be in places where you have expectation of it.

Safir pointed out that, while he was commissioner, the NYPD put surveillance cameras in public areas of housing developments. "We're not looking in bedrooms. We're not looking into private spaces," Safir said. "We're looking in public areas. Public spaces, elevators, hallways...."

Safir uses unusual definitions of *public* and *private*. Most airports and all gambling casinos are private property. Public housing is not; it's owned by state agencies. But the real point he makes is on reasonable expectations of privacy. And many Americans are following his lead after 9/11. The result is a real reduction in "zones of privacy."

In 2003, there were more than 3 million surveillance cameras in use in the United States. And they weren't limited to banks and casinos. Homeowners install hidden cameras to protect their property. Working mothers check on their children and baby-sitters by means of "nanny cams." Schools watch the comings and goings of students. Housing developments—even entire neighborhoods—screen for drug dealers and other undesirable elements.

Some see surveillance cameras as important security and anticrime tools; others see them as unwarranted invasions of privacy.

Some radical libertarians complain about filming in a public place as a threat to the self-ownership of every person in that place while the images were being filmed. But, in this context, the great (complete, categorical self-ownership) is the enemy of the good (using technology to privatize and decentralize law enforcement).

Private nanny cams don't trouble libertarians; any technology tool that reduces a family's—or neighborhood's—dependence on state law enforcement resources is good. The main problem with camera surveillance is statist confusion (like Howard Safir's) over the difference between *public* and *private* property.

The nanny cam in your daughter's nursery needs to belong to you. If it belongs to Howard Safir, everyone is in trouble.

Data Mining

Data mining is a broad search of public and non-public databases in the absence of a particular suspicion about a particular person, place or thing. It looks for patterns of occurrence, location or time. Officials and many security experts say such data mining techniques are necessary to flush out a foe that does not wear a uniform but blends in with ordinary civilians to infiltrate and undermine American society.

Civil-liberties advocates on the left and the right say the tactic could lead back to the days when agencies like the FBI conducted routine surveillance on law-abiding citizens.

One example of data mining's use: The Homeland Security Act created the Terrorist Threat Integration Center (TTIC), operated jointly by the FBI, CIA and Department of Homeland Security (DHS).

The Senate Governmental Affairs Committee's first hearing on TTIC sparked several key questions. Among those were whether TTIC adequately would address privacy and other legal concerns.

Privacy rights could be endangered by combining law enforcement functions with intelligence gathering and analysis. TTIC potentially would have access to "huge databases" of information from its component agencies such as the FBI and CIA Counterterrorism Center (CTC)—plus private sector security firms doing business with the government.

The practice of relying on commercial data allows government investigators to skirt existing privacy laws and gain access to a realm of personal details they would not see otherwise.

A range of laws limits how government can collect and use information on its citizens. Tax returns and census data are protected from misuse by stiff criminal penalties, while the Privacy Act of 1974 prevents agencies from indiscriminately passing around Social Security records or other personal data.

However, all of these laws limit how the state gathers and keeps information—none of them limit how private-sector security firms do the same.

And the FBI doesn't have to play word games with the definitions of *public* and *private* to threaten privacy. Synthesis of fairly-released personal information can become another invasion of privacy. Information from various commercial firms can be combined to compile a profile of a person who never expected *that* profile to be made.

A person releases personal information—makes it public—for specific purposes: to apply for a credit card or open a bank account. He or she assumes that the information will be used only to a certain degree and only within certain contexts. But combining that information with other personal information—say, health or romantic

matters—could create a profile that he or she intended to keep private.

In January 2003, Senators Russell Feingold, Ron Wyden and Jon Corzine cosponsored a bill called the Data Mining Moratorium Act, which would suspend data mining by federal agencies until Congress had conducted a thorough review of the practice. In congressional testimony announcing the bill, Feingold said:

> Through comprehensive data mining, everything from people's video rentals or drug store purchases made with a credit card to their most private health concerns can be fed into a computer and monitored by the federal government.
>
> …It is reasonable to ask Americans to sacrifice some personal freedoms, like submitting to more extensive security screenings at airports. But should we allow the government to track our every move from what items we purchase on-line to our medical records to our financial records, without limits and without accountability? We would catch more terrorists, perhaps, in a police state…. But that's not a country in which most Americans would want to live.

Feingold is a liberal from Wisconsin but he thinks and talks more like a libertarian than just about anyone else in the U.S. Senate.

Conclusion

In the wake of the 9/11 attacks, the temptation exists to swap privacy for security. But privacy is important to liberty for more personal reasons. The right to privacy is an important check on the state's behavior.

It's a short step from data mining to fundamental changes in expectations of privacy. When you hear someone talking about a method of surveillance being acceptable because no one should have an expec-

tation of privacy, anyway, you know you're listening to an ambitious statist.

Breezy talk of no expectation of privacy is something that should bother anyone who embraces liberty.

4 Property

Libertarian political philosophy is built on property rights. Libertarians believe these rights—properly applied—can free the world. How does *that* work?

In January 2003, a long-simmering real estate dispute between landowners and the local government in Lake Tahoe, Nevada, resulted in a lawsuit. Again.

The focus of the lawsuit was the Tahoe Regional Planning Agency (TRPA)'s opposition to what it called "monster homes"—multimillion-dollar mansions built to the limit of local zoning guidelines. The local regulators considered the monster homes a threat to Lake Tahoe's scenery; so, in November 2002, they made the guidelines stricter.

Developers and real estate professionals didn't like this. The stricter guidelines would freeze the supply of big-ticket houses—which was already not large enough to meet demand. So, a group called the Committee for Reasonable Regulation of Lake Tahoe hired lawyers to make a constitutional case: that the stricter zoning guidelines were an unconstitutional "taking" of individuals' property values.

"They have run amok," committee founder Bob Wheeler said of TRPA to a local newspaper. "It is an agency that is steering a ship that is rudderless."

The lawsuit, filed in U.S. District Court in Reno, claimed that the "scenic regulations" adopted by the TRPA lacked any scientific support and were an illegal taking of property without compensation. It also argued that the new rules violated a California/Nevada agreement that had originally established the TRPA.

That last argument had been banging around federal courts for years. A group of Lake Tahoe-area property owners had been seeking compensation for the first building limits set by TRPA when it was started in 1969. They lost; and, generally, their track record in court was pretty bad.

In 2000, the TRPA won a series of court decisions that confirmed its ability to control land use around Lake Tahoe. That summer, the U.S. Circuit Court of Appeals in San Francisco sided with the agency and reversed an earlier ruling that some landowners who'd sued TRPA in the 1980s were entitled to compensation for policies that took away their ability to build on their land.

Also that summer, a federal judge in Sacramento rejected the appeal of a ruling for the TRPA and against an individual landowner who'd built a home on a sensitive wetland area near South Lake Tahoe. And, completing the sweep, the same judge rejected a separate lawsuit that attacked TRPA's Individual Parcel Evaluation System—which was used to rate environmental sensitivity of vacant lots.

The landowners insisted that the TRPA was unique among zoning agencies in the U.S.; it made regulations that robbed property rights without compensating owners.

(In most situations, government agencies that pass laws reducing the value of real estate can be held liable for the damage they do to values.)

Larry Hoffman, one of the lawyers working for the landowners, said the legal battle would continue—either in appeals of older decisions or new lawsuits filed. "TRPA has held itself above the 5th Amendment," Hoffman said. "They say you can't use your land and we won't pay you."

Although the TRPA had been winning cases through the 1990s, the landowners had at least one precedent on their side: In 1999, the TRPA settled a lawsuit brought by Bernadine Suitim, an Incline Village (a town on the north shore of the lake) property owner. Suitim claimed that the TRPA had violated the 5th Amendment to the U.S. Constitution by forcing her to give up her ability to build on land she owned. The case was reviewed by the U.S. Supreme Court; soon after that, the TRPA settled, paying Suitim $600,000.

The Lake Tahoe landowners had that case in mind when they sued...and appealed...and sued again.

Property Is Key to Liberty

One of the difficulties of explaining liberty well in today's America is that so much of its origins focused on protecting property. This doesn't always resonate in a culture that likes its politics to have a more altruistic bent.

One philosophical criticism of libertarian values is that they are materialistic and selfish. A focus on property rights smacks of materialism to most pundits. And materialism, the American left and right tend to agree, is a limited perspective—a problem rather than a solution. Pundits would rather argue over abortion, affirmative action or foreign policy—and agree that materialism is the vulgar concern of unenlightened masses.

This elitism echoes a statist slant.

And this slant is an ironic one—because the state is good at defining and protecting materialism but lousy at defining and establishing the more altruistic topics. There seems to be something inverse about the preferences of big-government bureaucrats. They want to debate endlessly precisely the issues for which they are least equipped to provide useful solutions.

The focus of the founders' efforts was something that most Americans today take for granted: the security of person and property. The

best thing that the state can do for its citizens is to assure the security of person and property. And the greatest threat to these securities is the state—not other citizens. That's why the Constitution focuses on limiting what the state can do to your person and property.

Property Needs Markets

In this chapter, you'll read a lot about "takings." A key point to keep in mind: A "taking" can mean a regulation that limits and reduces the value of property—not literally taking possession of it. (People who've had their property devalued by statist regulations often *wish* the government had actually taken possession.)

Banning smoking in restaurants is a taking—an infringement on property rights. Opposition to such an ordinance is not about the rights of smokers. It's about the rights of property owners.

As New York City was preparing to pass a ban on smoking in 2002, Robert A. Levy of the Washington, D.C.-based nonprofit public policy research foundation CATO Institute wrote:

> The owner of the property should be able to determine—for good reasons, bad reasons or no reason at all—whether to admit smokers, nonsmokers, neither or both. Customers or employees who object may go elsewhere. They would not be relinquishing any right that they ever possessed. By contrast, when a businessman is forced to effect an unwanted smoking policy on his own property, the government violates his rights.

An important corollary to property rights is the establishment of markets that set the value of property. Free markets set a base line of truth and value. And this truth does a lot to prevent statist abuses of truth...and of people.

If the state can protect your person and your things—and assure your ability to deliver either safely to market—it has done its job.

Some lawsuits and public pronouncements about takings make any focus on property rights sound eccentric. These arguments usually involve political agendas from extreme and obscure perspectives. Extreme groups argue that any level of taxation or regulation constitute illegal taking of property; they make lawsuits that claim income tax is an illegal taking—which makes more reasonable arguments about excessive laws and regulation seem wacky, too.

Even the most rugged individualist admits that some level of taxation and regulation is required to assure a safe and secure path for developing property and bringing it to the marketplace. The challenge comes in keeping the state content with its relatively small role in the equation. States like to grow.

In the summer of 2002, Rhode Island Senator Lincoln Chafee—an icon of Republican statism in Washington, D.C.—introduced a wretched piece of legislation called the Community Character Act. The act would provide federal funds to assist state and local governments with urban planning efforts.

But the funds would come with strings attached. Local governments would have to meet a list of criteria, including requirements that money be used to "promote sustainable economic development (including regional economic development) and social equity" and enforce "approaches to land use planning that are consistent with established professional land use planning standards."

In announcing his opposition, Oklahoma Senator James Inhofe—something closer to a pragmatic libertarian—called Chafee's act a violation of the 10th Amendment and said it "undermines local control of important economic development and land use decisions."

Inhofe wasn't alone. A National Center for Public Policy Research brief on the Community Character Act concluded:

> The terms "smart growth" and "sustainable development," which are the stated goals of the bill, are, in reality, buzzwords used by environmental extremists to promote no-growth and no-development programs.

Land-use planning has a remarkably statist flavor. That statism has often been applied to abrupt—and mandatory—changes in policy, and has frequently resulted in unintended consequences.

Many anti-sprawl and slow-growth policies attack an individual's right to choose where to live and how to commute; this is why most Americans remain skeptical of the movement. Managed growth programs being implemented in various parts of the country—Portland, Oregon is one example—are often "anti-car, anti-suburban and anti-single-family home."

The hipsters who pose as libertarians hate to associate themselves with the nerdy or greedy believers who file illegal takings suits. There's something somehow humorless about the suits. But the greedy nerds have the better claim to true support of liberty.

The sanctity of person and property are essential to democracy. That's why so much of the Declaration of Independence and Constitution talk about them. Capitalism works in many political systems—but it works best when property is secure. The popular media likes to talk about the 1st Amendment…and the 2nd Amendment. It talks about interpretation issues like privacy and human rights. It doesn't talk as much as you'd expect about the 3rd, 4th, 5th and 6th Amendments; and they're every bit as important.

In short, one part of property rights is worth dozens of parts of privacy or anything else.

The Theory of "Takings"

The legal concept of illegal takings comes from the 5th Amendment, which most people equate with its protections against self-incrimination. Mobsters and crooked CEOs "plead the 5th." But there's more to it than John Gotti and Martha Stewart; the full text of the 5th Amendment reads:

> No person shall be held to answer for a capital, or
> otherwise infamous crime, unless on a presentment or

indictment of a Grand Jury, except in cases arising in the land or naval forces, or in the Militia, when in actual service in time of War or public danger; nor shall any person be subject for the same offence to be twice put in jeopardy of life or limb; nor shall be compelled in any criminal case to be a witness against himself, nor be deprived of life, liberty or property, without due process of law; nor shall private property be taken for public use, without just compensation.

Most people aren't aware of that last clause.

Under U.S. law, the government has two powers to control the use of private property: eminent domain and police power. Eminent domain involves the taking of property because of the clear needs of the public interest; people whose property is taken under eminent domain must be compensated by the agency doing the taking. Police power involves the control of property to prevent its use in a manner detrimental to the public interest; people whose property is regulated under police power may not have to be compensated.

In the 1922 decision *Mahon v. Pennsylvania Coal Co.*, the Supreme Court recognized the general principle that "if regulation goes too far it will be recognized as a taking."

"Goes too far" is a hazy term. As governmental regulation of property—land use controls, environmental regulations and the like—expanded over the years, the Supreme Court never developed a set formula to determine where regulation ends and taking begins. But, in the 1978 decision *Penn Central Transportation Co. v. City of New York*, it came close. There, the Supreme Court laid out general guidelines for identifying an illegal regulatory taking:

> The economic impact of the regulation on the claimant and, particularly, the extent to which the regulation has interfered with reasonable investment-backed expectations are... relevant considerations. So too, is the character of the governmental action. A "taking"

> may more readily be found when the interference with
> property can be characterized as a physical invasion
> by government than when interference arises from some
> public program adjusting the benefits and burdens of
> economic life to promote the common good.

The overriding objective was to vitalize the 5th Amendment's protection against government "forcing some people alone to bear public burdens which, in all fairness and justice, should be borne by the public as a whole."

At issue in *Penn Central* was New York City's landmarks preservation law, which the city cited to deny approval of construction of a 53-story office building atop Grand Central Terminal. The Supreme Court upheld the landmarks law. The economic impact on Penn Central was considered:

> The company could still make a "reasonable return"
> on its investment by continuing to use the facility as
> a rail terminal with office rentals and concessions, and
> the City specifically permitted owners of landmark
> sites to transfer to other sites the right to develop be-
> yond the otherwise permissible zoning restrictions—
> a valuable right which mitigated any loss.

As for the character of the governmental regulation, the Court found the preservation of historic sites being a permissible goal and one that served the public interest.

More recently, in its 1980 decision *Agins v. City of Tiburon*, the Court ruled that land use controls constitute takings if they do not "substantially advance legitimate governmental interests" or if they deny a property owner "economically viable use of his land." The second *Agins* criterion creates a categorical rule:

> [W]hen the owner of real property has been called upon to
> sacrifice all economically beneficial uses in the name of the
> common good, that is, to leave his property economically idle,
> he has suffered a taking.

The first part of the *Agins* test, focusing on whether land use controls "substantially advance legitimate governmental interests," was applied in the 1987 case *Nollan v. California Coastal Commission*. There, the Court held that extraction of a public access easement across a strip of beach as a condition for a permit to enlarge a beach front home did not "substantially advance" the state's legitimate interest in preserving public view of the beach from the street in front of the lot. The easement instead was designed to allow the public to walk back and forth along the beach between two public beaches. The Court concluded:

> [U]nless the permit condition serves the same governmental purpose as the development ban, the building restriction is not a valid regulation of land use but "an out-and-out plan of extortion." ...If [the government] wants an easement across the Nollans' property, it must pay for it.

For libertarians—and property owners—that decision was a hopeful sign.

Property Regulation Often Means Corruption

In 1995, officials in Warrington Township (in suburban Bucks County, Pennsylvania—near Philadelphia) learned that competing movie theater chains were interested in opening theaters in the town.

United Artists Cinemas (UA) was the first to submit a proposal for a multiplex theater, in January 1996. A year later, a competing developer submitted a plan to build a multiplex theater and retail center on a plot of land adjacent to UA's proposed theater site.

The town asked each developer to voluntarily contribute an "impact fee" to cover administrative costs and other municipal expenses related to the projects. The competing developer immediately offered to pay $100,000 per year; UA resisted.

In February 1997, the town voted to grant preliminary approval to the competing project—just one month after its initial application—and the project was granted final approval in May 1997.

UA said it was not granted preliminary approval until March 1997; when the project came up for final approval, the town tabled its vote three times—each time asking UA to pay the impact fee.

Finally, in September 1997, the town granted final approval after UA guaranteed that it would collect $25,000 in revenue from the project annually. But it altered some of the conditions to approval, making it more difficult for UA to begin building its theater. The competing project was completed in 1999. UA never built a theater in Warrington Township.

UA filed a federal lawsuit in 1998. It claimed that Warrington Township and its board of supervisors violated the theater chain's constitutional rights by delaying approval of the proposed theater when it refused to pay the "impact fee."

The court found that UA had a valid substantive due process claim because there was evidence that the township acted with an improper motive. On appeal, the township's lawyer argued that he urged the court to use a shocks-the-conscience test (usually used for the most extreme corruption cases), but that it refused.

UA's lawyers urged the court to stick with a long line of local cases that used a less-demanding test in land use cases. In those cases, the courts held that a municipal land use decision violates substantive due process if it was made for any reason "unrelated to the merits," or with any "improper motive." But, in early 2003, the appeals sided with the township. It ruled that land developers who claim their rights were violated by municipal zoning had to prove that the state's conduct "shocks the conscience," and not merely that they acted with "improper motives."

The appeals court ruled that decisions using the improper-motives test were "no longer good law." Writing for the majority, U.S. Circuit Judge Samuel A. Alito noted:

Land-use decisions are matters of local concern and such disputes should not be transformed into substantive due process claims based only on allegations that officials acted with "improper" motives.

In a strongly worded dissent, one judge insisted that the improper motives test was still good law, and that it was wrong to rely on *Lewis*, which involved a high-speed police chase, for a rule that would apply in real estate development cases. Judge Robert E. Cowen said he feared that switching to a shocks-the-conscience test would invite abuse:

Tossing every substantive due process egg into the highly subjective "shocks the conscience" basket is unwise. It leaves the door ajar for intentional and flagrant abuses of authority by those who hold the sacred trust of local public office to go unchecked.

... The alleged behavior in this case resolutely shocks the conscience. Public officials, sworn to uphold the law, deliberately extracted money, knowing that it was improper for them to do so.

In October 2003, the Warrington board of supervisors discussed settling the case. As part of any settlement, UA—which intended to sell the property—wanted the Township to waive various annual fees on the undeveloped property; in all, these waivers would be worth hundreds of thousands of dollars to a buyer.

There were still some details that had to be worked out. But Gerald Anderson, one the supervisors originally named in the suit, said, "We're getting closer to an agreement on the issue."

Criticisms of a Focus on Property Rights

Are property rights *fundamental?*

Classical liberals split into two groups on this question. Those who answer "no" have become statists; those who answer "yes" have various other questions to answer.

Some of those who answer "yes" believe that—even though property rights are fundamental—the state still has a right to regulate them (because property rights, unlike other fundamental rights, can affect people not party to a property contract). Those people become, more slowly, statists.

Libertarians can be thought of as the relatively few people who believe that property rights are fundamental—and should be regulated as little as possible.

Libertarian philosopher Murray Rothbard wrote:

> In the profoundest sense there are no rights but property rights.... Each individual, as a natural fact, is the owner of himself, the ruler of his own person. Then, "human" rights of the person...are, in effect, each man's property right in his own being, and from this property right stems his right to the material goods that he has produced.

John Locke argued for a "natural right of property." He used "property in one's own person" to mean that no one is born politically subject to another, but that each has upon reaching maturity rights of self-ownership. His argument places rights of property on a par with fundamental rights.

Statists argue that rights of property should be revisable by law to meet changing conditions for the sake of efficiency, public safety or some other social value. Hence, government can regulate uses of property and even appropriate property by eminent domain procedures, if necessary, for the public good (so long as fair compensation is made). From this perspective, property rights are not fundamental: They can be regulated and revised for reasons other than protecting and maintaining basic rights and liberties.

Libertarians argue that a person's rights to use and transfer particular possessions (e.g., an automobile or income) cannot be infringed or burdened for the sake of other social values. Instead one's use of property can only be restricted to protect other fundamental rights.

The fundamental libertarian claim is then that each person is the absolute owner of herself, body and powers. Because we each have absolute property in our persons, it is supposed to follow that each has absolute powers over what she owns or acquires consistent with others' ownership rights. On this conception a person's liberties are among the things owned by that person; in this sense, "liberty is property."

To libertarians, the problem with other principles of distributive justice—including socialism, so-called "democratic socialism" and totalitarianism—is that they involve people's partial property rights in other people. Therefore, socialism is a state-mandated form of slavery.

Intellectual Property Rights

Intellectual property is interesting because it tests the limits of assumed truths about the American system more than decades of abortion debate have. However, even as IP issues are being defined by federal courts, the courts rely heavily on language that's more than 200 years old.

For the first time since the fundamental rights in America were established, the notions of what property is and how it can be secured are changing.

The fate of the U.S. economy—or any modern economy—depends ultimately on a sensibly balanced system of intellectual property rights. The founders understood that. In the Constitution, they gave creators a limited monopoly over their creations as a means of fostering future creativity.

These limited monopolies (copyrights and, to a less-specific degree, trademarks) have always been a challenge to libertarians, who detest monopolies of any sort. But copyrights and trademarks, like other parts of the social contract, have always seemed like a necessary cost of efficient markets.

The aggressive libertarian—some say anarchic—bent of the Internet has thrown a big wrench in those assumptions.

Internet pioneers took a skeptical view toward intellectual property rules—and even laws. Some considered a radical definition of "fair use" the order of the day in commercial matters: Anything that could be hacked, copied or retro-engineered was fair game for free use by anyone smart enough to access it.

This pirate sensibility found its truest form in the Internet-based "file-swapping" service called Napster. The service allowed members to share fairly high-quality digital copies of copyrighted music for free. Users boasted that they'd never pay for recorded music again.

Outrage—and lawsuits—followed the system's popular rise.

Libertarians faced a dilemma. Services like Napster were undermining the intellectual property rights of musicians and record companies; on the other hand, the record industry was a ruthless system that hid sleazy business dealings behind grand talk of intellectual property rights.

But libertarians aren't anarchists. Intellectual property—like other property—has to be secure for markets to operate efficiently.

Napster was, effectively, litigated out of existence by the record industry. Still, it had its effect. Intellectual property businesses have learned that they need to enable some fair use of their material in order to keep the Internet marketplace satisfied with their products.

Conclusion

Although it may seem odd at first glance, property rights are the best weapon against the political radicalism of groups like al Qaida. They assure self-ownership and influence everything from freedom of speech to free markets.

At the foundation of every developed society is a fundamental agreement on what property is—and how it can be secured. All other liberties flow from that agreement.

5 Guns

Libertarians believe strongly in the right to own guns. How does that belief help bring freedom to a violent world?

Timothy Joe and Sacha Emerson had a bad marriage littered with adultery, psychological abuse and violence. They were from west Texas— San Angelo, a few hours south of Abilene—but they weren't yokels. He was a doctor.

Still, they acted badly toward each other. In August 1998, Sacha filed for divorce in county court. Her petition requested, among other things, a temporary injunction enjoining Timothy from using guns in her presence.

Timothy had been acting erratically since he'd separated from Sacha some months earlier. Sometimes a separation can ease tensions between a husband and wife; this wasn't so for the Emersons. And if there was any contact between them it could turn ugly. At one point, when Sacha and their daughter visited Timothy's office to take care of a simple insurance matter, Timothy pointed a semiautomatic pistol at them. He'd cocked the hammer and aimed at Sacha. He didn't shoot; but he did say he was going to kill a man with whom she'd been having an adulterous affair.

Timothy also made some damning comments to his office staff and the local police. He told an employee that he had an AK-47 rifle and that he planned to "pay a visit" to his estranged wife's boyfriend. To a police officer, he said that if any of his wife's "friends" were to set foot on his property they would "be found dead in the parking lot."

In September 1998, the local judge issued a temporary order that included a "Temporary Injunction," which stated that Timothy Emerson was "enjoined from" engaging in any of 22 enumerated acts, including threatening Sacha in person, by telephone or in writing and "intentionally, knowingly or recklessly causing bodily injury to [Sacha] or to a child of either party."

Timothy didn't pay much attention to the court order. He still made threats against his wife and her "friends"; and he still had a lot of guns.

In December 1998, a federal grand jury in San Angelo indicted Timothy for unlawfully possessing a firearm—specifically, the Beretta pistol he'd used to threaten Sacha—while subject to the September court order. The grand jury cited Section 922 of the U.S. Code, which stated in relevant part:

> It shall be unlawful for any person....
>
> who is subject to a court order that
>
> (A) was issued after a hearing of which such person received actual notice, and at which such person had an opportunity to participate;
>
> (B) restrains such person from harassing, stalking or threatening an intimate partner of such person or child of such intimate partner or person, or engaging in other conduct that would place an intimate partner in reasonable fear of bodily injury to the partner or child; and
>
> (C) includes a finding that such person represents a credible threat to the physical safety of such intimate partner or child....

Timothy had been casual about the hearings related to his divorce. But he fought the federal charges aggressively, moving to have them dismissed. He'd purchased the pistol in question—in fact, all of his guns—legally, from a licensed firearms dealer. And before the court order had been made. Except with regard to the threats against his wife and her friends, he'd never had any legal troubles.

Timothy's lawyers made a complex constitutional argument against the grand jury charges. They claimed that section 922 violated the 2nd Amendment and the Due Process Clause of the 5th Amendment. They also moved to dismiss on the basis that section 922 was an improper exertion of federal power and that the language of the section unconstitutionally usurped powers reserved to the states by the 10th Amendment.

Timothy's divorce proceedings took a back seat to his gun case— which, from a legal perspective made sense. His gun argument was stronger; it forced the federal courts to take a hard look at their rulings on gun ownership.

A district court granted Timothy's motions to dismiss the charges. It held that dismissal of the indictment was proper on 2nd or 5th Amendment grounds, but it rejected the 10th Amendment and Commerce Clause arguments. It went on to write that section 922 would deprive Timothy of his 5th Amendment rights.

This decision was a major win for Timothy. The district court held that the 2nd Amendment recognized the right of individual citizens to own and possess firearms, and declared that section 922 was unconstitutional on its face because it requires that a citizen be disarmed merely because of being subject to a "boilerplate [domestic relations injunction] order with no particularized findings."

But the victory wouldn't last long. The government appealed immediately.

On appeal, Timothy's lawyers switched from a constitutional argument to a more mechanical critique of section 922. They argued that the law should be construed to require that the particular predi-

cate court order include "an explicit finding that the person enjoined posed a credible threat of violence to his spouse or child."

In November 2001, the Fifth Circuit Appeals Court rejected this argument in its decision *United States v. Emerson*. It noted:

> Emerson filled out and signed BATF Form 4473 when, on October 10, 1997, he purchased the Beretta semiautomatic pistol.... This afforded notice to Emerson that so long as he was under a court order such as that of September 14, 1998, federal law prohibited his continued possession of that weapon.

The appeals court also reversed and rejected the lower court's conclusions about the 2nd and 5th Amendments. However, it did agree with the lower court on a few key points of interpretation of the 2nd Amendment.

For Timothy, the appeals court decision was devastating. For libertarians and gun enthusiasts, there was considerable silver lining to the appeals court's cloudy ruling.

A Litmus Test for Liberty

Some people ask whether there is a litmus test for libertarians—a single issue that defines the philosophy, as abortion does for evangelical Christian conservatives. Most libertarians bristle at the notion of a litmus test; they hope their beliefs allow for broad and diverse adherents.

In the U.S., the right to own a gun is essential to any practical meaning of liberty. An American who calls himself a libertarian but doesn't support the right of a citizen to own a weapon is an ass.

And there are some of those.

The 2nd Amendment to the U.S. Constitution reads:

> A well regulated Militia, being necessary to the security of a free State, the right of the people to keep and bear Arms, shall not be infringed.

The operative clause ("the right of the people to keep and bear Arms, shall not be infringed") secures the right. The explanatory clause ("A well regulated Militia, being necessary to the security of a free State") justifies the right. In the later 1990s and early 2000s, debates raged over how much importance to give to each clause.

America's founders believed strongly that an armed populace was the best deterrence to statist tyranny...and basic crimes. Thomas Jefferson, far from the most militant of the founders, wrote in a collection of essays he called *The Commonplace Book*:

> Laws that forbid the carrying of arms...disarm only those who are neither inclined nor determined to commit crimes.... Such laws make things worse for the assaulted and better for the assailants; they serve rather to encourage than to prevent homicides, for an unarmed man may be attacked with greater confidence than an armed man.

In his popular early-1800s edition of *Blackstone's Commentaries on the Laws of England*, St. George Tucker—a lawyer, Revolutionary War militia officer and, later, a U.S. District Court judge—wrote of the 2nd Amendment:

> The right of the people to keep and bear arms shall not be infringed, and this without any qualification as to their condition or degree, as is the case in the British government.
>
> ...The right of self-defense is the first law of nature; in most governments it has been the study of rulers to confine this right within the narrowest limits possible. Whenever standing armies are kept up, and the right of the people to keep and bear arms is, under any color or pretext whatsoever, prohibited, liberty is on the brink of destruction.

Tucker's analysis implies a couple of points that remain important 200 years later. First, the scope of the right to keep and bear arms is

not *restricted* to military purposes or the common defense; those are merely two of the many things that the right achieves. Second, "the people" means individuals—not a collective entity, and not a state.

Individual Versus Collective Right

Not everyone agrees with Judge Tucker. In recent years, three interpretations of the 2nd Amendment have emerged among American legal scholars.

The first interpretation is that the 2nd Amendment does not apply to individuals; rather, it merely recognizes the right of a state to arm its militia. This "collective rights" interpretation of the 2nd Amendment was embraced by numerous federal courts during the 1990s.

The second is that the 2nd Amendment recognizes some limited species of individual right. However, this right to bear arms can only be exercised by members of a functioning, organized state militia who bear the arms while and as a part of actively participating in the organized militia's activities. The "individual" right to keep arms only applies to members of such a militia, and then only if the federal and state governments fail to provide the firearms necessary for such militia service. Some federal courts accepted this model, sometimes referred to the "sophisticated collective rights" model.

The third, which comes closest to agreeing with Tucker, is that the 2nd Amendment simply recognizes the right of individuals to keep and bear arms. During the 1990s, virtually no federal courts subscribed to this model—referred to as the individual rights model or the standard model.

Statists who want to erode the right to bear arms argue that the 2nd Amendment protects a collective right, not an individual one. Pressed, they may retreat to the argument that—while the right to bear arms may apply to individuals—it only exists with predicate of a collective state right to keep that well-ordered militia.

Both arguments are crap.

The brilliance of the U.S. Constitution is that it uses simple ideas to build a complex system. It sees that protecting the liberty of the individual citizen allows for the best legitimate power of the state. The first eight amendments to the Constitution are meant to preserve specifically named individual rights. (The 9th Amendment ensures that those first eight are not the *only* individual rights so preserved.)

Some of the amendments protect individual rights to achieve explicit collective purposes—the 2nd Amendment is one of these. The right to own and carry weapons protects each individual citizen *against* the state; this protection eventually benefits the state, serving as a check against a legitimate government morphing into a tyranny.

But the protection against government tyranny is only one benefit of the 2nd Amendment; there are many others, including more robust self-defense and a deterrence against crime.

The people who drafted the U.S. Constitution had a strong belief that self-defense was the responsibility of the individual and the community, and not of the state. There's no evidence that anyone who signed the Constitution had even a crude notion of the right to bear arms as a "collective right." From the history of the document, it's pretty clear they were thinking of the statist ploys that the English king had forced on America when it had been a group of colonies.

Still, in the 1990s, Bill Clinton—an American president—followed the academic fashion and instructed his Justice Department to argue in federal courts throughout the land that there was no individual right to bear arms...only a collective right of the state to do what it needed to field a militia.

Clinton was still in the White House...and his policy still in place...when the *Emerson* case was first filed. While the case wound its way through the courts, Clinton was replaced by George W. Bush. But the effects of the Clinton era lingered, especially in the federal courts.

The *Emerson* decision rejected the collective rights arguments, "sophisticated" or not. This was the silver lining of the decision. Al-

though the Fifth Circuit Court of Appeals ruled against Timothy Joe Emerson in the specific, it wrote more generally:

> The government steadfastly maintains that the Supreme Court's decision in *United States v. Miller* (1939), mandated acceptance of the collective rights or sophisticated collective rights model, and rejection of the individual rights or standard model, as a basis for construction of the 2nd Amendment. We disagree.
>
> …The individual rights model, of course, does not require that any special or unique meaning be attributed to the word "people." It gives the same meaning to the words "the people" as used in the 2nd Amendment phrase "the right of the people" as when used in the exact same phrase in the contemporaneously submitted and ratified 1st and 4th Amendments.
>
> There is no evidence in the text of the 2nd Amendment, or any other part of the Constitution, that the words "the people" have a different connotation within the 2nd Amendment than when employed elsewhere in the Constitution. In fact, the text of the Constitution, as a whole, strongly suggests that the words "the people" have precisely the same meaning within the 2nd Amendment as without. And, as used throughout the Constitution, "the people" have "rights" and "powers," but federal and state governments only have "powers" or "authority," never "rights."

That last distinction is vital to libertarians. The term "states' rights" is used fairly often in a variety of political contexts. But it's always a bit of a misnomer. States don't have rights…and they shouldn't. Individuals do.

To drive home its point, the *Emerson* court concluded:

> [The 2nd Amendment] does not support an interpretation of the amendment's substantive guarantee in

accordance with the collective rights or sophisticated collective rights model, as such an interpretation is contrary to the plain meaning of the text of the guarantee, its placement within the Bill of Rights...and of the original Constitution as a whole.

This decision didn't come from the Supreme Court (which let it stand); but it marked the end of an era in academic and legal circles.

Six months later, in the late spring of 2002, George W. Bush's Justice Department argued before the Supreme Court that the 2nd Amendment "broadly protects the rights of individuals." That stance was at odds with decades of official government. And any libertarian should cheer the change.

The Militia Is Us

Perhaps one helpful way to see through all of the academic and political interpretation that clouds gun issues is to think of all Americans as members of a large, informal militia. (This is how many of the founders thought of citizens...and militias.) The mere chance that many Americans are armed and proficient with their guns prevents the government from acting too arrogantly.

The idea of an informal militia has some practical application. On 9/11, when passengers on hijacked United Flight 93 learned (from those among them who had cell phones) what had happened on the other planes, they organized and took action.

Realizing that their plane was heading for a suicide run on Washington, D.C., the passengers on United 93 rushed the cockpit and forced the plane into the ground in rural Pennsylvania. This was true heroism. The jet was stopped from reaching its target—but not by the Army, Navy or Air Force. Not by armed law enforcement officers. It was stopped by an informal militia of citizens acting selflessly.

The demand for uniformed police to defend a populace increases in proportion to that populace's inability to defend itself effectively.

That's why disarmed societies tend to become police states. So, the right to bear arms is preventive—it reduces the demand for a police state.

The police cannot provide security in your home, your business or the street. They show up after the crime to take reports and do detective work. The poorer the neighborhood, the riskier it is for peaceful residents.

Only an armed citizenry can be present in sufficient numbers to prevent or deter violent crime before it starts...or to reduce its spread. Rather than banning guns, the politicians and the police should encourage gun ownership, as well as education and training programs. A responsible, well-armed and trained citizenry is the best protection against domestic crime and the threat of foreign invasion. America's founders knew that.

Unusually Stupid Stuff From the ACLU

By many accounts, Timothy Joe Emerson was not a nice guy. It's hard to feel much sympathy for a father who pulls a gun on his ex-wife in front of his own daughter.

An unattractive defendant, building his defense on a fundamental constitutional argument...sounds like a perfect case for the American Civil Liberties Union (ACLU). The ACLU has made its reputation defending unattractive people and causes who count on extreme, though—often—logical, constitutional claims.

A libertarian may be tempted to support the ACLU in many of its causes. The group's claims to political neutrality and rigorous constitutional logic sound compelling. But, in truth, the ACLU is not politically neutral; it toes a rigidly ideological left-wing line. And its constitutional logic isn't all that rigorous.

Guns are a good example of the ACLU's less-compelling reality. Given its strict positions on freedom of speech and assembly (the 1^{st} Amendment), from illegal search and seizure (4^{th} Amendment) and from self-incrimination (5^{th} Amendment), the ACLU should hold a

hard line for gun ownership. It doesn't. And it's not even neutral on the topic; it supports the least libertarian gun control policies.

And the group plays some pretty intricate logic games to square its 2nd Amendment position. According to its Web site (www.aclu.org):

> We believe that the constitutional right to bear arms is primarily a collective one, intended mainly to protect the right of the states to maintain militias to assure their own freedom and security against the central government.
>
> In today's world, that idea is somewhat anachronistic and in any case would require weapons much more powerful than handguns or hunting rifles. The ACLU therefore believes that the 2nd Amendment does not confer an unlimited right upon individuals to own guns or other weapons nor does it prohibit reasonable regulation of gun ownership, such as licensing and registration.
>
> ...Except for lawful police and military purposes, the possession of weapons by individuals is not constitutionally protected. Therefore, there is no constitutional impediment to the regulation of firearms.

The site then goes on to quote selectively from an old U.S. Supreme Court decision (*United States v. Miller*, 1939) to create the impression that the Court approved of a collective rights interpretation of the 2nd Amendment. (In fact, that decision involved a law against the manufacture of certain sawed-off shotguns whose intended purpose was gangster street battles.)

If the ACLU stayed true to this logic, it would support government efforts to waive *Miranda* warnings to criminal suspects and hold terrorism suspects without charges as realities of "today's world."

It doesn't support those efforts.

The inconsistencies betray the ACLU's political bias, which harkens back the group's early leaders—lawyers with an ideological affin-

ity for Soviet communism. The ACLU pushes a left-wing agenda that marginalizes property rights, free markets and self-rule in favor of its version of a rule by the elite. (Its criticisms of government actions don't question statist ambition…they're simply one version of elite rule carping at another.)

Conclusion

Timothy Joe Emerson may have been a creep; and he may even have been a potentially violent creep. But, until he did something illegal with his guns, he deserved the same protection under the 2nd Amendment that pornographers enjoy under the 1st.

The people who drafted the U.S. Constitution (James Madison, chief among them) considered an armed population as a foundation of the militia that would provide security for a free state. Madison believed this free state—unlike the "kingdoms of Europe"—would not be afraid to trust its people to have their own arms.

The militia consisted of the people bearing their own arms when called to active service, arms that they kept and knew how to use. If the people were disarmed there could be no militia (well-regulated or otherwise) as it was then understood.

That expresses the proper understanding of the relationship between the 2nd Amendment's explanatory clause and its operative clause.

The 2nd Amendment protects a simple but dangerous liberty. It's the liberty of every person to put some practical stopping force behind the abstract notion of self-ownership. And that is perhaps the surest cure for totalitarian regimes.

Part Two:
Fundamental Concepts

6 The Philosophy of Liberty

Libertarian philosophy is tough to explain in simple terms. As a result, all sorts of bizarre people claim to be libertarians. Can a philosophy of liberty be explained basically?

The most difficult part of being a libertarian is maintaining some sort of philosophical consistency. Part of the difficulty comes from the fact that libertarianism is not actually a political philosophy; it is, more precisely, one of several applications of classical liberalism.

The rest of the difficulty comes from the fact that many Americans call themselves *libertarians*—but few have any consistent idea of what the word means. These people support various notions of civil rights and attendant responsibilities. But their notions are, all too often, just pretenses; they're really looking for a label that's fresher than the traditional "liberal" or "conservative." Their libertarian pretenses crash disastrously on the rocks of self-interest, fear, identity politics or other mental laziness.

The result: The television commentator Bill Maher proclaiming loudly that he's libertarian...and then supporting the worst sorts of statist regulatory schemes because he thinks they're "fair." Apparently, Maher's definition of *libertarian* focuses more on guilt-free sex with aspiring actresses than property rights.

There has to be more to it than this—even if libertarian philosophy is tough to understand.

For our purpose, the key question is: Do American libertarians *only* care about personal property? The short answer is *no*. To do the question justice, though, we need to start in paradise, move through the feudal Dark Ages, stop at John Locke for a bit, nod to Adam Smith on our way to Oliver Wendell Holmes and end somewhere around Robert Nozick.

From the Ranks of Classical Liberalism

Liberalism began in 17th and 18th Century England when several generations of economists and political philosophers carved out a rough system of beliefs that emphasized human free will and the superiority of the individual (or many individuals) over the institution (government or church).

This system eventually split into three camps.

The first camp became what modern philosophers call "classical liberalism." This application focuses heavily on economics. It endorses *laissez-faire* economics—which means that the state leaves merchants and businesses alone as much as possible. It accepts the justice of market-based distribution of wealth because it believes that individuals and small companies are collectively more efficient than big institutions. However, classical liberalism allows for a limited amount of state redistribution of wealth to preserve the institutions of market society.

The most important advocate of classical liberalism—its giant—was the English political philosopher John Locke.

The second camp became what modern philosophers call "popular liberalism." This application focuses less on economics and more on social and political relationships among individuals. Popular liberalism allows state regulation of commerce and redistribution of wealth—as long as these processes improve the clarity and equality of people's social relations.

In fact, popular liberals usually believe that state regulation is necessary to individual empowerment. This is why popular liberals flirt with socialism and totalitarianism. And the lazy ones do more than flirt.

Popular liberals care less about economic efficiency than their classical counterparts. What saves popular liberalism from totalitarianism is a respect for the individual person's own notions of social standing and political success.

Popular liberalism is the closest application to the political outlook that Americans casually call "liberal." The major advocates of popular liberalism include Immanuel Kant and John Stuart Mill.

The third camp became what modern philosophers call "libertarianism."

What "Libertarian" Means

Libertarianism differs from classical and popular liberalism in many ways—but one stands out: It focuses relentlessly on property rights. By extension, freedom of contract plays a central role in defining the particular rights and obligations that people have within a libertarian society.

Many people who believe in classical liberalism call themselves libertarians or say they share some beliefs with libertarians. And libertarians make the same claims about classical liberalism. Encouraging this crossover: One of John Locke's strongest beliefs was that the right to own property was fundamental to human existence. This belief has had a major influence on libertarianism—to the extent that some libertarians call themselves "Lockean liberals."

Some popular liberals argue that libertarianism's intense emphasis on property rights drives it out of any practical definition of *liberalism*. They claim that the mania for property rights leads libertarians to reject any role of the state in improving people's lives. And, they claim, this makes libertarians more like feudal landlords than liberals.

Like feudalism, libertarianism conceives of political power as based in a network of private contracts. Also, libertarianism has some trouble accepting inalienability—the belief that some rights are so fundamental that they can't be given up, even willingly. Inalienability is a central tenet of liberalism. Thomas Jefferson mentioned it right near the top of the *Declaration of Independence*:

> We hold these truths to be self-evident...that mankind is endowed by its Creator with certain inalienable rights...that among these are life, liberty and the pursuit of happiness.

Though inalienability can be a tough concept to understand immediately, the test for whether you believe in it is relatively simple: Do you believe that a person should be able to sell himself into slavery? A liberal will say *no*—there are some liberties that the state cannot allow anyone to give up and self-ownership is one.

A pure libertarian will say *yes*. He will conclude that the property right in oneself—and, therefore, the right to *sell* oneself—trumps the notion that self-ownership must be maintained at all costs. This line of thinking usually ends up collapsing on itself with convoluted arguments that liberals put self-ownership first because they really believe that the state owns its citizens.

That's not true. But, even if it were, libertarians need to accept that self-ownership is the most essential property right. Inalienable.

Laws shouldn't treat people as objects without rights, even if people want to be treated this way. There is no place within the liberal conceptual order for the political or legal recognition of people as property or as anything less than persons with fundamental rights.

Libertarians just have a different notion of *fundamental*.

How Small Should Government Be?

At its most basic philosophical level, libertarianism faces a conundrum: Its focus on property rights distrusts any statist regulation or

restriction; but that same focus demands that the state recognize and enforce individual contracts as binding.

The common solution that libertarians offer to this conundrum: Libertarianism isn't anarchy. Libertarians are willing to make a social contract—to accept some state authority in exchange for some stability in the public sphere. They just want to keep that contract as simple...and the state authority as small...as possible.

But asking the state to enforce a contract for slavery is not a small thing. And, if the libertarian accepts only a small level of state authority, the state may not be able to take the extreme step of enforcing such an outrageous contract.

Arguments like this led to the American Civil War.

Perhaps a more practical definition of *libertarian* has to do with a focus on the smallest-possible state—and admits that libertarians are willing to give up some property rights, so that the state remains small and weak. At the margin, their preference for a small state trumps their desire for pure property rights; they wouldn't want a government strong enough to enforce slavery.

To most liberals, a social contract is a hypothetical agreement among equals, by everyone with everyone else. Its purpose is to form a political society, then to establish a constitution and create on its basis a government that protects individual liberties.

Here, it might help to discuss a few of the concepts that characterize "Lockean liberalism." John Locke wrote that mankind had a fundamental nature that was independent and free. In this fundamental state, people could claim—by a sort of discoverer's right—whatever material wealth they wanted. He called these claims "original acquisition" of fundamentally free people.

This fundamental nature was like paradise. It was freedom.

But this freedom, like the Biblical paradise, fell. Institutions—primarily, the feudal state and the Church—sprang up to regulate human society. Soon these institutions became corrupt. They regulated people too heavily, to the point of denying the importance of

human nature. The institutions exploited people instead of serving them; the height of this perversity was the divine right claimed by monarchs. Locke conceived of liberalism as the philosophy that would reverse the perversion and put human rights back above the so-called "divine rights" of kings.

What did Locke want from his liberal state? The freedoms that people could fairly expect were not as broad as the freedoms humans enjoyed in their fundamental nature. These more regulated freedoms—liberties—were part of a basic social contract that people made with a non-corrupt state when they agreed to honor and benefit from the protection of its laws.

This is all very different from the libertarian's view. A libertarian sees the social contract as a series of (sometimes literal) private contracts between parties who may or may not be equals. And libertarians usually want more than the classical liberal's mild notion of *laissez-faire*; they prefer the so-called "night-watchman state"—which acts only when it must to prevent complete social collapse.

Libertarians often depict their view as based in a moral injunction against coercion or forcing people to do what they do not choose to do. "Coercion" in their account is not just any use of force but the aggressive interference with another's rights.

The point of libertarian arguments for minimizing interference is to keep to a minimum the kinds of political duties people have and, in particular, obligations to transfer market-acquired wealth.

Are Libertarians Just Greedy Materialists?

It's a fundamental libertarian belief that people ought to have unrestricted—or *nearly* unrestricted—liberty to accumulate, control and transfer property, whatever the consequences or constraints may be for other people.

The political values libertarians normally embrace—consent, noncoercion, nonaggression, noninterference—gain their force and con-

tent by reference to a deeper principle. But what is this principle? Is it only accumulation of property? Greed?

Libertarian self-ownership ultimately means that *all* rights are conceived as property rights.

Each person starts with ownership of her person and any possessions acquired by transfer. These property rights are deemed of equal significance, and each person is at complete liberty to transfer whatever rights he has.

To a libertarian, the best social value comes from the cumulative result of millions of contractual relations negotiated every day...or every hour. In this manner, business dealings form a sort of collective conscience that makes better choices than any individual or the state.

Original Acquisition and Coercion

The deeper meaning for libertarians is a sort of law of large numbers—millions of bilateral contracts and agreements end up producing more...and more efficiently...than the state's best-laid plans.

But another criticism remains: Libertarian philosophy is more about what it's *against* (coerced sharing of property) than what it's *for*.

By contrast, more egalitarian sorts of liberalism and socialism include various positive liberties, such as the opportunities made possible by a decent level of material well-being or the capacity to engage in the exercise of autonomous decision-making.

Said more simply, libertarianism's focus on small government and noninterference ends up tolerating—and perhaps even creating—social and economic imbalances. And that freedom means people end up being unequal. Freedom and equality are mutually exclusive.

The libertarian philosopher Robert Nozick considered this matter in the introduction to his best-known book, *Anarchy, State, and Utopia*. Specifically, Nozick wrote:

> Z [a worker] is faced with working or starving; the
> choices and actions of all other persons do not add up

> to providing Z with some other option....Does Z choose to work voluntarily? ...Z does choose voluntarily if the other individuals A through Y [the capitalists and the other workers who got the better jobs] each acted voluntarily and within their rights.

If the liberties protected in Nozick's model society are traceable all the way back to Locke's fundamental state of nature, then there is no way to determine whether the collective actions of A through Y count as illicit coercion of Z.

In other words, A through Y may be tolerating imbalances that *force* Z to work.

Suppose that the history leading to the allocation of capital and wage-labor that assigns Z to his fate has been impeccable—no corrupt states or institutions seizing or reallocating it—from the point of original acquisition and throughout all the transfers since then. Then, Z "rightly" shovels muck in the bitter cold for a pittance.

Nozick could live with this proposition.

But nagging questions remain. It's difficult to know how "rightly" wealth and social power have been accumulated. Again, thinking of Z: How can a libertarian determine that Y has managed to act voluntarily and without violating the prohibition against interference unless he has already determined that A through X have managed to act voluntarily? And how is he to determine *that*?

He can't. And libertarian philosophers like Nozick distinguish themselves from liberals by saying that he *shouldn't*.

Among the souls who struggle in the state of nature attempting to acquire original holdings, some succeed, some fail. Some who succeed do things that prevent those who fail from acquiring the property they desire—things like getting there sooner than the others (as in the Oklahoma land rush), erecting physical barriers to their entry, issuing credible threats against trying to cross them and so on.

None of this is very edifying. And it certainly makes libertarian philosophy sound like the empty greed critics make it.

Pragmatism Helps Maintain Liberty

Pure libertarianism needs something to curb its extremity. That something is pragmatism.

Philosophical pragmatism is an essential American development. Its animating principle is that truth is social and constructed rather than transcendent and objective. It holds that ideas prove their worth in action, and that the results of an idea are the best criteria by which to judge its merit. And since what works for me might not work for you, pragmatism advocates a strenuous openness to all perspectives.

With its insistence on the fusion of being and doing, thought and action, pragmatism has one foot in academia and the other in everyday life.

Philosophical pragmatism arose out of disillusionment with the postures of moral certitude that led up to—and may have caused—the Civil War. Pragmatists believe that ideas are not "out there" waiting to be discovered, but are tools—like hammers and microchips—that people devise to cope with the world in which they find themselves. They believe that ideas do not develop according to some inner logic of their own, but are entirely dependent on their human holders and the environment. Therefore, an idea's survival depends not on its stubborn immutability but on its willing adaptability.

Ideas that are not useful, that do not suit the occasion, are not valid. And since ideas are socially generated, no single mind can lay claim to an idea.

The Civil War bred in the mind of the country's most important legal figure of late 19th Century America a disgust for the postures of moral certainty. That figure was Oliver Wendell Holmes.

Holmes joined the Northern army at the beginning of the war, caught up in an abolitionist passion. The fighting cured him of that. By the end of the conflict, Holmes, wounded three times and nearly killed, came to see life as a Darwinian struggle. "Behind all the high ideals seethed the brute impulse to murder and expropriate."

Holmes never questioned the right of the dominant group to rule as a result of its victory over its opponent. The sacredness of human life was not something found in nature or objectively demonstrable; "the sacredness of human life is a formula that is good only inside a system of law." And because moral values are not objective, the law cannot be based on them. Thus Holmes's famous formulation: "The life of the law has not been logic: it has been experience."

So, the balance to libertarianism's ideological excesses, conundrums and other problems comes from experience with laws and politics.

Conclusion

The Holmesian world-weary optimist would hope that the experience of statist expansion during the months after 9/11 will give libertarian philosophy some of the elegance and robustness it needs.

But the chances are greater that there are going to be more experiences than elegance.

In his 1988 book *All the Laws but One: Civil Liberties in Wartime*, William Rehnquist, chief justice of the United States, gave libertarians cause to worry. In the book, he wrote:

> It is neither desirable nor is it remotely likely that civil liberty will occupy as favored a position in wartime as it does in peacetime. But it is both desirable and likely that more careful attention will be paid by the courts to the basis for the government's claims of necessity as a basis for curtailing civil liberty. The laws will thus not be silent in time of war, but they will speak with a somewhat different voice.

He concluded that "the least justified of the curtailments of civil liberty" were unlikely to be accepted by the courts in future wars.

This casual discussion of the curtailing of civil liberties makes some politicians crazy. Rehnquist counts thoroughly on the experience and pragmatism of the people—in most cases, judges like him-

self—to prevent things like Japanese-American internment camps and the suspension of *habeas corpus*[1]. But history, even American history, has shown that judges don't always behave pragmatically and wisely.

So, Rehnquist's sanguine outlook may not be warranted.

Likewise, in March 2003, Justice Antonin Scalia—speaking at John Carroll University in suburban Cleveland—said that the government can limit individual rights during wartime without violating the Constitution. He said:

> The Constitution just sets minimums. Most of the rights that you enjoy go way beyond what the Constitution requires.

But this may not be the threatening, civil rights-ignoring statism (they often say "fascism") that some of Scalia's critics took it to be. A more reasonable interpretation of his statement would be that people need to look to their local governments or cultural institutions—instead of the federal government—for the rights and social connections that they seek.

Even libertarians would agree that, the smaller the state gets, the more assertive local governments have to be in policing and shaming errant behavior. The glory days of early America prove the point: The federal government was weak but local moral codes were very strong.

Early conservatives argued that the expansion of the state crowded out the ability of private institutions (what Edmund Burke called the "little platoons") to police, nudge or otherwise influence individual behavior. And they succeeded—in preventing even faster growth.

America after 9/11 has seen a large expansion of the state again. And it may be crowding out Burke's little platoons.

This time, people who value liberty have to hope that Holmes's all-important experience gives them the wisdom to use libertarian philosophy efficiently.

But *efficiently* may not mean *purely*.

[1] There's a much more detailed discussion of these issues in Chapter 10: Habeas Corpus

The best use of libertarianism may include a dash of classical liberalism. There are numerous points from which to build bridges between the two applications. Classical liberalism agrees that market distributions, realized under competitive conditions, provide the most efficient standard. Because classical liberals put emphasis on market efficiency, they also assign greater weight to rights of private property and freedom of contract. They may be more open to state regulations than libertarians—but a pragmatic attitude toward the state should save libertarianism from the conundrums that sticking hard to its orthodoxies creates.

The value of philosophy comes from the fact that it gives the philosopher clarity and strength of mind, especially in a debate or argument. But intense debate over minor points makes philosophy seem...and, sometimes, actually become...trivial. This happens a lot. It happened famously to Leon Trotsky after his falling out with Russian Communists in the 1930s. He spent the last years of his life bickering and feuding over minutia with the people who should have been his closest ideological allies. Eventually, one of them put an icepick in his skull.

Anyone who loves liberty should see that the real enemy is the statist, the elitist who presumes to coerce others to live in a "proper" way. A libertarian can live with some comfort among—and make political alliances with—anarchists, classical liberals...even a few popular liberals.

7 Liberty and the Marketplace

After the 9/11 attacks, George W. Bush approved huge federal budget deficits that cast doubt on his claims of being a "fiscal conservative." Was he justified in doing these things?

William Leggett is one of the heroes of American libertarianism. The early 19th Century journalist, author and political agitator believed in a pure form of liberty—he read the Constitution more strictly than Antonin Scalia and supported *laissez-faire* economics more passionately than Adam Smith.

In one of his most succinct lines, Leggett wrote:

> [If we] leave trade to its own laws, as we leave water
> to the laws of nature, both will be equally certain to
> find their proper level.

Leggett reveled in contradictions. He respected commercial savvy; but he distrusted the financial houses of the young Wall Street. He denied that the federal government had the right to abolish slavery in the southern states that allowed it; but he encouraged slaves to follow the founders' example and revolt against their masters.

Even beyond his politics, Leggett was a colorful man with a scathing wit. The son of a Revolutionary War officer, he was court-martialed by the Navy for insubordination—he'd ridiculed the stupidity of se-

nior officers. In blank verse. Discharged from the Navy, Leggett dabbled in acting and theater criticism. Through his criticism, he met William Cullen Bryant at the New York *Evening Post*.

Bryant was a man of fine taste who positioned his newspaper as a populist crusader. He recognized in Leggett a kindred spirit, though coming from an entirely different political perspective. Leggett was a self-professed "fanatic in freedom," arguing for the maximum personal liberty in all pursuits. This passion didn't make Leggett a dilettante, though; his levity and wit combined with serious stuff.

Some excerpts from a November 1834 editorial that Leggett wrote for the *Evening Post* give a good example of his libertarian bent:

> The fundamental principle of all governments is the protection of person and property from domestic and foreign enemies....
>
> Whenever a Government assumes the power of discriminating between the different classes of the community, it becomes, in effect, the arbiter of their prosperity, and exercises a power not contemplated by any intelligent people in delegating their sovereignty to their rulers. It then becomes the great regulator of the profits of every species of industry, and reduces men from a dependence on their own exertions to a dependence on the caprices of their Government. Governments possess no delegated right to tamper with individual industry a single hair's-breadth beyond what is essential to protect the rights of person and property.
>
> ...As a general rule, the prosperity of rational men depends on themselves. Their talents and their virtues shape their fortunes. They are therefore the best judges of their own affairs, and should be permitted to seek their own happiness in their own way, untrammeled by the capricious interference of legisla-

tive bungling, so long as they do not violate the equal
rights of others, nor transgress the general laws for
the security of person and property.

But modern refinements have introduced new
principles in the science of Government. Our own
Government, most especially, has assumed and exer-
cised an authority over the people, not unlike that of
weak and vacillating parents over their children, and
with about the same degree of impartiality.

In his time, Leggett was best known for his criticism of the bank-
ing and financial establishment that was emerging in New York. He
considered it highly undemocratic, currying favor with politicians and
ignoring or abusing ordinary investors. He wrote extensively about
New York money men being a perversion—not a product—of a free-
market economy. And he set the standard refutation to the complaint
that *laissez-faire* economics justifies greed and financial malfeasance.

He was right then…and he is still right 170 years later. Enron,
ImClone and WorldCom don't happen because of *too little* regulation.
The crooks who perpetrate these scams are usually good at working
regulations and regulators. On the issue of big business corruption of
politics, Leggett concluded:

It is the nature of political abuses to be always on the
increase, unless arrested by the virtue, intelligence and
firmness of the people.

Leggett's anti-establishment sensibility pitted him against the stat-
ist/big business cronyism that poisoned the beauty of free markets.

Myths and Facts About Free Markets

That beauty has always been a fragile thing. Too fragile, perhaps
to survive for long in a world full of ambitious statists.

In his *Farewell Address*, George Washington articulated the sen-
sible nub of true fiscal conservativism:

...As a very important source of strength & security, cherish public credit. One method of preserving it is to use it as sparingly as possible: avoiding occasions of expense by cultivating peace, but remembering also that timely disbursements to prepare for danger frequently prevent much greater disbursements to repel it—avoiding likewise the accumulation of debt, not only by shunning occasions of expense, but by vigorous exertions in time of Peace to discharge the Debts which unavoidable wars may have occasioned, not ungenerously throwing upon posterity the burden which we ourselves ought to bear.

Like William Leggett's writing, Washington's *Address* offers a firm rebuke to the statists of current deficit-spending times.

A commitment to minimal public debt is an essential part of libertarian public policy. An aversion to debt—like an aversion to regulatory bungling in financial markets—marks the libertarian notion of fiscal conservativism.

But *fiscal conservatism* means different things to different people. And it isn't always the same thing as *laissez-faire* economics. When George W. Bush took office, he'd been speaking like a supporter of small government and free trade. Then, one of the first economic policy positions he took was enacting a series of protectionist tariffs—singling out steel, sugar and computer components as worthy of special treatment from the state.

These tariffs might have been a bigger political problem for Bush, save for the fact that the 9/11 attacks took Americans' minds off of economic policy. The same was true for the federal budget deficits that Bush pressed upward (or is that downward?) in the wake of 9/11. These debts weren't fiscally conservative; and they certainly weren't small-government libertarian. But few Americans seemed to notice; and few of those who noticed seemed to mind.

Perhaps this is the ordinary course of things. Perhaps the public forum naturally focuses on one big issue at a time—and the big issue after 9/11 was national security. (And George Washington did allow for debts generated to pay for "unavoidable wars.")

Bush's actions are still telling, though. Resorting to protectionism so quickly and running up deficits so readily after the attacks shows that Bush is a statist—albeit a *corporate* statist—at his core.

(To his credit, Bush started removing the tariffs in late 2003. But the practice had been set by then.)

Pure free markets—like perfect liberty or perfect information—are a Platonic ideal. In fact, people, companies and states are manipulating markets all of the time. Governments subsidize behaviors or industries with tax breaks or $800 toilet seats. Companies game the tax code or safety regulations to make more money…or to survive through hard times. And all of these actions generate waves of consequences, intended and unintended.

One of the ways that libertarians differ from statists is that libertarians believe markets can survive these games. Market regulations and controls—at their most effective—only delay or redirect responses. The Soviet Union eventually crumbles. Ma Bell eventually gets ground into pieces. Reckless college freshmen eventually run out of credit on their Visa cards. Social Security will eventually go bankrupt.

Libertarians know this—and aren't afraid of the market's eventual collection call because they see it coming. Statists are like those reckless college freshmen: They think that by making regulations managing markets, they'll avoid the inevitable.

Just like those college freshmen, they're wrong.

Enforcing a Few Basic Rules

A libertarian accepts that the state should enforce a few basic rules in any market. Ideally, these rules reflect the social contract—they are designed to assure fair and constant access to the marketplace for goods

or services. And they assure basic levels of safety and reliability for everyone buying those goods and services.

Chaotic marketplaces are inefficient marketplaces, sometimes fatally so.

To move beyond America's shores for an example that illustrates this point: So-called "third way" economists in central and South America argue that chaos is the reason that so many of their poor countries have a hard time climbing out of poverty. Countries with volatile histories have trouble bringing *anyone* to market; residents distrust the currency, the military, the bureaucrats...and each other. So they don't do anything more than they have to in order to eat.

This is a valid observation. The government economists lose their bearing when they extend their observation to developed countries— claiming, as many do, that developed countries are so because their regulations prevent chaos.

This conclusion betrays a statist bias. Regulations don't prevent chaos and uncertainty; they're symbiotic *with* chaos and uncertainty. They are reciprocating in their bad encouragement of each other— just like the corrupt politicians and the bankers in William Leggett's New York.

States work best—states *only* work—when they enforce a few basic rules and enforce them consistently.

Monopolies Versus Deregulation

This focus on a few basic rules is the reason that libertarians are almost always in support of deregulation.

One of the few matters that should be regulated is monopolization. Keeping one company (or person) from controlling an entire marketplace is an important prerequisite to economic liberty.

When it was first enacted during the reform period around Theodore Roosevelt's presidency at the start of the 20th Century, American antitrust law was designed to prevent monopolies and car-

tels from manipulating the markets in which they operated. The theory behind the laws was that monopoly and cartel pricing decisions hurt consumers. To that extent, antitrust laws could—arguably—advance libertarian goals by assuring access to market for individuals and small companies.

I add that "arguably" because libertarians of a philosophically purer sort don't agree with this pragmatic perspective. They argue that antitrust laws of any sort are just damaging statist meddling. (The so-called "law and economics" school of public policy writers takes this line.) Pure libertarians often think themselves into prison cells of inactivity but, in this case, they have a point.

The problem with antitrust laws is that ambitious statists use them as a tool for going beyond preventing monopoly and manipulation. They use the laws to control marketplaces and—in extreme cases—promote political or "social justice" ends. That's very bad.

So, pragmatic libertarians have a choice: Support deregulation always and risk monopolies or support limited antitrust laws and risk the abuses of ambitious statists.

Examples of overzealous antitrust prosecutions abound. Through the mid- and late-1990s, the U.S. Justice Department pressed a complex antitrust case against Microsoft Corp. The federal government accused the giant software maker of, among other things, using its powerful market position in basic computer operating systems to force customers to buy inferior add-on programs. This charge turned on some pretty convoluted disputes over the particular role that bundling plays in computer software sales.

Ultimately, Microsoft settled some of the charges, won in court on others…and waited for a new White House Administration to take over and back away from a messy case.

Perhaps a better contemporary example of the libertarian's dilemma between deregulation and monopoly is the giant Texas-based media company Clear Channel Communications. Clear Channel has numerous operations ranging from television stations to billboards—but the

core of its business is a very large and profitable chain of radio stations and an affiliate unit that produces popular music concerts. Clear Channel's radio/concert business benefited handsomely from a decade of deregulation in the radio industry.

Until the 1990s, the Federal Communications Commission (FCC) had enforced rigid rules about *who* could own local radio stations and *how* they could own them. There were limits to how many stations a single person or company could own in a single geographic region—and nationally. The theories behind the FCC rules were based on the belief that radio stations were a sort of public utility. When radio was first emerging as an industry in the 1920s and 1930s, people in the industry worried that an unregulated market in broadcast licenses (which permitted use of public airwaves) would change radio from a unique local service to a generic national product.

In the 1990s, that was a trade-off they were willing to make. The radio industry was no longer the unique broadcast service that it had once been; television, the Internet and various satellite-based technologies all competed for Americans' attention. People in the industry asked the federal government to loosen the rules about who could own stations where.

The U.S. Congress complied by passing the 1996 Telecommunications Act, which singled out radio for sweeping ownership deregulation. The national caps for radio station ownership were lifted and broadcasters were allowed to own up to eight stations in each metropolitan area. Within five years, Clear Channel expanded from owning 40 stations to more than 1,000. And it began to exert monopoly-like control over radio of all genres: talk, sports and music.

Was this necessarily bad? Law and economics types would say *no*. Clear Channel's booming market share simply reflected efficiency in the radio industry.

But a growing number of critics made complaints. In 2003, during testimony about cell phone regulations before the Senate Commerce Committee, FCC Chairman Michael Powell—the pro-deregu-

lation son of Secretary of State Colin Powell—faced an unexpected grilling about radio from several senators.

They wanted to know what the FCC planned to do about the radio industry's "runaway consolidation" (an oxymoronic phrase). Various specific issues came up:

- markets in which Clear Channel had multiple stations were losing programming variety. In some cases, stations that had been staffed by local programmers and on-time talent switched to syndicated programming;

- some musical acts and their managers had alleged in civil lawsuits that Clear Channel squeezed artists by threatening to limit radio airplay if the acts didn't tour with its concert division;

- along the same lines, some consumer-protection groups claimed that Clear Channel was part of a large collusive, kickback scheme within the radio industry. The scheme, called "pay-for-play," supposedly used independent record promoters as the channel by which record companies paid radio stations to feature their acts on the air.

These questions reflected a favorite strategy used by statist political lobbying groups—organize or cooperate with civil lawsuits against large corporations and then debate in public forums using the unproved allegations in the lawsuits as "evidence" of problems or wrongdoing. It can be a very effective process.

While the real evidence of wrongdoing by Clear Channel was slight, the company did thrive in industry segments that were known for their sleazy business practices. And small record companies could certainly offer lots of anecdotal evidence of collusion in the radio industry. The combination made Clear Channel a rich target for this sort of attack. Its troubles in Washington, D.C., gave the statists who opposed media deregulation lots of ammunition.

In the course of his grilling, the FCC's Powell admitted to the senators he was "concerned about the concentration, particularly in radio." However, he generally stuck to his deregulatory position—namely, that the media industry was changing fast enough that old regulations were no longer appropriate.

To this, Oregon Senator Ron Wyden—always reliable for the statist spin—said, "The country ought to be pretty reluctant to repeat the radio experiment." He said this, even though there was little proof that Clear Channel's growth made pay-for-play any more prevalent.

Does Wall Street Value Liberty?

It's unusual for a political appointee like Michael Powell to stay true to deregulatory idealism. Most get worn down into a statist's default—that their industry or subject matter is so particular that it needs special rules. Then, the appointee leaves office and goes to work in that field, selling his access and knowledge of the special rules.

Like the state itself, the so-called "revolving door" between government and the private sector becomes a self-sustaining system. Its experts believe their subject matter is too complex for the common person. And they send their lawyers—and themselves—in and out of government service to make sure it *remains* unknowingly complex.

This is precisely the corruption that outraged William Leggett.

Especially after the dot.com collapse of 2002 and accounting scandals (Enron, WorldCom, etc.) of 2003, Americans are skeptical of Wall Street. Some libertarians worried that this skepticism was an opportunity for more regulation; but it could just as well be an opportunity for freer markets.

A fundamental part of *laissez-faire* economics is the belief that financial markets, left to themselves, will evaluate risk efficiently. This is why it's important that entrepreneurs who think they see value where others don't get so rich or go broke; they have to pull the rest of the market up or down—depending on whether they're right.

To a less severe degree, small investors and individuals who guess wrong or don't read quarterly statements closely have only themselves to blame if they get burned in the market. And companies that commit fraud, like Enron or WorldCom, eventually crash and burn.

If you put all your retirement money in Enron stock while it was flying high, you were greedy and stupid. And greed and stupidity get punished.

A fundamental reality of any economy[1] is that there are very few entrepreneurs and many investors—be they large or small.

Although they like to describe themselves as something more profound, Wall Street banks simply work as middlemen between the two groups. In the early 1990s, these investment banks—staffed with Ph.D.s and MBAs wielding pricey software programs based on models devised by Nobel Prize-winning theoreticians—took to describing "risk management" as their focus.

The tools of this risk management were investments—interest rate swaps, collateralized mortgage obligations, derivatives of every type. Often taking the legal form of private contracts, these investments were largely unregulated. And they were complex.

This might sound like a case study for libertarian deregulation. It wasn't. It was closer to a hard lesson in the sort of corruption that poor regulation allows.

Like the revolving door, the complexity of derivatives worked as a kind of shield. The regulators were fooled; government agencies like the Securities and Exchange Commission (SEC) and Federal Trade Commission (FTC) as well as various state and federal bank regulators were blinded by the complexity and assumed someone else was responsible for watching derivatives.

The marketplace was fooled, too...for a time. But the biggest players in derivatives trading and investing were misleading every-

[1] I try to avoid the phrase "capitalist economy." *All* economies are capitalist. Systems like socialism and communism are simply sets of regulations that attempt to control capital flow. These systems always fail—the only question is how their failure will take place.

one—business partners, lenders and even themselves—about how they were using the things. In many cases, these Wall Street "boutiques" claimed to use the complexity of derivatives to make money without risk. In reality, some were borrowing heavily to make bets whose mechanics they didn't understand any more accurately than their receptionists did.

Through most of the 1990s, the most prestigious place for a member of the Wall Street elite to work was a so-called "hedge fund." These funds would pool money from big investors (companies or individuals) and do various high risk things with it. The promise was that the high risk investing would result in big profits. Investing in derivatives was one of the most common hedge fund investments.

The arrogance of the hot shots who ran hedge funds was (and, in some cases, still is) stunning, even by Wall Street's arrogant standard. But the underlying promise of hedge funds—great wealth without risk—was absurd. As William Donaldson, who'd later become head of the Securities and Exchange Commission, said in 1992, "No matter how much hedging is done, somebody winds up holding the hot potato when the music stops."

Implicit in this quote is a basic understanding of the limited but legitimate role that the state has in regulating financial markets (and businesses): Make sure that elites and banking insiders don't poison market efficiency. The SEC can't save every greedy investor from losing his life savings by investing with Enron; but it does need to make sure that investments are generally legitimate—so that everyone else will have enough confidence to keep investing.

Unfortunately, from a libertarian perspective, William Donaldson wasn't appointed head of the SEC until 2003.

Conclusion

I opened this chapter with a question about whether George W. Bush was right to abandon his self-professed fiscal conservatism after

the 9/11 attacks. I've spent this chapter making the libertarian case why heavy state spending is *never* a good idea.

No single person or company is smarter than the marketplace. No regulator or political appointee is smarter than the marketplace.

Libertarians defer to the marketplace. They don't envision a statist mechanism that ensures each citizen a "right" to income and financial well-being. They want to provide for minimum social comforts; but the minimum is conceived as a matter of public charity required by the need to prevent social strife and assure an efficient marketplace.

Statist critics argue that libertarians put absolute property and contract rights before market efficiency. This isn't necessarily so. Self-ownership demands at least minimally efficient markets.

Of course, freely associating individuals may enter agreements designed to restrict others' options—frustrating instead of promoting market efficiency. And this market inefficiency is the reason that the state has a legitimate role in preventing monopolies and cartels.

The statists base their criticisms on the assumption that pure libertarians (or law-and-economics professors) believe that the right of unrestricted freedom of contract is so central to liberty that abuses must be allowed. There may be some who believe this. But, generally, the criticism is an over-simplification of libertarian beliefs.

In a free state, the government doesn't try to dictate what financial markets do. The government does have a responsibility to protect and assure a basic level of stability in financial markets—but that stops a long way before prohibiting individuals or companies from investing their money where they choose.

A free market leaves room for abuse because there's a thin line between legitimate bargaining and worse behavior. Bargaining is essential to market efficiency. As Adam Smith wrote, "the propensity to truck, barter and exchange one thing for another [is] a necessary consequence of the faculty of reason and of speech." Smith argued:

> If we should enquire into the principle in the human
> mind on which this disposition to trucking is founded,

it is clearly the natural inclination every one has to persuade. The offering of a shilling, which to us appears to have so plain and simple a meaning, is in reality offering an argument to persuade someone to do so and so as it is for his interest ...And in this manner every one is practicing oratory on others through the whole of his life.

This can sound like a combination of free speech liberties and free market bargaining. Is the freedom to make a business decision—even a bad business decision—a free speech issue? Not exactly. But an efficient, free market is; and bad decisions are an inevitable part of a free market.

Free speech and fair markets both stem from the first fundamental freedom: self-ownership.

A pragmatic libertarian knows that monopolies and cartels scare people away from the marketplace just as much as socialist programs and high taxes do.

In many cases, the wizards of Wall Street and other institutional financial establishments have a contempt for their customers that borders on (and, in a few cases, actually becomes) criminal.

The best way for someone who values liberty to think of financial crimes is that same way he thinks of violent crimes. The state has a responsibility to prosecute murderers and rapists not to seek vengeance for wrongs but to hold up its end of the social contract by protecting its citizens' persons and property.

Of course, the state can't prevent crimes from occurring; free markets and free societies will always leave room for some abuse. The state's interest is in making this room as small as possible, while avoiding meddling or bungling.

Bush's post-9/11 spending spree was troubling because—reflecting his corporate statism—it built bureaucracy as much as it made citizens and markets safe.

8 Life and Death

Should you trust the same state bureaucracy that screws up your driver's license to decide whether you live or die?

On April 21, 2003, Scott Peterson was arraigned in Stanislaus County (California) Criminal Court on a double murder charge, specifically that he "did willfully, unlawfully, feloniously and with malice aforethought murder Laci Peterson"—his wife—and "Baby Conner Peterson, a fetus"—who would have been his son.

The second murder charge, concerning the unborn baby, was the one that could land Peterson on death row; it was the "special circumstance" required under California law for the death penalty.

The Peterson case was a magnet for tabloid media. Peterson was a nervous salesman-type whose checkered employment history suggested he lacked salesman skills. His wife had been missing since Christmas Eve; and the police had been watching Peterson carefully even before Laci's body washed up on the Oakland side of San Francisco Bay. In a gruesome extra detail, Conner's body was found nearby the next day (apparently, Laci's body had expelled the baby at some point after it had been dumped in the Bay).

Peterson denied that he'd killed his wife and child. He insisted things had been fine with his wife and that he'd left for a solitary late-

night fishing trip—on Christmas Eve, in a boat he hadn't told his wife he'd bought—to clear his mind before the holiday rush with his in-laws.

Then a "massage-therapist" mistress turned up who said that Peterson had told her things weren't going well with his wife. There were money problems. And borrowing from Laci's parents again was going to cause family problems....

But the tabloid details don't have much to do with liberty issues raised by the Peterson case. Those focused more on two points. First, if an unborn baby can be a murder victim, how does the state justify the legal killing of babies in abortion clinics around the U.S. every day? Second, with Peterson facing the death penalty, should libertarians support that controversial punishment?

Abortion and Fetal Murder

Abortion is probably the most divisive public issue in America. It's a flashpoint for everything from religion to sex to money to education. Some groups argue that the surgical or chemical termination of a pregnancy is the murder of a person; others insist that a woman's ability to make her own decision about completing or terminating a pregnancy is an essential privacy right. Both sides are passionate and their positions are irreconcilable.

The issue doesn't burn so controversially for most libertarians. To them, it's a matter of property rights. They see a woman's body as her own property—and her decision to have or abort a child as a clear example of ownership of self. And the laws recognizing the killing of a fetus against the pregnant woman's wishes as murder also match up. After all, the fetus was the property of the woman carrying it.

But is *everything* a property issue? At some point, doesn't a fetus have the same fundamental liberty rights that any person has? And what is that point?

Several high-profile abortion rights groups screwed up their analysis of the Peterson case. In a rush to grab media attention after Peterson

was formally charged, the head of a suburban New Jersey chapter of the National Organization for Women told a local newspaper that charging him with double murder was bad because it could aid the antiabortion movement by portraying a fetus as a person.

She was immediately swamped with angry criticism—some of it from pro-abortion feminists, her normal allies. The New Jersey woman quickly backed off from her comments, saying that she'd merely been "thinking out loud" when she gave the interview.

But her original position is the one that most pro-abortion groups hold. They believe that fetal harm laws present a "slippery slope" toward treating unborn children as people—and limiting a woman's ability to choose abortion to end an unwanted pregnancy.

Section 187 of the California Penal Code makes it a crime to murder "any person or fetus." The law specifically excludes legal abortions and acts "solicited, aided, abetted or consented to by the mother of the fetus."

Some 22 other states have enacted laws similar to the California law that makes it a crime to kill a fetus.

And fetal harm laws aren't limited to abortion or murder. They have been used to penalize women for using drugs or drinking during pregnancy. In 1998, Wisconsin made a fundamental change in its child protection laws to allow judges to confine pregnant women who chronically abuse drugs and alcohol. South Dakota has enacted similar legislation. And in South Carolina, a woman who admitted using cocaine during her pregnancy was convicted of homicide after her baby was stillborn.

This is a profound—almost symbolic—example of statist interference and coercion.

The "Right" to Abortion

Abortion is not guaranteed as a right in the Constitution or any other founding document. The U.S. Congress has never passed a law

supporting abortion as a legal right or privilege. The legality of abortion in America rests on the thin branch of a split decision from the Supreme Court.

As most Americans know, the 1972 decision *Roe v. Wade* made abortion legal. But the decision did not rest on any notion—legal or otherwise—of "choice." It was based on the right to privacy implied, though never explicitly stated, in the U.S. Constitution's 1st, 3rd, 4th and 5th Amendments.

And the arguments against legal abortion don't rest on any notion of "life" in the cosmic or biblical sense. They are based on the word *life* in the legal sense, as set forth explicitly in the 5th and 14th Amendments.

So, the real debate over abortion—which is rarely heard—is whether the right to privacy or the right to life should prevail. And this debate ends up focusing on another question: Is a fetus human?

If a fetus isn't human, getting an abortion is no different from getting a tattoo or liposuction. If the fetus is human, abortion is homicide and should be illegal except when, to save her own life, the mother aborts in self-defense.

The abortion debate is responsible for one of the most obvious confusions in American political debate. Republicans usually oppose government regulation in the name of free choice; the party's strategists happily call the Republicans the "leave-us-alone coalition."

But on the most sensitive subject of all—reproductive rights—American conservatives endorse statist interference and coercion.

Democrats are no more coherent: a party that will do anything to protect a "woman's right to choose" an abortion won't support her right to choose a school for her child.

Anti-abortionists believe that they're winning the battle for Americans' minds; they have highlighted rare practices like so-called "partial-birth abortion" that most people find repugnant. Technology has helped; modern sonograms are so powerful that they can delineate tiny fingers and toes. Expectant parents take photographs of their

future offspring and keep them along with their other baby pictures. The net effect? According to a Gallup poll, the proportion of the public who believe that abortion should be legal in all cases dropped from 34 percent in 1992 to 24 percent in 2002.

But there's a limit to how far the legal system—and perhaps even the cultural systems—will allow abortion rights to erode.

Despite the polls, surveys and political spin, most Americans seem to want to preserve some form of legal abortion. They don't celebrate abortion; but they also don't want a return to illegal abortions. Bill Clinton's rejoinder that he wanted abortion to be "safe, legal and rare" does seem to reflect the majority sentiment.

This is an example of the toleration-versus-approval liberty equation that occurs in various social contexts (and that will appear throughout this book). Generally, toleration adds a great deal of liberty to any population; approval—especially when it's mandated—doesn't.

Many of the restrictions on abortion rights imposed by anti-abortionists had the paradoxical effect of making the practice more acceptable. In 2002, more than half of all abortions were performed in the first eight weeks of pregnancy, up from 40 percent in 1973. And 89 percent of all abortions took place in the first 12 weeks.

Though abortion will remain a flashpoint of American politics, the statistical trends of the early 2000s suggest that it may decline in terms of controversy. Antiabortion advocates will claim victory in reducing the numbers of the procedures; pro-abortion advocates will claim victory in keeping it safe and legal.

Libertarians will watch things like fetal harm laws as a dangerous sign of nosy statist interference and coercion. Perhaps when heat from the abortion debate dissipates, the fetal harm laws can be axed...or at least rewritten to limit their reach.

A murder like that of Laci Peterson and her baby is always going to be horrific. Whoever did it is as good a candidate for the death penalty as any.

But is the death penalty good enough for the murderer?

The Death Penalty

In January 2003, Illinois Governor George Ryan made a dramatic move. He emptied out the state's entire death row by reducing the sentences for all 156 inmates.

Since the U.S. Supreme Court reinstated the death penalty in 1976, Illinois had executed a dozen inmates. But its death row was the least credible in the country; dozens of inmates had been put there wrongly. A series of investigations by a group of reporters, attorneys and Northwestern University journalism students had freed 13 death-row inmates—either because they were innocent or because there had been significant procedural flaws in their arrests or trials.

Ryan had been elected governor in the early 1990s as a pro-death penalty, law-and-order Republican. But the shaky convictions took a significant toll on his position. At first, in 2000, he ordered a moratorium on executions so that each death row case could be reviewed. And he appointed a commission to examine the situation and make suggestions for reforming the state's death penalty process.

In the spring of 2002, the commission recommended dozens of reforms. Without major changes, the committee wrote, Illinois should eliminate the death penalty altogether.

Efforts to enact the recommended reforms died in the state legislature, where party politics ended up grinding each idea into political dust. And, through most of 2002, Ryan's administration was plagued with a scandal involving bribes paid to secure various types of state professional licenses. Ryan wasn't implicated in the bribery charges himself—but some close allies were, and the scandal hurt his public standing as his second term approached its scheduled end.

Frustrated by the lack of progress on the political front, Ryan pardoned three death-row inmates in December 2002. In early January 2003, he pardoned four more. And, a few days before his time as governor ended, he commuted the death sentences of all the remaining inmates to life without parole.

His statement on the matter, coming from a loyal law-and-order Republican, bears notice:

> Because the Illinois death penalty system is arbitrary and capricious—and therefore immoral—I no longer shall tinker with the machinery of death. I started with this issue concerned about innocence. But once I studied, once I pondered what had become of our justice system, I came to care above all about fairness.... If the system was making so many errors in determining whether someone was guilty in the first place, how fairly and accurately was it determining which guilty defendants deserved to live and which deserved to die?

The talk of immorality doesn't resonate much with libertarians. But Ryan's mention of the "machinery of death" and "so many errors" does. This gets at the basic libertarian argument about the death penalty: Is the state competent to administer death efficiently? As many libertarians have asked, is the same bureaucracy that takes weeks to process a driver's license up to the task of taking a person's life? In Illinois, the answer was *no*.

And it's *no* everywhere else.

Legal Complexities

Questioning the death penalty might seem trivial in post-9/11 America. There are clearly organized, committed groups of people in the world willing to go to extraordinary lengths to kill Americans they've never met.

Since these people bring the rules of engagement from a declared war to lower Manhattan, logic seems to dictate that they be met with the same response. They deserve to die...and their comrades may deserve to die preemptively, just as if they were soldiers for a country that had declared war on the U.S.

Even libertarians acknowledge national defense—and war, when necessary—as a legitimate service of the state to its people. But law enforcement isn't the same thing as national defense; and the death penalty is a tool of law enforcement, not war-making.

Breakdowns in the machinery of death happen often. Illinois isn't the only state that has had problems applying the death penalty. In 2002, Maryland governor Parris Glendening followed George Ryan's lead and called for a moratorium on death sentences while the University of Maryland conducted a detailed, scientific study into how they were administered.

The results were surprising. Geography turned out to have a lot to do with whether a killer got the death sentence. An overwhelming number of Maryland's death row inmates came from Baltimore County. And race was a factor—the race of the victim. While the race of the killer didn't seem to matter much, killing a white person posed three times the chance of a death sentence than killing a nonwhite.

The Maryland report concluded that the problem with death sentences didn't come from bloodthirsty judges or lazy juries; both of those groups seemed to be fair. The problems seemed to lie in "institutional biases" of prosecutors working only the early stages of murder cases—when decisions about whether or not to seek the death penalty were being made.

When investigators—like the Northwestern University group in Illinois or the University of Maryland group—examine death cases, they usually start with the sentencing in the cases and work their way backward.

The highest rates of sentencing error are consistently found in states such as Arizona, Nevada or Pennsylvania, all of which have very "broad" death penalty statutes—that is, statutes that allow for capital punishment for a wide variety of crimes—while a state like Colorado, which has a very narrowly applied death penalty, has far fewer errors.

In reviewing all 5,760 death sentences issued in the U.S. between 1973 and 1995, Columbia University professor Jim Liebman found

that 41 percent—about 2,360 cases—had been overturned on appeal because of "sentencing errors." Among those, more than 300 were overturned on the grounds that the aggravating or special circumstance (usually required for the death penalty) did not exist. A third were overturned on grounds of "ineffective counsel" (most often for failure to introduce mitigating evidence at a sentencing hearing).

While guilt must be proven beyond a reasonable doubt, the standards for justifying the death penalty are much lower. During trial, the burden of proving guilt is on the prosecution; during sentencing, part of the burden is on the defense—to bring in mitigating evidence to convince a jury that death is not appropriate. Bad lawyers can really screw this up.

Asking Too Much of the State

There is an impulse in most Americans to support use of the death penalty in dealing with society's worst, most violent criminals. There's a simple moralizing satisfaction in turnabout justice. This harkens back to the "eye for an eye" notion of justice that pervades the first half of the Bible. And it's especially true in the wake of 9/11.

But the state should not be allowed to mete out vengeance. Its interest is in assuring safe commerce in its public places. Its aim should be to discourage criminal behavior generally—not specifically or individually.

Allowing the state's prosecutors to seek the death penalty puts a lot of authority in their hands. It invites various corruptions—from the institutional bias that the Maryland study found to more conscious, cynical choices made for political gain.

To ask the state to administer complex systems gives it license to expand...and, eventually to interfere and coerce. The institutional self-interest of a state agency will—from the beginning—corrupt the best intentions of the complex programs. It's better for everyone to solve the problem by not asking the state to do too much.

Just as it's important to limit the state's ability to imprison suspects without charges, it is important to limit the ability to put criminals to death. Habeas corpus abuses are relatively easy to remedy—you let people out of jail. Death penalty abuses are harder to repair.

Ideally, Americans consume the revenge fantasies of Clint Eastwood or Arnold Schwarzenegger to release their animal impulses for swift, violent justice. We shouldn't make public policy on these fantasies.

Stumbling through Life and Death

If you researched the phrases "asking too much of the state" and "death," you might get a lot of references to one Terri Schiavo. The Florida woman is a shining example of the state trying to administer life-and-death issues far beyond its competence.

In February 1990, Schiavo—who was 27 at the time and had serious health problems—suffered a heart attack as a result of a potassium imbalance. Her husband called 911 and Schiavo was rushed to the hospital. She slipped into a coma and never recovered.

Through the 1990s, Schiavo lived in a series of nursing homes, under constant care. She was fed and hydrated by tubes. She had numerous health problems, but none were life threatening. And, most depressingly, her brain deteriorated. At first, this was because of the lack of oxygen it suffered at the time of her heart attack; but the years of very little brain function also took a toll. By 1996, a CAT scan of her brain showed a severely abnormal structure. Much of her cerebral cortex was simply gone, replaced by cerebral spinal fluid.

A state court decision explained further:

> Although the physicians are not in complete agreement concerning the extent of Mrs. Schiavo's brain damage, they all agree that the brain scans show extensive permanent damage to her brain. The only debate between the doctors is whether she has a small amount of isolated living tissue in her cerebral cortex

or whether she has no living tissue in her cerebral cortex.

As the 1990s gave way to the 2000s, Schiavo's husband and her parents began to disagree over her prospects. Her husband believed that Schiavo was not going to recover and should be removed from her feeding tubes; her parents insisted that she might get better.

In October 2002, as a result of her parents' claims—in court—that different treatment options offered promise to restore some of Schiavo's cognitive functioning, a Florida state court held a trial on that issue. In that trial, the husband and parents ended up arguing over whether Schiavo was in a persistent vegetative state.

At trial, three of the five expert witnesses agreed with the husband that Schiavo was a vegetable.

Schiavo's parents launched a character assault on her husband, claiming that he wanted her dead so that he could inherit cash left from a malpractice settlement she'd won after her heart attack. They pointed out that he'd found a new girlfriend and was preparing to start a new life.

The court's decision was not so damning:

> Many patients in this condition would have been abandoned by friends and family within the first year. Michael has continued to care for her and to visit her all these years. He has never divorced her. He has become a professional respiratory therapist and works in a nearby hospital. As a guardian, he has always attempted to provide optimum treatment for his wife. He has been a diligent watch guard of Theresa's care....

But it had been more than a decade; and Schiavo's husband told the court that he believed his wife would not have wanted to live indefinitely in a persistent vegetative state.

The court, acting as an independent arbiter of Schiavo's best interests, sided with the husband and ruled that she should be taken off the feeding tubes.

Instead of the rational conclusion to a sad story, the court's ruling only increased passions. Schiavo's parents aligned with several groups that opposed so-called "right to die" laws and fought desperately in legal and media circles to keep Schiavo connected to her feeding tubes. At one point, they succeeded in getting a court order after the tubes had been removed—and the tubes were put back in Schiavo's arms.

The court hearing the parents' main appeal (there were several) made as definitive a ruling as it could:

> ...the difficult question that faced the trial court was whether Theresa Marie Schindler Schiavo, not after a few weeks in a coma, but after ten years in a persistent vegetative state that has robbed her of most of her cerebrum and all but the most instinctive of neurological functions, with no hope of a medical cure but with sufficient money and strength of body to live indefinitely, would choose to continue the constant nursing care and the supporting tubes in hopes that a miracle would somehow recreate her missing brain tissue, or whether she would wish to permit a natural death process to take its course.... After due consideration, we conclude that the trial judge had clear and convincing evidence to answer this question as he did.

Still, Schiavo's parents resisted. They appealed to the governor to "do something." They appealed to the Florida state legislature. They went on TV.

In the fall of 2003, as Schiavo's nursing home was preparing to remove her feeding tubes again, the Florida legislature passed a law designed particularly for Schiavo's circumstances that prohibited the tubes from being removed.

This was one of the most bizarre, inappropriate and possibly illegal abuses of the state legislative function in recent memory. And the governor signed it.

Florida politicians had overridden their state courts, their state constitution—which guaranteed a right to privacy and allowed residents or their legal guardians to terminate life support—and even their own laws to supply a continuing family melodrama for daytime television talk shows.

Governor Jeb Bush talked about finding some way to appoint a new guardian for Schiavo. This, even though the one she had—her husband—had followed the letter of his legal duties and been praised particularly by the courts for his conscientiousness. This was state interference and coercion at its most craven.

The Schiavo case is an example of why, as technology advances, solid political philosophies will become more important. As machines and programs do more and more for people, people need to have a firm notion of life and what its fundamental liberties are.

Conclusion

As advances in medical technology have allowed people to sustain life artificially, American courts have reached a pretty wise conclusion about making the decision to pull the plug. They have consistently held that this decision is best made by one person.

Each state uses slightly different language, but the point is usually the same. The person who acts as surrogate decision-maker for the patient on life support has one duty—to determine what the patient would have wanted.

The theory behind this model: When it comes to a life-and-death decision, it's better to have consistency and finality than contentiousness and chaos. And chaos is what Terri Schiavo got, because of nosy statist interference.

Terri Schiavo didn't leave a living will that stated exactly what she would want if she slipped into a persistent vegetative state. The closest thing to that was the judgment of the man she'd chosen to marry. When there is a spouse in such a case, the courts usually ap-

point him or her guardian. And that's fitting. The difference between a spouse and other family members is that you choose your spouse.

Respect for that choice is a good thing. It's essential to keeping the mechanics of death—at least the ones that most people are likely to encounter—in the hands of family.

And out of the hands of the state.

As America looks for justice in a world full of violent terrorists, libertarians are right to extend this point through various issues of life and death.

The state should defer to the husband in the Schiavo case because it is less competent than he to make a hard call.

Likewise, the state is not competent (regardless of how well judges think of themselves) to implement the death penalty fairly. It should recuse itself from that heavy burden.

As it should recuse itself from abortion—neither outlawing the wretched procedures nor paying for them.

9 Liberty Versus Anarchy

Statists claim that libertarianism is just a right-wing version of anarchy. Is there any truth to this argument?

The World Trade Organization scheduled a major meeting in Seattle in late November and early December of 1999. The WTO chose Seattle because—as the home to Microsoft Corp. and Amazon.com—it represented the birthplace of the digital economy.

Members of the WTO were accustomed to dealing with protesters who objected to the "globalism" of the organization's economic policy-making. But the WTO had no idea how much the Seattle meetings would become a focal point for anti-globalist—and anarchist—activities.

In a series of demonstrations that took place in Seattle over the course of several days, protesters vandalized and looted retail storefronts (with a special venom directed at Seattle's many coffee shops), torched cars and fought with police.

Who were these protesters? Many claimed to be anarchists; but the actual anarchists in the crowd were outnumbered by trade unionists and members of radical environmental groups.

Still, the anarchists drew the most attention and led the way—picketing various WTO meetings, taunting the police and blocking Seattle streets during rush hour.

The smashed Starbucks windows remained the memorable image of the meetings. The connection between gourmet coffee and the WTO was a little fuzzy, though. True, Starbucks and similar outfits get their coffee from Central and South America; but they usually follow politically correct guidelines in dealing with foreign growers. They're hardly the corporate fat-cats that the protesters equate with the WTO.

Then again, there's hardly *anyone* who matches the fat-cat image that the protesters hated so dearly.

The alliance among anarchists, trade unionists and the liberal environmentalists in Seattle was loose. The anarchists objected to the global aims of organizations like the WTO, the International Monetary Fund and the World Bank; they objected to the global policy-making that claimed its legitimacy in "free trade." The environmentalists and unions tended to be more self-interested, pushing agendas that reflected their partisan or financial interests.

For some young anarchists, the Seattle riots—however imperfect—were a rallying point. For the first time in a generation, radical politics translated into rebellious action. Left-wing journals rhapsodized about a new beginning for anarchist street politics.

But the philosophical perspective that holds sway in the anticapitalist/anti-corporate circles might be better described as an *anarchist sensibility* than as *anarchism* per se.

What Is Anarchy?

In any exploration of libertarian political philosophy—and in this book—the question eventually comes up, "What's the difference between libertarianism and anarchy?" The answer is complex, but the important thing to remember is that libertarianism isn't anarchy.

Anarchy is built around the proposition that nationalism—as in nation-states, capitalist-free markets and centralized authority, law enforcement or military—must be abolished. "The movement" (as believers call anarchy) isn't new; a century before punk-rockers claimed the title, Henry David Thoreau was a well-known anarchist.

In the late 19th and early 20th Centuries, anarchy anchored the radical side of the U.S. labor movement and political left—as communism would in later decades. One difference: Anarchy wasn't linked to membership in a specific organization in the way that communism was linked to membership in the Communist Party. Another: The movement has long been shaped more by emotion than logic.

There have been anarchist organizations—most famously the Industrial Workers of the World (IWW)—but organization has never been a strength of the movement.

At the end of the 19th Century, a stumbling U.S. economy encouraged widespread anticapitalist sentiment among workers; in its formative years the American Federation of Labor (AFL) associated itself with this radical sensibility. But, in the early years of the 20th Century, a better economy turned the AFL's attention to the middle-class concerns of skilled workers. The big union moved away from political radicalism and focused on better wages and workplace conditions—while accepting the basic tenets of capitalism.

This left some space for a more radical labor movement. The IWW stepped in. The IWW adopted what its members called an anarcho-syndicalist perspective—which rejected capitalism as the prevailing economic model and stood for militant labor unionism. It organized the unskilled, foreign-born and black workers ignored by the AFL.

The AFL participated in electoral politics, advising members to vote for politicians most likely to support labor interests; the IWW wanted revolution, which ruled out engagement in the political arena.

IWW locals were often short-lived—weakened by their reluctance to sign contracts, based on their belief that any agreement with capitalists was "collaboration."

The movement's weaknesses surfaced when the Socialist Party leader Eugene V. Debs was sentenced in 1918 to 10 years in federal prison for criticizing America's involvement in World War I. Debs was an ally of the IWW and other anarchist organizations. Their leaders should have rallied against his imprisonment—which even mainstream political groups questioned for being too harsh. But they didn't.

And perhaps the low point for the movement came in the case of Nicola Sacco and Bartolomeo Vanzetti, two anarchists accused of a payroll robbery and related murder in 1921. Carlo Tresca, the closest thing the anarchist movement had to a leader at that point, concluded that anarchists alone would not be able to mobilize mass support for Sacco and Vanzetti. So, the leadership of their defense campaign was expanded to include communists and socialists of various ideologies. But the result was a disaster. The groups argued endlessly over fine points of radical orthodoxy—and failed to produce a coherent legal strategy.

As in Debs's case, Sacco and Vanzetti were convicted (unlike Debs, they were sentenced to death) even though mainstream legal experts questioned the strength of the case against them. By 1927, when Sacco and Vanzetti were executed, anarchy had lost any influence within the U.S. left.

Because anarchy never achieved the political power of socialism or Marxism, it's retained through current times the romantic image of noble failure.

Dove-Tailing to Libertarianism

Anarchists generally want a form of direct democracy based on small consensus-finding meetings rather than voting. This focus on consensus-building, combined with the belief that people can develop fully as individuals only among other people, leads the anarchists to accept the idea of shared property—which might seem to clash with their "smash everything" reputation.

In current times, there's a large dollop of fashion wrapped up in most anarchists' political philosophy. The label *anarchist* is more attractive to rebellious young people than *socialist* or *communist*, which bring to mind the compromises, lies and failed politics of the morally bankrupt Soviet Union.

Anarchy has a more colorful history. The movement attracts not only those who can bear angry isolation but those who revel in it.

Early versions of the spiritual movement that contemporary Americans know as New Age were intertwined with anarchy in the late 19th and early 20th Centuries. Health and dress reformers, homeopaths and herbalists, practitioners of free love and nudism were often sympathetic to anarchism—and were often anarchists themselves.

Anarchy is big on *nature*. But its most distinct characteristic is an intense distrust of the "machinery" of government, the law courts and the military. This distrust distinguished anarchists from Marxists in the early 1900s; and remains the anarchist's most compelling feature today.

Anarchy is big on *direct action*. Direct action can mean, simply, that the people must liberate themselves and not delegate that job to parliaments or other representatives. But at the end of the 19th Century, it was associated with dynamite used by lone individuals or small conspiracies and the black flags waved at anarchist marches.

Anarchy is big on *criticism*. Many anarchists believe the movement should focus on the exposure of corruption rather than any constructive strategy.

In current times, this direct action has morphed into the anarchist's penchant for street theater and performance art. Broken Starbucks windows. This is the middle-class version of "propaganda of the deed"—the violent aspect of anarchy that led earlier believers to acts of assassination and terrorism in the hope of inciting mass uprisings.

And, finally, anarchism is big on *liberty*. This is where it crosses over with libertarianism. Anarchist objections to global organizations like the WTO and IMF resonate with many libertarians and advo-

cates of small government. There is surely a bureaucratic arrogance to organizations like the WTO and IMF (and the United Nations, for that matter) that calls to mind conspiracy theories involving Freemasons, Jews or the Bavarian Illuminati (or all of them together). On a less paranoid level, there is surely a worrisome connection between the statist governments of George W. Bush or Bill Clinton and the corporate giants in energy, entertainment or banking.

So, what's the difference between an anarchist and a libertarian? Other than their clothes?

Anarchy's publicity tactics often overshadow its political message. What do protesting anarchists want—government at the most local level or the chance to set fire to police cars?

Some anarchists...or at least some allies of anarchists...seem like they'd rather burn the cop cars.

At some point, anarchy ceases to be about political theory and becomes a lifestyle choice. The penchant for anonymity, *noms de guerre* and black clothes gives anarchism its cachet—and its largest obstacle.

Anarchy is plagued by the company it keeps. All anarchists are antiauthoritarian; but not all antiauthoritarian types are anarchists. Some are just violent thugs or petulant adolescents.

Most people recognize anarchy by pompous talk and solitary, misanthropic action—assassination, vandalism and pierced noses. The anarchist's notion of liberty is passionate contradiction to the status quo; the libertarian's notion of liberty is the ability to move away from the status quo.

Cell Phones Help Anarchists

The Internet and cell phones have been good for anarchy. These technologies play to the strengths of a decentralized movement. In the periodical *Socialist Register*, left-wing journalist and historian Naomi Klein wrote about these effects. She wrote that street protests like those in Seattle "are not demonstrations of one movement, but rather

convergences of many smaller ones, each with its sights trained on a specific multinational corporation (like Nike), a particular industry (like agribusiness) or a new trade initiative (like the Free Trade Area of the Americas), or in defense of indigenous self-determination (like the [radical Mexican] Zapatistas)."

Klein went on to write:

> Thanks to the Net, mobilizations are able to unfold with sparse bureaucracy and minimal hierarchy; forced consensus and labored manifestos are fading into the background replaced instead by a culture of constant, loosely structured and sometimes compulsive information swapping.
>
> ...There is no question that the communications culture that reigns on the Net is better at speed and volume than it is at synthesis. It is capable of getting tens of thousands of people to meet on the same street corner, placards in hand, but it is far less adept at helping those same people to agree on what they are really asking for before they get to the barricades—or after they leave. Perhaps that's why a certain repetitive quality has set in at these large demonstrations....
>
> The Net made them possible, but it's not proving particularly helpful in taking them to a new stage....

But, to someone who values liberty, the Internet does enough in bringing together groups of like-minded people. The "new stage" that writers like Klein talk about is often the problem—a political establishment in which the devious self-interest of statism overwhelms idealism.

Still, someone who values liberty will prefer anarchy to left-wing orthodoxies. In fact, anarchism and Marxism have a history of antagonism. Anarchist firebrands Emma Goldman and Alexander Berkman supported the Russian Communists in 1917—but fell out with them once Lenin and his followers started building a totalitarian state.

Marxism preferred to use the mechanisms of the state to control political power for the benefit of workers; anarchy preferred to smash the mechanisms of state. Anarchists criticized Marxists for treating the state as an instrument that could simply be taken over and used for other ends. Anarchists saw the state not as a tool but as an instrument of oppression, no matter who controlled it. The failure of the Soviet Union proved them right, ultimately, about Lenin.

The distinction between anarchism and libertarianism sounds similar. Libertarians accept the need for a limited central state—if only to provide basic levels of safety and security. Their focus is on keeping the state limited to a disciplined—and small—number of activities.

Anarchists still want to smash the mechanisms of state. As I've noted, anarchy is an emotional system.

Anarchists Aren't Always Thinking

The anarchist mind-set of the protesters who attacked police cars in Seattle has little to do with the theoretical debates among libertarians, anarchists and Marxists. It has a lot to do with strong antiauthoritarian passions.

Anarchy's absolute hostility to the state and its tendency to adopt a stance of ideological purity limit its usefulness as a political philosophy. Frankly, libertarians are too pragmatic to embrace this sort of ideological zealotry.

There are versions of anarchy that are deeply individualistic and incompatible with socialism. But these are not the forms of anarchism that hold sway in radical activist circles, which have more in common with the fashionable radicalism advocated by writers like Noam Chomsky. And these are the writers who influence the anti-globalization movement of the 2000s.

But some anarchists—perhaps many anarchists—aren't influenced by any writers at all. Anarchy has long been associated with hipster fashions like street theater and political art. And many of its adherents

never get past that. Combine the shallow appeal with a tendency to insist on principle to the point of disregarding likely results and you get a political philosophy that appeals primarily to precocious 19-year-olds.

Conclusion

During the summer of 2000, just as the Democratic National Convention was taking place in downtown Los Angeles, a couple who lived in nearby Pasadena hosted meetings for the North American Anarchist Conference.

With the Seattle riots of a year earlier still fresh in people's minds, law enforcement agencies vowed to keep close tabs on the Pasadena meetings. Then Los Angeles Police Chief Bernard Parks made a public announcement that he'd be watching the anarchists. Federal agents sat in unmarked vans across the street from the suburban home in which the meetings were taking place.

In some ways, this seemed like a return to the menace—and relevance—that anarchists enjoyed in the early 1900s.

But, to listen to the Pasadena anarchists, a reasonable person could conclude they were libertarians. The couple hosting the meetings—both graduate students at CalTech—explained that they were drawn to anarchism because they felt American liberal politics had sold out to corporate interests.

One of their guests told a local newspaper:

> I can clearly imagine a society in which we have local neighborhoods that run their own sources of energy, that produce their own goods, and that organize in national and international consensus-based organizations. But it wouldn't be a state-run, centralized economy. It would be driven by cooperatives, by membership-based organizations.

This hardly sounds radical...or fashionably trouble-making. But it's clearly more passionate than logical.

There are appealing elements to anarchy—its emphasis on organization of small autonomous groups, its decision-making by consensus and its penchant for colorful protest. And the decentralized organization makes it possible for groups that disagree in some respects to collaborate in regard to common aims.

But movements dominated by an anarchist mind-set are prone to burning out early. Absolute internal equality is hard to sustain. Movements need leaders.

Anarchy—like Marxism—is an ideology that opposes leadership in the conventional political sense. But an anti-leadership political philosophy doesn't eliminate leaders; it only denies that it has leaders. The result is a Soviet Union in which Josef Stalin can claim that "the people" engineered Ukrainian famines...as opposed to his small circle of sycophants.

Pragmatic libertarians accept a state—and a state's leaders—as a necessary cost of the social contract. Their focus is on limiting the powers of the state and its leaders so that a Stalin or Mao or Milosevic can't come into power.

Just as liberals and conservatives in the U.S. are usually both statists, libertarians and anarchists are both dedicated to liberty. But, just as liberals and conservatives see the state in wildly different ways, libertarians and anarchists see liberty differently. Libertarians look at liberty as the rational result of the social contract that people make with the state. Anarchists look for the passion...and fashion...of individualism.

And there's undeniable value in that passion. Anarchists just don't know what to do with it.

A coherent libertarian might find more in common with an angry, not-quite-rational anarchist than with a politically-conservative statist.

Part Three:
Mechanics

10 Habeas Corpus

Fighting terrorists requires some extraordinary tactics. Can libertarians support wartime approaches to arresting and holding these people?

In March 2003, Maher Hawash was on his way home from his job at Intel in Portland, Oregon, when FBI agents surrounded him in the company parking lot and arrested him. At the same time, agents armed with assault rifles were searching Hawash's home, upsetting his wife and three small children.

Hawash was an immigrant—born on the West Bank and raised in Kuwait—in his late 30s who'd been a U.S. citizen for some 15 years. He had worked at Intel for more than a decade, first as an employee and then as a contractor. In many ways (including his foreign place of birth), Hawash seemed to be a typical high-tech professional living on the West Coast.

The Feds thought he was something more dangerous. They believed Hawash had been channeling money to sham charities that operated for the benefit of al Qaida and related groups; and they had some reason to believe he'd tried to join the Taliban army in Afghanistan. The agents took Hawash to a federal prison outside of Portland, where he was held in solitary confinement. And held. And held....

As the days and weeks went by without any charges filed against him, Hawash became a rallying point for critics of the federal government's post-9/11 law enforcement enthusiasms. A group of friends launched a Web site to draw attention to his imprisonment without charges. They compared him to the "disappeared" dissidents in Latin American dictatorships or the Jews of Hitler's Germany; they cast law enforcement agencies as the Gestapo and anyone who raised questions about Hawash's innocence as bigots or dupes. He had a lawyer, the support of the ACLU and the attention of at least a few West Coast politicians.

Several weeks into Hawash's imprisonment, his lawyer got a habeas corpus hearing in federal court. Habeas corpus is the legal theory that the government must "produce the body" of anyone it arrests to face criminal charges in a public forum. If the charges aren't made, the prisoner must be released.

Habeas corpus is not unique to the United States—most developed democracies recognize the tenet in some form. It is an essential protection of personal liberty and a check against the common tendency that most states have to perform security functions in secret.

The court listened carefully to Hawash's lawyers and then ruled cautiously: It warned the Feds that they couldn't keep Hawash in jail forever without charging him…but allowed them some discretion to keep him in custody at least until they could take his complete deposition or have him testify before a grand jury.

It was difficult for anyone outside of the case to offer any useful analysis. Under the USA Patriot Act, most of the records were sealed.

The Feds wouldn't comment on whether Hawash was himself a suspect of a crime or merely being held as a material witness to something he'd seen or knew about. (If he were a material witness, he could be held indefinitely.) Hawash's friends admitted that his arrest might have been linked to a 2000 contribution of more than $10,000 he made to the Global Relief Foundation, an Islamic charity later investigated for financial links to terrorism.

Within a few weeks, Hawash was being moved. He wasn't in the Portland area any more—but the government was being cagey about exactly where he was. As the media (especially online) began to pick up the story, the Justice Department let out small details. Hawash was not being kept in Guantanamo Bay. His wife and children had been allowed to visit him. His lawyer knew what was going on but was under court order not to comment.

In late April, federal authorities charged Hawash with plotting to aid al Qaida and Taliban forces fighting U.S. soldiers a month after the 9/11 terrorist attacks. Specifically, Hawash was charged with conspiracy to levy war and two counts of conspiring to provide material support to the two groups. In its indictment, the Justice Department said Hawash had been part of a Portland-based group with six other suspects who'd already been charged.

Hawash appeared at his indictment—and seemed in reasonably good shape. He listened to the government lawyers present an early version of their case.

Hawash had flown to Hong Kong in late October 2001, where he met five friends: Jeffrey Battle, Patrice Ford, Habis Abdullah Al Saoub and brothers Ahmed and Muhammad Bilal. Another suspect, October Martinique Lewis, stayed in Portland and wired information and more than $2,000 to Battle—her ex-husband—as the group tried to travel west from Hong Kong to fight for the Taliban regime.

According to the government, Hawash was angry about what he perceived as an anti-Islamic bias in the United States. He had planned to travel through Asia to Afghanistan, where he could join the Taliban army. But he came back to the United States in a few weeks, after failing to get any closer than western China.

After the indictment, Hawash was kept secretly again for several months.

Finally, in August 2003, he pleaded guilty to a charge of aiding the Taliban—agreeing to testify against his friends in exchange for the other terrorism charges being dropped. Hawash would serve at

least seven years in federal prison under the deal, which was approved by U.S. Attorney General John Ashcroft.

"You and the others in the group were prepared to take up arms, and die as martyrs if necessary, to defend the Taliban. Is this true?" Judge Robert Jones asked Hawash during the plea hearing.

"Yes, your honor," Hawash replied.

Hawash stipulated that he took some of the other defendants to the Portland airport for their trip and provided one of them with cash for the trip. Four days later, he flew to Hong Kong and was met at the airport by two of the other defendants. He gave cash to members of the group. After returning to Portland, he sent an additional $2,000 to a defendant who stayed in China.

Hawash agreed to all of this after acknowledging he was satisfied with his legal counsel and had read the plea agreement carefully. He acknowledged further that he had made the plea "freely and voluntarily." He understood he would spend the next seven to 10 years in federal prison as part of the agreement.

Hawash's attorney said his client had decided to cooperate with the government—but declined to comment on any other details of the deal.

The plea bargain seemed to be a vindication of the Justice Department's troubling approach. The defendant was an educated man who admitted in what seemed like an informed manner to breaking U.S. law. But the secrecy that shrouds national security cases always raises questions. Were his attorneys in constant contact with him? Could Hawash have been coerced in some manner, when he was being kept in undisclosed locations? Was there more to the plea bargain than the court—or the public—was told?

How Habeas Corpus Works

Technically, habeas corpus is a check of executive branch power that's performed by the judiciary branch of government.

In other words, the process usually goes like this: The executive branch, through one of its law enforcement agencies, arrests someone. Government prosecutors (who also work for the executive branch) are supposed to produce an indictment of the arrested person in a timely manner—usually 24 to 72 hours. If they don't, a court can issue a writ of habeas corpus that demands the executive branch produce the prisoner in court. When the prisoner is produced, the court considers whether the state has reason to keep him in custody. It can—as it did in Hawash's case—grant the executive branch more time to assemble a case. Or it can order the prisoner to be released.

There are many ways that ambitious statists can work around habeas corpus standards, though most require a request by the executive branch and consent of the judicial branch. Law enforcement agencies can arrest and hold people with great discretion if the courts agree the people are material witnesses to a criminal case. Also, under the Patriot Act (and other laws), the executive branch can ask the courts to declare a case secret—in the interest of national security—and hold suspects with less regard for habeas corpus.

The courts can, at any time, lift the gag order or free the material witness no matter how strongly the executive branch protests.

Some of the proceedings in Hawash's case fell under each of the exceptions. Initially, the Justice Department told the courts that he was being held as a material witness against his fellow travelers; later, it claimed that his case was a national security matter. The federal courts in Oregon had agreed to keep his bail hearing and other matters secret and closed to public review. They also agreed to seal most of the documents supporting the government's case against Hawash.

The History of Habeas Corpus

As important as habeas corpus is to American liberty, its history can be measured most memorably by the number of times it has been suspended.

The first suspension came immediately on the heels of the passage of the U.S. Constitution. In the years between the end of the Revolutionary War and the beginning of the War of 1812, England remained unhappy about losing its American colonies and kept a large number of spies in its employ. These weren't spies in the James Bond sense of the word; they tended to be more open in their allegiance, collecting and reporting information about politics, money and military movements without much discretion.

The result was the Alien and Sedition Acts. These odious laws were an overreaction to a legitimate problem. They allowed habeas corpus to be suspended in any case involving allegations—mere allegations—of traitorous behavior.

Statists of that time (and a few of today's version) defend the Alien and Sedition Acts as necessary measures during a turbulent period. Then again, statists aren't big fans of habeas corpus protections.

The Alien and Sedition Acts were repealed as soon as Thomas Jefferson succeeded John Adams as president. But 60 years later—in the depths of the Civil War, Abraham Lincoln suspended the right of habeas corpus in most regions of the country. To Lincoln's credit, he didn't dress up this encroachment on essential liberties in euphemisms. He stated plainly that, in a time of civil war, no country could risk a court's release of a spy or traitor.

"By general law," Lincoln wrote to a newspaper editor in 1864, "life and limb must be protected; yet often a limb must be amputated to save a life; but a life is never wisely given to save a limb."

Lincoln's decision followed the reality of the times. Many states—especially Kansas and other western border states—were effectively under martial law, with rights of habeas corpus already suspended. The resulting conflicts between angry citizens and overzealous military units gave birth to the period nickname "bloody Kansas."

The end of the Civil War in 1865 saw the return of habeas corpus rights for most Americans. But the cycle was due to turn again...and, again, it would come about 60 years later.

In the 1920s, fears about the violent tendencies of some anarchist groups led President Woodrow Wilson to condone the so-called "Palmer Raids." Amid labor unrest and fears of spreading communism, America was rocked by a series of politically-motivated bombings in 1919 and 1920. One of these bombings destroyed the home of Woodrow Wilson's Attorney General, A. Mitchell Palmer.

Palmer, known by the oxymoronic nickname the "Fighting Quaker," retaliated with a series of raids on and arrests in the homes of political agitators, labor organizers and immigrants. Wilson gave law enforcement agencies wide discretion in arresting and holding suspected bombers. In most cases, the raiders were groups of local police led by a handful of federal agents (it was an early example of the "strike force" model of law enforcement cooperation that's still in use more than 80 years later).

Palmer was determined to root out "bombs and bombers" who were terrorizing Americans. In more than 30 cities around the country, some 6,000 people arrested and hundreds of these were deported, including the anarchist writer Emma Goldman.

Most of the people arrested in the Palmer raids were eventually released; and fewer than 300 were actually deported. Palmer didn't root out any bombs: No explosives were found in any of the raids, and just three pistols were confiscated. (This certainly echoes in the elusive "weapons of mass destruction" that justified the U.S. ouster of Iraqi dictator Saddam Hussein in 2003.)

The effects of the Palmer raids were mostly political; they were deplored as crude and lawless intimidation. Public response was quick and more sophisticated than some statists (and Wilson was certainly a statist) expected. Even though Americans were worried about communists and anarchists—especially ones who threatened to bomb public gatherings—they were also worried about a federal government that crashed into people's homes and arrested them with little concern for the due process of law. Wilson's attempt to act decisively about the threat backfired on him in the court of public opinion. It was one of

several reasons that his presidency was considered a failure even in its own time.

But perhaps the most egregious example of habeas corpus erosion came about during World War II, when Americans of Japanese ancestry were placed in camps far away from the shores of the California coast.

In February 1942, Franklin D. Roosevelt signed Executive Order 9066 authorizing military commanders to exclude people from designated areas to prevent "sabotage and espionage." Within a few weeks, General John DeWitt issued proclamations that excluded persons of Japanese ancestry from the Pacific Coast—and, in Washington, Congress made it a crime to violate the proclamations. So, nearly 80,000 citizens and more than 40,000 resident aliens were taken from their homes and incarcerated without charges or trial.

The whole process was challenged in court; but then, as now, many people overestimated the wisdom of judges. The U.S. Supreme Court supported the internment of Americans of Japanese ancestry in the sniveling decision *Koramatsu v. United States*. In that ruling, the court called the internment "temporary exclusions" and that "Mr. Koramatsu [the plaintiff standing in for all of the relocated citizens] was not excluded from the Military Areas because of hostility to him or his race." That last statement was plainly false; the Justices justified their mendacity by arguing that courts should defer to the government in wartime.

Why Holding You Without a Charge Is So Bad

Some argued during World War II—just as some argued after 9/11—that temporary violations of constitutional rights are not a big deal. And, they argue, this is especially true during wartime, when the whole American system that recognizes and supports constitutional rights is endangered.

Those people were—and are—fools.

Next to killing its own citizens, imprisoning people without charges is the worst thing a government can do. It is the most literal infringement of liberty. On a more abstract level, it assumes that the state's prerogatives come before the individual's constitutional liberties; this is the all-too-common epitome of statist arrogance.

The state only exists to serve the individual citizen's constitutional liberty. People who spend their entire lives working in the government often forget this essential truth. The social contract gives the state immense powers—military, economic and judicial. These powers have to be measured with extreme care; this is why politicians and public servants are supposed to be humbled by their responsibilities, because those powers are so large.

And, because the powers the state has are so large, the state has no purpose—even self-preservation—that precedes serving individual liberty. This doesn't mean that the state must destroy itself to protect the liberties of those who would destroy it. But the state's actions for self-preservation must be made with the realization that it doesn't exist for its own accord; it exists to serve.

Statists will often make the argument that the state must exist first, in order to serve anyone. But this argument is a bit of sophistry designed to justify erosion of individual liberty. If a state's existence and its ability to serve individual liberty conflict, it may already be destroyed.

In fact, existence-versus-service is a false choice. The state gets its power from the service it provides; a state that preserves itself at the expense of individual liberty has violated the social contract that it makes. It ceases to be legitimate.

Of course, a state will sometimes limit the liberty of a specific individual—as when it imprisons a felon. It may have to limit one individual's liberty in order to balance others' liberties (this is, in a nutshell, what courts do); but it must proceed carefully when doing *that*. And, in the case of imprisoning a felon, it must respect the limits and processes put on its use of power by constitutional law.

The relationship between states and individuals is inherently antagonistic. America's founders understood this. The antagonism is the reason that the Bill of Rights is such an important part of the U.S. Constitution. The Bill of Rights explicates the things that the state cannot do to infringe an individual's liberties.

Tripping Up Over Rhetoric

It's important to guard habeas corpus as a check on state power for many reasons—but a key one is that statist bureaucrats will sometimes trip over their own political rhetoric.

In the immediate wake of the 9/11 attacks, George W. Bush impressed most Americans with his seriousness and his reserve. Not all of his cabinet members followed his lead. And, as the months passed, even Bush began slipping into existence-versus-service rhetoric. He started giving speeches that used the refrain "Freedom is at stake" to defend big-government actions that were at odds with the tenor of his earlier talks.

The Justice Department defended peevish, authoritarian actions—such as not releasing the number of people held as material witnesses to terrorism investigations—as national security measures. As he had in other contexts, Bush Attorney General John Ashcroft led the way with ill-advised comments. In early 2003, he told the Senate Judiciary Committee that people who criticize the government's infringement on liberties "aid terrorists...They give ammunition to America's enemies."

These exaggerations created the impression that the Bush White House had little regard for habeas corpus or the due process of law. Bush supporters insisted that certain quotes, mistaken from the start or quoted out of context, created a worse impression than the administration's practices reflected. (And, in more hushed tones, some supporters conceded that Attorney General Ashcroft had a particular "gift" for making statements that seemed strident and extreme.)

But some of the Bush Administration's practices also invited the concern that actions were following the overheated rhetoric.

After American troops landed in Afghanistan and ousted the Taliban regime with surprising speed and ease, the Bush administration decided to hold some 650 prisoners indefinitely at the Guantanamo Bay base in Cuba. These captives were locked in a legal limbo: They were not granted prisoner-of-war status and they weren't immediately charged with any crimes. The government suggested that when they were tried, they would be tried before military tribunals instead of U.S. or international courts.

Many of the Guantanamo prisoners were not Afghans, but Muslims from other countries who'd come to live under the Taliban theocracy and—in at least some cases—join al Qaida. However, at least two of the Guantanamo prisoners were American citizens. That raised some problems.

Initially, government lawyers took the hard line that U.S. courts had no jurisdiction over the "enemy combatants," whatever their citizenship. The Feds argued that enemy combatants were a new class of prisoner in a new age or terrorism; these prisoners had no right to see a lawyer or anyone else and they could be held until the government determined that the war on terrorism was over.

Again, the issue of national security was offered as the ultimate trump. The Bush Administration argued that the extraordinary status of the Guantanamo prisoners was necessary to obtain intelligence about further terrorist attacks.

As long as American citizens were among those prisoners, the extraordinary would cause political problems for the Bush White House. Critics could say—rightly, but very narrowly—that the government was claiming the right to imprison anyone, even a citizen, indefinitely and without charges. Comparisons to the Soviet Union's *gulag* prisons started bubbling up in the press.

The "enemy-combatant" tag probably fit Yaser Esam Hamdi, an American-born Saudi captured in Afghanistan while fighting for the

Taliban regime. Although he had been born in Louisiana, Hamdi was not an American citizen when he was captured.

John Walker Lindh—the notorious "American Taliban"—was still a U.S. citizen when he was captured fighting for the Taliban. His case caused even more problems.

Eventually, the Bush Administration had the couple of Americans among the Guantanamo prisoners brought back to the U.S. and tried in regular federal courts.

Lindh was convicted under a law passed in the 1990s that prohibited aiding known terrorist organizations including the Taliban. He wasn't convicted of the crimes—such as conspiring to kill Americans—that Ashcroft had taken to the airwaves to allege when Lindh had been captured. Instead of coming across as a bloodthirsty terrorist, at trial Lindh seemed more like the neurotic, spoiled child of self-centered parents. In all, though, the Lindh case roughly followed the parameters and due process of American law.

The case of Jose Padilla, the so-called "dirty bomber," remains less certain. Padilla was first detained at Chicago airport in 2002 as a material witness to a grand-jury probe, not as a criminal suspect or hostile fighter. Only later was he transferred to a navy brig as an enemy combatant, and then on the authority of the president.

A judge eventually ruled that he should be able to see a lawyer, but the government refused that order and appealed the decision.

Conclusion

The government's suspension or disregard for habeas corpus is always troubling...but it isn't a new problem. In most war times— and, generally, in approximately 60-year cycles—Americans live through some crisis that seems to call for suspension of this essential check on statist ambitions.

The U.S. Constitution is full of habeas corpus protections, both explicit and implicit. The 5th Amendment requires due process—from

arrest to trial to jail; the 6th Amendment requires a speedy trial before a jury of your peers. The 8th Amendment prohibits excessive bail and unusual punishments.

At various times, including post 9/11, the U.S. Government has wanted to dispense with some or all of these protections. All states seem to be tempted from time to time to expand their powers by limiting individual liberty—and this applies to the egregious (though recurring) desire to lock certain people up without charges, without a trial and without any explanations.

This impulse is an affront in many ways; but the worst thing is that it puts the prerogatives of the state ahead of the liberty of its citizens.

After the 9/11 attacks, George W. Bush asked John Ashcroft, his attorney general, to protect America from future attacks. Ashcroft took the charge seriously; in numerous interviews after 9/11, Ashcroft said that he saw himself as a general in a home-front war, who had all the powers of a battlefield general. This overblown self-image may explain some of Ashcroft's ill-advised rhetoric; and a greater concern is that Ashcroft may believe some of his own words.

In his 1988 book *All the Laws But One: Civil Liberties in Wartime*, U.S. Supreme Court Chief Justice William Rehnquist wrote: "The laws will...not be silent in time of war, but they will speak with a somewhat different voice."

Rehnquist thought that his statement was a wise, pragmatic sentiment (playing off of the ancient Latin proverb "In Times of War the Law Is Silent"). And libertarians value pragmatism...it keeps them connected to the daily reality of the social contract. But Rehnquist's statement isn't wise; it's cynical and short-sighted—as well as a little imprecise.

In times of war most of all, constitutional rights need to stand strong. If they don't, the state has no cause to continue fighting.

11 Posse Comitatus and Martial Law

What do libertarians make of U.S. Army soldiers patrolling the border at San Ysidro or the grounds around the capitol?

In early 2003, rumors circulated around Washington that the Bush Administration was considering a plan to change the Posse Comitatus Act. Supposedly, these changes would allow more aggressive use of regular U.S. military forces in civil law enforcement.

The rumors had started, in part, because of several comments made by Homeland Security Chief Tom Ridge. While admitting that it "goes against our instincts as a country to empower the military with the ability to arrest" people within U.S. borders, Ridge said that the Posse Comitatus Act should be reconsidered. This was exactly the sort of public statement that stirred passions of the "black helicopter" conspiracy theorists of the Far Right and the Hollywood conspiracy theorists of the Far Left.

Ridge wasn't alone in looking at ways to work around the Posse Comitatus Act. A number of groups—most associated with the Republican Party—argued that national security required a military presence to help guard the borders with Mexico and Canada. And they pointed out that the Act would not have to be changed to allow this;

if Congress specifically stated that border security was an allowed use, the military could be called in to patrol the U.S. side.

There was precedent for this. As drug-legalization groups had been complaining for nearly two decades, Congress had approved exceptions to the Act in order to orchestrate the so-called "War on Drugs."

Bush Administration spokesmen portrayed the critics as a motley crew of survivalists, hemp activists and Oliver Stone-style paranoids lined up against Tom Ridge. But more rational libertarians and civil rights activists were also troubled by Ridge's talk.

The Posse Comitatus Act

The Posse Comitatus Act—passed to end the federal military occupation of the Reconstruction-era South—is a staple of government restraint. It's also a staple of states-rights political philosophy.

Though it has been modified several times since the 1800s, it still prohibits the U.S. military from enforcing civil laws "except in cases and under circumstances expressly authorized by the Constitution or Act of Congress." This remains the reason that—in times of crisis—the National Guard and not the U.S. Army is usually called in to keep peace. (National Guard divisions are technically considered to be state militias, under the authority of state governors—not the president—even if they are being paid by the federal government.)

The phrase *posse comitatus* translates as "posse of the county" and has its legal origins in English common law. To simplify slightly, posse comitatus represents the power of the local government—usually represented by the county sheriff—to call upon its citizens to enforce criminal law. The familiar "round up the posse" scene from western novels and films is the American translation of the English common law concept.

In its founding documents, the United States encouraged this kind of local law enforcement and discouraged law enforcement at the national level. The Declaration of Independence reflects a strong mis-

trust of a standing army. While allowing for a standing army, the Constitution restricts military budgets to two years and designates the President as the Commander-in-Chief—placing the military clearly under civilian authority. The Bill of Rights prohibits the peacetime quartering of soldiers in private homes (a favorite tactic of the English government in Colonial America) and provides for states to have a "well-regulated militia" as a counterbalance to a national army.

Basically, the United States has lost its skepticism of the military since those early days.

The Fugitive Slave Act of 1850 allowed federal marshals to operate as local police to return escaped slaves to their owners. Interpreting the Fugitive Slave Act, Attorney General Caleb Cushing issued an opinion that the posse comitatus could include the military—even if entire units had to be called upon while remaining under the direction of their own officers. This use of the military became common; most infamously, in "bloody Kansas," federal troops were used to stamp out violent disputes between pro- and anti-slavery factions.

Also, federal troops battled anti-slavery activist John Brown during his raid on Harper's Ferry, West Virginia. And the Army was called in to quell the Draft Riots in New York during the early years of the Civil War. In short, the use of regular federal army troops to keep peace over slavery disputes during the 1850s and 1860s was the "War on Drugs" of its time.

The growing use of federal troops for local law enforcement reached new heights after the Union won the Civil War. During the Reconstruction Era, the U.S. Army was effectively the police force in many southern states. And this was too much.

In the 1876 U.S. Presidential election, Rutherford B. Hayes squeaked out a marginal win with the disputed electoral votes of South Carolina, Louisiana and Florida. In those states, outgoing President Ulysses S. Grant had sent troops as a police force for federal marshals to use to prevent corruption at the polls. Southerners argued that the use of the Army was—itself—the biggest corruption. Many believed

that the troops were a heavy-handed reminder of the South's loss in the Civil War, intimidated voters and encouraged support for Hayes.

The Hayes win (in a precedent for George W. Bush's disputed 2000 election) left the U.S. deeply divided. In 1878, Congress passed the Posse Comitatus Act to prevent repeats of Grant's tactics. The original wording of the law stated simply:

> Whoever, except in cases and under circumstances expressly authorized by the Constitution or Act of Congress, willfully uses any part of the Army as a posse comitatus or otherwise to execute the laws shall be fined under this title or imprisoned not more than two years, or both.

This is an important concept for any society that values liberty. An unrestrained military runs the risk of jeopardizing democratic institutions and drifting away from its principal mission—defending the nation. Coups and military governments are more likely to follow.

The ideas behind the Posse Comitatus Act are as old as democracy itself. The Roman Republic didn't let its national army come any closer to the capitol city than the Rubicon River, many miles to the north. The Roman Senate's belief was that, if the army entered Rome, its generals might be tempted to take over the government. History proved the senators right. Soon after Julius Caesar defied tradition and brought his army into Rome, the Republic fell and the Empire emerged—with Caesar at its head.

How the Act Works

The Posse Comitatus Act is, technically, a criminal law that allows prosecution of military personnel who disobey. But its importance is greater as a statement of policy that embodies the American principle of separation of military and law enforcement authorities. (Of course, laws passed to make points are seldom good ideas...but that's a different matter.)

Unfortunately, so many exceptions have been applied to the Posse Comitatus Act that its effectiveness as a bright line of government restraint is debatable.

To start, the Act's effect is limited to the United States and does not bar the military's support of law enforcement agencies abroad.

The Act applies expressly to the Army and—after some modernization—the Air Force. Congress left out mention of the Navy, Marine Corps or Coast Guard. So, strictly speaking, the Act doesn't limit their involvement in domestic law enforcement. Still, the Defense Department applies the Act to the Navy and Marine Corps.

The Coast Guard is another matter. Currently, it falls under the authority of the Department of Homeland Security; but, historically, the Coast Guard has had a complex nature. Before the creation of the Department of Homeland Security, the Coast Guard was part of the Department of Transportation—in peacetime. In wartime, it would transfer to the Defense Department.

The upshot of all of this: The Coast Guard has often been used in domestic law enforcement activities—especially those related to drug smuggling and illegal immigration.

But the federal government has not always been satisfied with the existing loopholes in the Act. On several occasions, the government has argued for other exceptions. One of these occasions was the infamous 1973 standoff at Wounded Knee, South Dakota, between federal authorities and a group of Native American radicals that called itself the American Indian Movement.

In the wake of the shootings, the U.S. government made a complex legal argument about "active" and "passive" violations of the Posse Comitatus Act to defend its actions. Passive military assistance to federal agencies was acceptable, the argument went, because it did not subject any civilian to the regulatory, proscriptive or coercive power of the military.

Federal courts largely bought the argument, creating several formulations for distinguishing between active and passive military ac-

tion. In short, the formulations allow the military to offer so-called "passive assistance" in support of law enforcement. In *United States v. Red Feather*, the court ruled that provision of military equipment and supplies was not an active use of the military. Scouring its reference books, the court found support in the Economy Act of 1932—a Depression Era reform that provided for the transfer of resources between executive departments.

(The Economy Act is linked historically to another notorious violation of the Posse Comitatus Act. In 1932, General Douglas MacArthur led regular Army troops against so-called "Bonus Army" protesters in Washington, D.C. The Bonus Army was made up of World War I veterans who were demanding special bonuses from the U.S. government to help them through the Depression. Some of the protesters had set up a shanty town near the White House. MacArthur was sent in to clean out the shanties; the result was the death of at least one of the veterans, injuries to many others—and major embarrassment for the government.)

And there are even more exceptions, beyond the legal ju-jitsu that followed Wounded Knee. Other courts have ruled that the Posse Comitatus Act explicitly recognizes constitutional and legislative exceptions to its application.

Most of the constitutional exceptions lie in the so-called "twilight zone" where the President may act where Congress has not. This twilight zone—which came long before the famous television show of the same name—was first recognized by the U.S. Supreme Court in its 1952 decision *Youngstown Sheet & Tube Co. v. Sawyer*. And it has been upheld in several decisions since.

Congress has allowed various other exceptions—including removal of persons illegally occupying Indian lands, assistance with disaster-relief efforts, protection of civil rights where local authorities do not or cannot protect them and quelling labor strife.

For example, regular Army troops were used to maintain order during school desegregation in the South in the 1960s. In 1970, Ri-

chard Nixon sent 30,000 federal troops to replace striking postal workers in New York. In 1981, Ronald Reagan used troops to replace striking air traffic controllers. And, in 1992, some regular Army troops were deployed on the streets of Los Angeles after the Rodney King verdict was read and riots erupted.

The Posse Comitatus Act was one of the principal issues in the investigation of the military's involvement in the disastrous early-1990s confrontation with the Branch Davidian cult near Waco, Texas. But even that problem didn't seem to make any lasting lessons. Within one week of the April 1995 bombing of the Alfred P. Murrah federal building in Oklahoma City, Bill Clinton proposed an exception to the Act to allow the military to aid civilian authorities in investigations involving "weapons of mass destruction."

And even these aren't all of the exceptions.

Another exception is asserted by the Department of Defense regulations based upon the "inherent right of the U.S. Government...to ensure the preservation of public order and to carry out governmental operations...by force, if necessary."

When the government starts asserting its "inherent rights," individual liberty is almost always in danger.

The Biggest Exception

However, all other exceptions to the Posse Comitatus Act pale when compared to the War on Drugs.

In 1981, Congress created an exception to the Act that allowed military involvement in drug interdiction within U.S. borders. The Act was amended in 1986 when Ronald Reagan signed into law a National Security Decision Directive that stated illicit drug trafficking was a threat to national security; it directed the Pentagon to participate in law enforcement actions to interrupt the traffic.

Defense Secretary Casper Weinberger was opposed to the military taking on civilian police activities. He said at the time:

Calling for the use of the government's full military resources to put a stop to the drug trade makes for exciting rhetoric. But responding to those calls would make for terrible national security policy, poor politics and guaranteed failure in the campaign against drugs.

And he was right. The War on Drugs was not a good fit for the military. The chronic nature of the drug problem required the military's deep involvement over time—with few standards against which to measure progress.

But the military embraced drug interdiction as a way to maintain budget levels in an era of cuts. By 1993, the Department of Defense budget included more than $1.4 billion for drug interdiction missions; it resulted in a "drug command," entirely focused on the domestic mission of drug interdiction.

Drug interdiction had traditionally been a task for civilian law enforcement, and long-term military involvement came close to subjecting civilians to military power—a clear fear of the founders.

In June 1997, Representative Ron Paul of Texas read the following statement into the Congressional Record:

In a police state the police are national, powerful, authoritarian. Inevitably, national governments yield to the temptation to use the military to do the heavy lifting. [O]nce the military is used, however minor initially, the march toward martial law... becomes irresistible.

The Newest Exception

Following 9/11, the government's focus on exceptions to the Posse Comitatus Act changed from drugs to terrorism.

Before 9/11, the federal bureaucracy had defined terrorism as a law enforcement issue. That created considerable legal limits on its

ability to actively support domestic anti-terrorism actions. After 9/11, the definition changed. Terrorism was a national security issue—and the military could get involved in its prevention.

Chris Quillen—a counterterrorism analyst with the Oak Ridge Institute for Science and Education and a former Army intelligence analyst—explained the effects of this change in the Spring 2002 issue of the military and political journal *Parameters*:

> Political pressure to "do something" too often results in military involvement in domestic affairs. ...After the attacks on 11 September, uniformed troops became regular fixtures at the nation's airports, military overflights of our major cities was accepted and even welcomed, and Navy ships were dispatched off the coasts of Washington, D.C., and New York City. ...Advocates of an expanded military role correctly note that many of the homeland defense missions they envision for the Army have a firm constitutional basis, including the Preamble's call to "insure domestic tranquility" and "provide for the common defense."

However, these arguments fail to acknowledge the founders' concerns regarding the effects of a large standing army on a democratic government.

The last part of the Bill of Rights—the 10th Amendment—says plainly that the states and the people retain all powers not specifically delegated to the federal government by the Constitution. So, the presumption that the federal government can take command of a local situation is dubious.

Most federal terrorism response plans attempt to finesse this issue by assuming local officials have asked for federal help—usually by the governor or the President declaring a state of emergency.

But military brass sometimes overestimate how much local leaders *want* military presence; most local officials look at states of emergency as a financial tools—not law enforcement ones.

Honest confusion about how to use the U.S. military in the War on Terrorism exists at every level of government. This confusion could have catastrophic consequences during a domestic terrorist incident.

The White House and the Congress are inclined to call in the Army because they are all federal entities. And there are some good reasons to use federal troops—they often have the unique technical and logistical capabilities to act quickly and decisively. But law enforcement is local in character—responding to needs at the city, county or state level. Civilian law enforcement trains for the law enforcement mission, which differs from the military mission.

In other words, this comes down to the issue of rules of engagement.

Civilian law enforcement requires the recognition of and focus on individual rights; it seeks to protect those rights, even if the person being protected is a criminal suspect. Prior to the use of force, police officers attempt to de-escalate a situation. Police officers are trained to use lesser forms of force when possible to draw their weapons only when they are prepared to fire.

On the other hand, soldiers are trained to use deadly force. Escalation is the rule. In an encounter with a person identified with the enemy, soldiers need not focus on—or even recognize—individual rights. And the use of deadly force is authorized without any aggressive or bad act by that person.

This conflict over rules of engagement has surfaced time and again. The FBI used military rules of engagement at Ruby Ridge, Colorado, in 1992 when it tried to arrest Randy Weaver—an arms dealer with ties to some violent right-wing political groups. In the FBI's defense, Weaver did resist arrest; but the Bureau's reaction was wrong by any law-enforcement standard. Its agents ended up killing Weaver's wife (who was not a criminal suspect) and his 14-year-old son.

This *really* inflamed the passions of right-wing conspiracy nuts. But it also made an impression on mainstream Americans. The FBI has rightly paid a huge political price for its actions at Ruby Ridge; a

decade later, the incident remains a blemish on the agency's public image and political reputation.

The Bush Administration's Secretiveness

The Ruby Ridge episode went from bad to crisis when the FBI hierarchy turned noncooperative with investigators—including some of its own. While the overused term "cover-up" may exaggerate what happened after Ruby Ridge, it is fair to say the FBI was unduly secretive about who'd been in charge and who'd made decisions.

Secretiveness is often a problem when it comes to the federal government and its exercise of even rightful powers. Statists tend to support... or at least to rationalize...this secretiveness. People who value liberty shouldn't.

So, if the Posse Comitatus Act might allow federal military engagement for specified national security assignments why should the Bush Administration need to be secretive? The answer is "9/11."

In October 2001, Attorney General John Ashcroft changed the baseline government policy on Freedom of Information Act (FOIA) requests from one favoring disclosure to one favoring secrecy. Under the Ashcroft policy, agencies would refuse to disclose information sought under FOIA if there was any "sound legal basis" for doing so.

In November 2001, Bush signed an executive order granting himself the power to veto all requests to open the records of former presidents, even if a former president wants his records released. Under the Presidential Records Act—like FOIA, passed in the wake of Watergate—most records of a president are to be made available for public review 12 years after the president leaves office. Bush's executive order effectively ended the Presidential Records Act and allowed him to deny public access to records from the Reagan Administration—including records related to his father's role as vice president.

And there were other secrets. The Bush Administration wouldn't say why it was holding individual detainees at Guantanamo Bay; it

wouldn't disclose the basis for its prosecution of alleged 9/11 accomplice Zacarias Moussaoui; it wouldn't say how many immigrants it detained or deported after 9/11.

Administration spokesmen said the secrecy was an unavoidable cost of the War on Terror. Perhaps. But, as the first and then second anniversaries of 9/11 passed, the War on Terror grew into a rationalization for secrecy as the norm.

A Logical Extension: Martial Law?

Some libertarians fear that the logical extension of the erosion of the Posse Comitatus Act and the Bush Administration's desire for secretiveness is—and there's no way to report this without sounding like a conspiracy nut—martial law.

Casting a cool eye on that proposition, a reasonable person might ask, "What is the likelihood that the security-versus-liberty trade-off could skew so far as to result in martial law?"

The basic mechanics of martial law have long been in place. The federal government's "continuity of [the] government" planning process includes the option of martial law—and how it would affect agencies like the Federal Emergency Management Administration (FEMA) and the Department of Homeland Security.

The details of martial law exist currently in the law. Section 32 CFR 501.4 of the Code of Federal Regulations states, tautologically:

> Martial law depends for its justification upon public
> necessity. Necessity gives rise to its creation, necessity
> justifies its exercise; and necessity limits its duration.
> The extent of the military force used and the actual
> measures taken, consequently, will depend upon the
> actual threat to order and public safety which exists
> at the time.

Virtually any military officer in a position of authority can make the decision to declare it. The Code states:

In most instances, the decision to impose martial law is made by the president, who usually announces his decision by proclamation, which usually contains his instructions concerning its exercise and any limitations thereon. However, the decision to impose martial law may be made by the local commander on the spot, if the circumstances demand immediate action, and time and available communications facilities do not permit obtaining prior approval from anybody.

Most of the Code of Federal Regulation is made up of dry, legally-precise technicalities. The sections on martial law are distinctive because they're so vague.

Martial law has been declared over limited U.S. jurisdictions more than 100 times in U.S. history, though none recently. The last occasion was in Hawaii, starting just after the Japanese attack on Pearl Harbor and lasting through World War II.

The operating assumption is that someone in the constitutional chain of command would be in charge of the country in an emergency. But the "continuity of government" plan assumes the opposite—and tries to maintain a shadow government that can function even if a terrorist act wiped out everyone in Washington.

Since the early 1950s, rotating groups of several hundred civilian and military employees have been living in fortified mountain bunkers. These bunkers are home for government employees who stay in three-month stints. In the event of a massive terror attack, the "underground government" would try to contain disruptions of the nation's food and water supplies, energy and telecommunications networks, public health and civil order. People who've been in the bunkers say that the plans for continuity call for a stark rule of martial law in the aftermath of terrorist mayhem.

This is a statist's dream of centralized planning and control, succeeding as it never has—anywhere—in practice because it's born in extreme circumstances.

But, if they were a little wiser, these dystopian statists would check their enthusiasm. The dream of effective centralized planning and control is a false one; and it's done harm from Cambodia to the Russian steppes. This dream is inherently un-American, in that it assumes the governed derive their liberty and well-being from government—instead of the government deriving its legitimacy and power from the governed.

The ultimate misimpression of this contingency planning is its reliance on "martial law." In fact, martial law is barely more organized than chaos. Why? Because there is no body of statute—no Code of Regulation—that constitutes martial law. Martial law isn't a system of law at all. It's rule by the most senior military officer present at a given moment. It can be efficiently managed, sometimes. More often, it results in a patchwork of totalitarian fiefdoms.

Conclusion

In the United States, the Posse Comitatus Act and the tradition of civilian control of the military are strong deterrents to the coups and military juntas that plague so many developing countries. But Americans need to be careful to maintain these deterrents.

There's nothing in the American water or Americans' genes that make us free. Our institutions and laws do that.

In the meantime, liberty is a fragile thing. It can very well be rubbed out by secretive governments and ambitious statists who plan for centralized control.

The erosion of liberty—like all erosion—is difficult to recognize because it goes so slowly, so gradually. Bright lines can help prevent erosion. The Posse Comitatus Act and the Freedom of Information Act are two such bright lines. People who love liberty should protect these bright lines jealously.

12 Secret Courts

If a pragmatic libertarian accepts a minimal state, are secret spy courts okay?

In February 2003, federal prosecutors brought racketeering charges against Sami Al-Arian, a university instructor from Florida. The Feds charged the 45-year-old Al-Arian with 50 counts of financing and otherwise supporting a terrorist organization called Palestinian Islamic Jihad (PIJ).

Led away in handcuffs from his Tampa home by FBI agents, Al-Arian told reporters (who'd been tipped off about the arrest), "It's all about politics." Maybe. But Al-Arian had made himself an obvious suspect by appearing on television programs after 9/11 spewing anti-American and anti-Israeli rhetoric.

According to the indictment, PIJ supported more than 100 suicide bombings in Israel—and was functioning in the U.S. since the 1980s, using American academia as a front.

Al-Arian, who taught computer engineering at the University of South Florida, was born in Kuwait and immigrated to the U.S. to attend North Carolina State University in the late 1970s. He stayed, legally, and became a permanent resident in the late 1980s. Federal prosecutors claimed that, all the while, he was deeply involved in a

loose affiliation of radical Islamic groups that eventually coalesced into PIJ. According to the Feds, Al-Arian was a senior member of PIJ's Shura Council, or governing body. He ran a complex network that moved money, support and logistical advice to terrorists around the world—but particularly in Israel.

The indictment charged that, among other things, in 1994 Al-Arian received a lengthy fax "listing people killed and names and account numbers of people receiving money on their behalf."

Days after his arrest, Al-Arian was fired by USF President Judy Genshaft. Frankly, many people in the Tampa area were surprised he was still an employee. He'd been on paid leave since an appearance on the Fox News Channel shortly after the 9/11 attacks, when he admitted his connections to known terrorist groups.

Later, Al-Arian appeared in federal court in Tampa. Security was tight as marshals lined the corridors and Al-Arian's supporters packed the courtroom. The judge ordered him held without bail.

The FBI began monitoring Al-Arian's activities and bugging his conversations in the early 1990s. At that point, the agents used powers granted to the Justice Department under the Foreign Intelligence Surveillance Act (FISA). PIJ was designated as a foreign terrorist organization in 1997, which made the FBI's surveillance easier. But, through the 1990s, FISA's narrow application made it impossible to base a criminal indictment on that surveillance.

What Is Terrorism?

Was Sami Al-Arian a terrorist when he built up PIJ's presence in the U.S.? Traditionally, intelligence and law enforcement agents used four criteria in determining terrorist activities. In order to count as terrorism, an action usually had to be:

- premeditated;

- political, in that it was designed to change the existing political order;

- aimed at civilians; and

- carried out by subnational groups—not by the army of a country.

After the 9/11 attacks, the notion that terrorism has to be carried out by specific terrorist groups was de-emphasized by law enforcement. Also, in late 2001, George W. Bush signed an executive order aimed at curtailing fundraising for terrorist organizations. In that order, terrorism was defined as:

> an activity that involves a violent act or an act danger-
> ous to human life, property or infrastructure; and ap-
> pears to be intended to intimidate or coerce a civilian
> population; to influence the policy of a government
> by intimidation or coercion; or to affect the conduct
> of a government by mass destruction, assassination,
> kidnapping or hostage-taking.

The element of conspiracy—the idea of agents working on behalf of larger organizations—was noticeably absent.

Terrorism is a difficult enemy for an open society, because it is so easy for the terrorists to take advantage of our society's freedoms to plan their attacks. But the terrifying nature of such a threat shouldn't be reason to erode those freedoms.

In the December 2001 issue of *Reason* magazine, Robert Higgs—author of the libertarian book *Crisis and Leviathan*—predicted that, as a result of America's anti-terrorist measures, "the socio-political system will gravitate ineluctably toward totalitarianism." That's an understandable position; but it's too pessimistic. War *always* presents opportunity for statists. The rest of us have to keep them in check.

To a libertarian, the War on Terrorism shouldn't mean that statist security interest—even if it's legitimate—trumps individual liberties. The result is a difficult balance to be maintained by the government. The pragmatic libertarian's responsibility is to make sure the balance is maintained.

The Difficulty of Fighting Terrorism

The first few months of 2003 were a busy time for courts dealing with criminal cases involving alleged terrorist activities.

The trial judge presiding over the case of Zacarias Moussaoui—the so-called "20th highjacker" and the only person in the U.S. charged with direct involvement in the 9/11 attacks—raised questions about whether Moussaoui could be tried fairly in the shroud of secrecy government lawyers had wrapped around the case.

She also held that Moussaoui's defense lawyers were entitled to interview a high-ranking al Qaida official in U.S. custody—an idea that the federal government had opposed at the appeals-court level. (Different elements of Moussaoui's case were being considered simultaneously in different federal courts.)

If the trial court concluded that the Justice Department had to share some of its secrets to try Moussaoui—or if the appeals court agreed that the al Qaida interview could go forward—most observers predicted that the Justice Department would simply dismiss the case and file new charges against Moussaoui before a military tribunal.

George W. Bush had signed an executive order in November 2001 establishing such tribunals. In trials before them, the rights guaranteed to defendants in U.S. criminal trials—rights defined in the Constitution, the Federal Rules of Criminal Procedure and the Federal Rules of Evidence—would not apply.

Was this part of the ineluctable slide toward totalitarianism Higgs was referring to? Perhaps. But a pragmatic libertarian can't give up on the American system because of one executive order.

Tracking terrorists is difficult. The smart ones hide behind American liberty and legal due process. The FBI believes that between 14,000 and 20,000 Islamic militants from around the world received some kind of training in al Qaida camps in Afghanistan through the 1990s. Hundreds of those people (mostly men) live somewhere in the United States. And, perhaps more importantly, many hundreds of sympa-

thizers and supporters (like Sami al-Arian) who never attended the camps live in America.

This is the risk of living in an open society. And even the staunchest libertarian would agree that the state needs effective tools for minimizing that risk. In the post-9/11 era, the U.S. has been sloppy about identifying and enacting those tools.

Sharing information among law enforcement agencies can create some abuses of police and prosecutorial powers. But libertarians need some pragmatism when considering this issue. Of all the various ways that the state could go about combating terrorism, a more streamlined approach to data sharing seems reasonable.

And sometimes it seems essential. In January 2002, the INS announced that it was going to add the names of more than 300,000 illegal aliens who had been ordered deported, but whose location the INS could not verify, to the FBI's National Crime Information Center (NCIC) database.

This move followed several media reports that 9/11 ringleader Mohammed Atta had had encounters with police in various places before the attacks. And it was an admission that policies barring local and state police law enforcement officials from communicating with the INS seemed to have played a role in enabling the attacks.

According to post 9/11 analysis of records, Atta was stopped by a traffic cop in Florida for driving without a valid license and was let go with a ticket—even though his visa was expired. He failed to show up in court for the offense, but no one went out looking for him afterward. Almost unbelievably, Atta later landed a plane illegally at Miami Airport and was allowed to walk away—again with no communication between local officials and federal authorities.

Worse still: For about two weeks before the 9/11 attacks, the U.S. government knew the names of two of the other hijackers. It knew that they were al Qaida killers and that they were in the United States. In fact, the two were living openly under their own names, Khalid al-Mihdhar and Nawaf al-Hazmi. They used those names for financial

transactions, flight school and to earn frequent flier miles. They shared an address for a time with Mohamed Atta.

According to an article that appeared in the Internet magazine *Slate*, a New York-based FBI intelligence agent looking for al-Mihdhar and al-Hazmi in August 2001 didn't have the computer access he needed to do the job alone. He asked for help from the bureau's criminal investigators and was turned down.

FBI headquarters had refused to involve its criminal agents. In an e-mail to the New York agent, headquarters staff said:

> If al-Midhar is located, the interview must be conducted by an intel[ligence] agent. A criminal agent CAN NOT be present at the interview. This case, in its entirety, is based on intel[ligence]. If at such time as information is developed indicating the existence of a substantial federal crime, that information will be passed over the wall according to the proper procedures and turned over for follow-up criminal investigation.

This was damning stuff—a nightmare of bureaucratic paralysis. But the cure might be worse.

The Public Courts

In March 2003, a federal court ruled that a U.S. citizen arrested in America could not be held incommunicado indefinitely. He had the normal rights of a criminal defendant—to see a lawyer, a judge or personal visitors—even if the military labeled him an "enemy combatant." This was a blow to the Bush Administration's more aggressive statists.

The case involved Jose Padilla, a U.S. citizen (and convicted murderer) who was arrested in May 2002, after flying from Pakistan to Chicago, on suspicion of plotting a dirty-bomb attack for al Qaida. Instead of being tried for a crime, Padilla was held—in the U.S.—as

an enemy combatant. An enemy combatant doesn't have to be treated like a prisoner with due process rights. This was a dodgy tactic of dubious legality.

In *Padilla v. Rumsfeld*, Judge Michael B. Mukasey of the U.S. District Court in Manhattan, tried to establish a procedure to allow U.S. citizens and others detained in the U.S. to contest the military's claims that they have enemy combatants.

Mukasey split the difference with the Administration. He upheld the government's central contention: that it can detain any "enemy combatant" indefinitely without criminal charges, and without the protections required for criminal defendants. But he insisted that Padilla should be allowed to see a lawyer or appear in court.

The Bush Administration submitted a sworn statement from the director of the Defense Intelligence Agency, which stated that allowing any contact between Padilla and a lawyer could destroy the "dependency and trust" necessary for effective interrogation.

Mukasey dismissed this forecast as "speculative." He suggested that, if Padilla were given a chance to consult a lawyer, he might realize that "cooperating with his captors" was his best option.

Mukasey concluded that:

> I cannot confirm that Padilla has not been arbitrarily detained without giving him an opportunity to respond to the government's allegations. …there is no practical way for Padilla to vindicate that right other than through a lawyer.

Of course, these decisions all came from public courts. The Patriot Act greatly expanded the government's ability to use several secret courts…and other secret tools for combating terrorism.

The Secret Courts

Federal spy courts are a risk to fundamental liberties. And their role after 9/11 has expanded dramatically.

The Foreign Intelligence Surveillance Act (FISA)—which created the secret warrants and courts—was passed by Congress and signed into law by President Jimmy Carter in 1978. It primarily affected the FBI, giving its agents the ability to use the warrants to bug foreign embassies and to keep tabs on suspected spies within the U.S.

FISA called for the chief justice of the U.S. Supreme Court to appoint seven members to a special court to hear requests for secret warrants. It also called for the chief justice to appoint three members to a FISA Court of Review.

FISA dispensed with the usual legal standards in criminal cases. One example: Under ordinary U.S. wiretap laws, the targets of taps had to be notified eventually that they'd been tapped; targets of FISA investigations did not have to be notified—ever. Almost nothing was reported to Congress about FISA warrants—simply the number asked for and granted.

In 1995, the FISA was amended to allow agents to conduct clandestine searches of homes and property—not just wire taps. But the FISA stated plainly that the spy courts could dispatch agents and their high-tech listening devices only for purposes of counterintelligence, not investigating criminal cases.

The Patriot Act expanded the government's power by erasing that distinction.

Specifically, the FISA specified that "the purpose" of a secret warrant had to be counterintelligence—that is, spy work. Article 2:18 of the Patriot Act amended that to say, "a significant purpose" must be intelligence gathering. That allowed other potential purposes for secret warrants.

The effect of this expanded power remained secret. Statistics about spy court warrants issued after the 9/11 attacks are classified. However, Justice Department officials eventually acknowledged that Attorney General John Ashcroft had signed more than 170 FISA warrants in the year after the attacks; this was three times the number that had been authorized during the preceding 23 years.

In addition to FISA warrants, the Patriot Act allowed federal agents to issue "national security letters"—a sort of administrative subpoena—that required businesses to hand over electronic records about finances, telephone calls, e-mail and other personal information. The national security letter is only subject to judicial review after the fact...and only if a case comes to court as a result of the investigation.

Public response to the growing role of secret spy courts was not uniformly positive. Although some pundits and media outlets defended the FISA courts as a necessary tool for fighting terrorism, more questioned the extent of their stepped up use. And those questioning the broadening use were not alone. Even the FISA court judges had concerns.

In May 2002, the seven FISA judges issued a unanimous decision aimed at preventing criminal prosecutors in the Justice Department from using FISA to orchestrate domestic criminal investigations. The judges were trying to formalize the "wall" that had developed over the years between Justice Department prosecutors and FBI agents collecting information obtained through FISA warrants.

The only problem: the Patriot Act explicitly tore down that wall. And this was one of the sensible things that the Patriot Act accomplished.

To quiet the growing dissent, in November 2002, the U.S. Foreign Intelligence Surveillance Court of Review—the equivalent of a supreme spy court, comprised of three senior appeals court judges—spoke publicly for the first time in its history. It had reviewed the lower court's decision and reversed it.

The higher court sided with John Ashcroft. It affirmed his proposal to allow direct use of evidence gathered under FISA by criminal prosecutors. The opinion interpreted the FISA as imposing no limits on who may use the authority provided that:

- the information sought is broadly defined as "foreign intelligence information";

- the target is deemed an agent of a foreign power; and

- the purpose must include something more than solely a national security-related criminal prosecution such as a terrorism-type crime.

So, criminal prosecutors could use FISA, provided that there was some separate intelligence interest and that the investigation and prosecution did not focus solely on ordinary or street crime. More importantly, the Court of Review actively stated that crimes like credit card fraud or bank robbery could be intertwined with foreign intelligence activity and, thus, qualify for FISA investigation.

The Court of Review also considered the constitutionality of FISA warrants—given the concerns voiced by the lower spy courts about conflicts with established 4th Amendment law. It hedged on the clearest 4th Amendment questions—but stated that the government is presented with "special needs" and that the president has authority to conduct warrantless searches to obtain foreign intelligence information. Most of the legal conclusions were based on Article III of the U.S Constitution—which describes the president's war-making powers.

Following the Money

Terrorists need two things to operate effectively: a safe haven and a ready supply of money. If you take away their money, everything else—including the safe havens—falls apart.

But the money trail can be tough to locate. The FBI reported that the 9/11 hijackers organized and executed their scheme for less than $300,000, which was moved through some 26 different bank accounts in $2,000 or $3,000 pieces.

Khalid Shaikh Mohammed was Osama bin Laden's money man and the mastermind of his most destructive operations. Mohammed set up and used checking accounts, debit cards, credit cards from financial institutions in Dubai, the United Arab Emirates and the United States.

Mohammed's money movers would have dozens of access devices or credit card numbers, and computer lists with hundreds of stolen or fraudulently-acquired credit card numbers.

Terrorists fundraisers have existed in the United States for decades. They include members of most well-known militant Islamic organizations—al Qaida, Hamas, Hizballah, Palestine Islamic Jihad and others. Sami Al-Arian was one example of this subculture of thieves and confidence artists.

How do they operate within their enemy? They operate under humanitarian cover, or religious cover, or human rights cover. They lie about their activities; they use innocent-sounding names.

For example, the al Qaida organization operated from its very inception under an organization called the Benevolence International Foundation (BIF). It was deliberately set up in the United States to provide a conduit for al Qaida money.

From 1993 to 1999, BIF collected over $12 million by way of personal checks, wire transfers and stock donations. Monies were then transferred overseas by wire to al Qaida-controlled accounts and ultimately withdrawn in cash to support al Qaida operations.

Hizballah operated a cigarette smuggling scheme in Charlotte, North Carolina. Hamas operated through an organization that received nonprofit status called the Holy Land Foundation for Relief and Development.

What are the denominators common to all these schemes?

1) al Qaida, Hamas, Palestine Islamic Jihad deliberately set up in the U.S. to exploit domestic cultural freedoms, religious tolerance and lax financial controls.

2) The disparate and compartmented number of agencies collecting information made it very easy for terrorist groups to find the crevices in the cracks to evade any detection.

The people who get involved with these financing schemes—whether they're laundering dirty money or taking money from legal

sources and moving it to support terrorist activities—often come from a merchant background. They are very creative and very entrepreneurial, and they know how to game the U.S. banking system.

So, state agencies fighting terrorism need to do more—or different—than just chasing after the details of financial scams. They need to compare data across a breadth of fields. Bank accounts should match up against immigrant status...which should match up against local and federal criminal records.

In an increasingly deregulated industry, insurance companies have started considering factors as far afield as credit ratings and buying habits when deciding whether or not to sell you auto insurance. Libertarians accept this as a marketplace reality. Law enforcement agencies should be able to do the same.

One elegant, non-traditional plan for aggregating intelligence was dashed in a crude stroke of political grandstanding. In 2001 and 2002, a group of foreign policy experts at the Defense Department created a test version of what they called a "futures market" in which people could wager on government stability and the chances of terrorist actions in various parts of the world.

The Policy Analysis Market (PAM) would work like a traditional futures markets, such as those for corn or interest rates. Participants could buy contracts based on various propositions about events at specific future dates. Those contracts would rise or fall in value as the date approached and the likelihood of the event became greater or lesser. Players could make money by guessing right—and buying or selling futures in a timely manner.

Even when traders are not necessarily experts, their collective judgment is often remarkably accurate because markets are efficient at uncovering and aggregating diverse pieces of information. And it doesn't seem to matter what the markets are being used to predict: irrational actors (box-office results), animal behavior (horse races) or a random interaction between weather and soil (orange crops).

So, it was reasonable to think a prediction market might add something to America's understanding of the future of the Middle East.

But in early 2002—just as PAM was moving into its final testing phase—word started spreading about a government-run dead pool. Ridiculous political grandstanding followed.

U.S. Senators Ron Wyden and Byron Dorgan led the jihad against PAM. At a crowded press conference, they called the plan "harebrained," "offensive" and "useless." The media followed their lead, ginning up outrage about such a heartless activity.

Sadly, the attacks on PAM had little to do with how effective it would or would not have been. Wyden and Dorgan stressed that their objection was based on the fact that making a market in chaos and terrorism was "offensive" and "morally wrong" to their delicate sensibilities.

Their objections were strikingly naïve. There may be something morally unappealing about wagering on tragedy, but markets do that all the time. The entire insurance industry is built in wagering on individual tragedy. And this is something that markets should do—harness amoral profit-motive to improve the collective good.

Conclusion

What can be done—without turning the U.S. into one big bunker—to help with the fight against terrorism?

One common suggestion has been that the CIA should be made...well, less central. The idea is that the Agency should be split into two parts: One to gather and analyze intelligence from around the world and one to do the same, domestically. The domestic spy agency would be modeled roughly after Great Britain's MI5.

MI5 describes itself as Britain's defensive security intelligence agency. It cannot detain or arrest its targets but seeks to "to gain the advantage over (them) by covertly obtaining information about them, which we can use to counter their activities."

DHS chief Tom Ridge visited MI5 headquarters during a trip to Britain in 2001. He later said he doubted the Bush Administration would create a similar domestic intelligence agency, because MI5's powers would be unacceptable under the U.S. Constitution.

But most libertarians—even pragmatic ones—are too skeptical of statist bureaucracies to support new ones. Besides, there seems to be plenty of budget and human resources already at the DHS and the FBI; perhaps one of them should reinvent itself as the American MI5.

The Bush Administration strengthened intelligence gathering and sharing after the 9/11 attacks. It created a Terrorist Threat Integration Center to bring together information gathered by the CIA, FBI and other agencies. The center reports to the CIA director but is not part of the agency.

In late 2003, with fears of new al Qaida attacks rising, the Justice Department announced new FBI guidelines that would allow intelligence and law enforcement agents to work together on terrorism investigations.

The ACLU was quick to condemn the guidelines as creating the possibility of "an end run around 4th Amendment requirements."

Statist politicians and groups like the ACLU are blind to the simple benefits that reasonable Americans want for the social contract. Not being killed by terrorists is one of these benefits.

Staunch libertarians have a point when they object to growing government databases, interconnected, that might be the final Orwellian stage in the development of a statist monster. To a pragmatic libertarian, the best solution seems to be some sort of reassignment or restructuring of resources that will make past disputes between different agencies a quaint memory.

A social contract means that every citizen surrenders some natural liberties in exchange for membership in a society that will provide basic goods. Catching terrorists is a basic good.

13 Immigrants and Immigration

The American public seems to believe that immigration influences terrorism. Libertarian philosophy favors free immigration. Can the two points be reconciled?

The 9/11 attacks resulted in some harsh actions toward foreign nationals living in the United States. While these actions were understandable on the simplest tactical level, they conflicted with America's tradition of valuing liberty.

The Patriot Act granted considerable discretion to the attorney general with regard to handling immigrants; his office could detain them for any—or no—reason, even if they were in the U.S. legally and couldn't be deported.

Section 411 of the Patriot Act makes a legal immigrant's "unknowing association" with terrorists a deportable offense.

Section 412 allows the attorney general to order a brief (up to seven-day) detention of aliens without any prior showing or court ruling that the person is dangerous. All that the attorney general has to do is certify that he has "reasonable grounds to believe" that a noncitizen endangers national security. No judicial review is provided except for habeas corpus.

And Section 412 went even further. It allowed the attorney general to continue to hold the noncitizen indefinitely without trial, if there was no country willing to accept him upon deportation.

Soon after the Patriot Act was signed into law, Justice Department agents working with local police detained some 1,200 legal immigrants (although the Justice Department claimed it didn't have to use its Patriot Act powers to do so). Most of the detainees were Muslims and people from predominantly Muslim countries. Some were held for months in federal prisons before being allowed to see lawyers or being brought before immigration judges.

The Department of Justice also reactivated little-used registration requirements for men from 25 countries, all but one of them Arab or Muslim. Some 32,000 men registered; about one in 12 of these was eventually held for deportation.

Some critics of the Bush Administration protested that these detentions (which they often, and wrongly, called "illegal") were a threat to American law. But the protests didn't have much traction with public opinion, which still had the 9/11 attacks fresh in its memory.

Also working in the government's favor: The fact that the number of immigrants detained or held for deportation hearings wasn't huge. Fewer than 5,000 were detained—this from a total population of 18 million legal resident aliens, an estimated 10 million illegal immigrants and another 8 or 9 million foreign-born citizens.

The problem with the immigrant detentions wasn't their numbers; it was the chilling effect that they had on the hard-working immigrants in the U.S. America has always been good to immigrants. Anything that changes that image is a victory for al Qaida.

Immigration is another issue that brings to light several conflicting elements of civil liberty.

On the most abstract level, a commitment to liberty might seem to mean a commitment to open borders…and free immigration. The founders who built the United States didn't conceive of a time in which free immigration would be questioned. Then again, they didn't

conceive of a government that would offer costly benefits and services to residents.

The statist perspective is to boost the government benefits available to citizens and non-citizen residents of the U.S.—but to limit entrance to the country. This strategy seems…well, unsporting. It's an elitist argument, pulling up America's ladder of social and economic advancement.

A more consistent argument would be to minimize the state benefits available and liberalize the terms of immigration. No country should turn away people who are willing to work hard. It's one of the perversions of statism that self-described liberals can be so illiberal about poor, hungry people coming to a place to improve their lives.

Liberty isn't a zero-sum commodity. Sure, it needs to be protected—and even rationed—in some situations; but the volume and quality of the liberty that people enjoy grow as the number of free people grows. Add to that the fact that it's difficult to export liberty and you get the result that, even in troubled times, immigrants are still attracted to America.

There's real value in that attraction; and no libertarian wants to screw up that value.

History of U.S. Immigration

In the 19th Century, the United States experienced the biggest wave of immigration of any place or period in the history of the world. It also saw the greatest growth in production and the standard of living in the history of the world. Most historians and economists agree that this was no coincidence.

The massive influx of people didn't eliminate jobs. In addition to being workers, these immigrants were also consumers. They boosted demand for manufactured goods. Since most of these new workers saved their money, they helped generate investment capital—which financed more production and a larger job market.

The country's immigration policy at the time was one of open borders. Anyone who wanted to move to America could. The concerns that the government had about immigrants were health-related: Those who had symptoms of contagious diseases were either sent back to their countries of origin or quarantined until the illness passed.

Very little was promised to these immigrants. Their lives were often hard, especially in their first years in the States. The federal government didn't provide health care or pension benefits. Immigrants counted on support from communities of fellow immigrants to help them get established and integrated to the American system.

U.S. immigration policy started moving away from open borders in the 1920s, when the anarchist and communist "Red Scare" led to overreactions like the Palmer Raids. Before that, anti-immigrant bigotry had been a private matter; the Red Scare infected state policy.

In an arc of 25 years—through the Depression, the 1930s and World War II—a controlled immigration policy took hold in the U.S. The agencies charged with enforcing this policy were spread among various departments, including State, Treasury and Justice.

In the 1950s, the various agencies were brought together in one—the Immigration and Naturalization Service (INS). But the restructuring didn't do much for efficiency or effectiveness. The INS was, from its earliest days, one of the worst-run bureaucracies in the federal government.

Two examples:

- The Border Patrol—the INS's front-line division—is the only federal law enforcement agency that does not require its agents to have a college degree. There's a democratic aspect to this policy; the Border Patrol sometimes gets quality people not considered by other agencies. But it also means that the hiring process has to weed out many poor applicants; and Border Patrol faces more unwarranted complaints of bias and discrimination than other federal law enforcement agencies.

- More egregiously, the INS's terribly out-of-date and fragmented IT system is the result of a conscious decision in the 1970s not to automate immigrant data files—in order to preserve low-level clerical jobs.

That second item may be the worst case of bureaucracy run amok in the annals of statist excess.

In the wake of the 9/11 attacks, the INS's problems got even worse. Media outlets hammered the agency for approving the ridiculously incomplete visa applications of several of the suicide terrorists (two of them had listed "Marriott Hotel, New York" as their destination). And things got even worse when word broke that the INS had sent a student visa to one of the terrorists a week after the attacks.

In a 1999 interview, INS Commissioner Doris Meissner said, "You don't overcome a history like that in four to five years." And she was right. Four or five years later, the agency was still a mess.

The hard reality is that the INS simply doesn't function as it should.

The General Accounting Office reported in May 2001 that the receipt of new applications (for green cards, citizenship, temporary workers, etc.) increased 50 percent over six years and the backlog of unresolved applications quadrupled to nearly four million. The number of citizenship applications filed in the 1990s was about 6.9 million, triple the level of the 1980s; temporary admissions nearly doubled in the 1990s to more than 30 million; and the number of (very labor-intensive) applications for asylum in the 1990s was nearly one million, more than double the level of the 1980s.

Congress tried giving the INS more money. The agency's 2002 budget was up 15 percent from the prior year—and the 2003 budget went up another 12 percent.

The post-9/11 era should have been a boon for the INS, but it wasn't. In the first 10 months of the 2002 fiscal year (which included that last part of 2001), about 2,000 of 15,000 Border Patrol agents and immigration inspectors transferred to other federal agencies. The Border Patrol hired 1,499 new agents during that time, but lost 1,459

veterans, for a gain of 40 positions—and a significant loss of experience.

Many of the departing Border Patrol agents were opting for higher salaries in the federal sky-marshal program.

When the Department of Homeland Security was established in 2002, one of its significant steps was to take over control of the INS—and DHS Secretary Tom Ridge ordered the INS restructured completely.

How Many Immigrants Are Really Dangerous?

INS incompetence clouds any conclusions about how many immigrants to the U.S. actually pose some terrorist danger. The consensus among legal experts—which is borne out by common sense—is that the numbers are very few. More importantly, the troublemakers may be identifiable by erratic behavior related to their immigration paperwork.

A report published by the Center for Immigration Studies drew some conclusions about terrorists:

> ...we found that 22 of 48 foreign-born al Qaida-linked terrorists who were involved in terrorism in the United States between 1993 and 2001 had committed significant violations of immigration laws prior to taking part in terrorism. Thus, strictly enforcing immigration laws must be a key component of our anti-terrorism efforts.

Three of the 9/11 terrorists had overstayed their one-year visas. Ringleader Mohamed Atta was allowed to re-enter the U.S., at Miami International Airport, despite overstaying his previous visa. Immigration inspectors say conducting random checks at international gates would help stop future Attas. They could nab departing foreign visitors who'd overstayed their visas, document them and ban them from future entry.

Most immigrant aliens who violate immigration laws are not terrorists. However, letting a large illegal population reside in the United States abets terrorism for two reasons.

First, it creates a large underground industry that furnishes illegals with fraudulent identities and documents that terrorists can (and have) tapped into. Several of the 9/11 terrorists were assisted in getting their Virginia driver's licenses from someone who specialized in helping run-of-the-mill illegal aliens get theirs.

Second, the existence of a huge illegal population creates a general contempt or disregard for immigration law. Although the general public may still want the law enforced, the scale of illegal immigration creates a tacit acceptance by law enforcement, policymakers and even immigration agents. With millions of illegal immigrants already in the country, it's perhaps easy to understand why the immigration inspector at Miami's airport allowed Mohammed Atta back into the country in January 2001—even though he had overstayed his visa on his last visit and had abandoned his application to change status to vocational student by leaving the country.

This is a point of major importance for libertarians: Having laws on the books that no one enforces is a bad idea. It encourages contempt for those laws in specific, and all laws in general.

Don't pass laws to send a message. Don't pass laws that you don't intend to enforce.

Tracking "Students"

One of the largest single categories of long-term temporary visitors to the United States is foreign students. In 2001, there were more than a million foreign students and exchange visitors admitted (including their spouses and young children).

A number of terrorists have entered the U.S., on student visas, including Eyad Ismoil, a conspirator in the 1993 World Trade Center bombing, and 9/11 hijacker Hani Hanjour. Ismoil dropped out of

school after three semesters and remained in the United States illegally; Hanjour never even attended class.

A 1996 immigration reform law mandated that the INS develop a computerized tracking system for foreign students to replace its paper-based system. Unfortunately, that system didn't move beyond the pilot stage because of scorched-earth opposition from universities and colleges. Schools continue to oppose the more recent Student Exchange and Visitor Information System (SEVIS), fearing the extra administrative burden—but also because they don't like the idea of treating foreign students differently from their American counterparts.

DHS and INS officials insisted that SEVIS would enhance security by combating fraud and ensuring that international students comply with the terms of the visas through which they entered the United States. But the system faced technical challenges from its inception.

The $36 million Internet-based student registration system enables U.S. academic institutions to maintain accurate and timely data on foreign students, exchange visitors and their dependents, and communicate this information to the departments of Homeland Security and State in real time.

As of February 15, 2003, all higher education institutions in the United States accepting foreign students were required to use SEVIS to issue new SEVIS I-20 forms. By August 1, 2003, information on all international exchange students had to be entered in the system.

Yet educators say that SEVIS had been plagued with technical problems. At an April 2003 forum in Washington, one university official described numerous technical and data integrity problems associated with the SEVIS system. International student advisors are often "timed out" of SEVIS when entering data and then required to reenter information. She also described incidents of SEVIS forms processed at one school being printed at another.

At the same forum, Maura Harty, an Assistant Secretary of State for Consular Affairs, gave the government's official line of the SEVIS system. She said:

> I know that you are concerned with the impact that
> the implementation of the Department of Homeland
> Security's SEVIS has had on our ability to issue visas
> to students, exchange visitors and their dependents
> in a timely manner.
>
> ...And while we, too, know that some SEVIS records
> are still not being made available to our embassies
> and consulates, due to technical glitches, I can tell
> you that state and DHS data technicians cooperate
> daily to locate, correct, if necessary, and forward these
> SEVIS files to our consular consolidated database.

Harty couldn't resist placing some blame with the bumbling INS.
She pointed out that most federal agencies were aware of—and frustrated by:

> ...intense bureaucratic warfare within the INS over
> the failure to fund and implement this student-track-
> ing program....

A libertarian...like many Americans...hears this bureaucratic back-
biting and wants to do away with the entire federal system of manag-
ing immigration. When borders were free, there was no need to think
twice about alphabet-soup-named computer systems for holding im-
migrant data.

Citizenship

A Center for Immigration Studies report found that Middle East-
erners are one of the fastest-growing immigrant groups in the United
States, growing sevenfold in 30 years—from fewer than 200,000 in
1970 to nearly 1.5 million in 2000.

More importantly, the religious composition of those immigrants
changed dramatically over the same period. In 1970, 15 percent of
immigrants from the region had been Muslim—29,000 people; the
rest were mostly Christian ethnic minorities fleeing predominately

Muslim countries. By 2000, an estimated 73 percent of all Middle Eastern immigrants (1.1 million people) were Muslim.

The recruitment of naturalized citizens is an al Qaida strategy. A November 2001 report in the *San Francisco Chronicle* quoted an Arabic-language newspaper account of a confession by Khalid Abu al Dahab—described as a "communications hub," shuttling money and fake passports to terrorists around the world from his California apartment. Dahab, a naturalized American citizen, said "bin Laden was eager to recruit American citizens of Middle Eastern descent."

When Dahab and fellow terrorist and naturalized citizen Ali Mohammed traveled to Afghanistan in the mid-1990s to report on their efforts to recruit American citizens, "bin Laden praised their efforts and emphasized the necessity of recruiting as many Muslims with American citizenship as possible into the organization."

The Mechanics of Immigration

There are three parts to any immigration enforcement system: First, the visa process overseas; second, inspections and patrols at the border; and, finally, enforcement of immigration laws in the interior of the country.

Since the 9/11 attacks, the first two parts of U.S. immigration filter have seen improvements. Increased rigor in the consideration of visa applications at our consulates abroad, and progress toward implementing an effective entry/exit tracking system at the border have marked real steps forward. Much remains to be done; but the problems are being tackled.

The third filter is in much worse shape.

The INS continues to ignore the birthplace of visitors entering the U.S. with second-country passports. So when an Iraqi or Yemeni arrives to enter the U.S. with a Canadian passport, the INS doesn't consider place of birth, and inspects him as if he had been born in, say, Vancouver.

That means he avoids being fingerprinted and photographed on his first U.S. entry, like all other Canadians. He also avoids U.S. consulate pre-screening, because Canadians can enter the U.S. without a visa. And of course, he avoids filling out any entry-exit forms, and can stay in the U.S. for virtually as long as he wants.

And if he boards the U.S. from Mexico or the Caribbean, he can even avoid using a Canadian passport. The INS requires as little as a Canadian ID and a Canadian wallet-sized birth certificate.

Immigration Under DHS

The DHS planned to dismantle the dysfunctional INS and organize it in several parts. The details of that plan are worth a quick look.

Most immigration enforcement functions would be in the DHS's Bureau of Border Security (BBS) within the Border and Transportation Security (BTS) directorate. The BBS would house the following immigration functions:

- border patrol;

- detention and removal;

- inspections;

- intelligence; and

- investigations.

The BBS would also administer the Student and Exchange Visitor Information System (SEVIS), a computerized system to track immigrant students and exchange students.

The BTS directorate would also assume the primary role in visa issuance, a function long administered by the State Department; it would issue, administer and enforce regulations on the grant or denial of visas and the functions of consular officers overseas. Consular officers would still remain State Department employees, but would be subject to the rules established by the BTS directorate.

Separately, the Bureau of Citizenship and Immigration Services (BCIS) would perform the immigration service functions currently performed by the INS. These consist primarily of adjudication functions, like adjudicating visa petitions, naturalization petitions and asylum and refugee applications.

Free Borders Are Critical

The argument for free borders suffered a blow when Muhammad Atta skipped through security en route to flying a jet into the World Trade Center.

Immigration is a risk, especially when the world is full of radicals who hate America. But there's a big difference between a Haitian or Guatemalan trying to get to the States to find work and send money home and a self-loathing Arab playboy connecting through JFK on a shaky student visa.

A pragmatic libertarian will grudgingly admit that immigration management is one of the few tasks best handled by a small-as-possible state. But, having granted this fact, the pragmatic libertarian will insist that immigration policy should be as simple—and as open—as possible. If the state must be trusted with the task, make the task as limited as it can be.

As America's experience in the late 19th and early 20th Centuries proved, a free borders policy creates wealth for an immigrant country. Some experts argue that 19th Century America was a unique circumstance in history; but those experts are just historical chauvinists. Free immigration combined with free financial markets has been a recipe for economic success since the Babylonians were first grooming their beards.

Statistics from modern day Hong Kong confirm the universal importance of free borders. From 1970 to 2000—a 30-year period that included a change in the island's political oversight from Britain to China—Hong Kong maintained an open immigration policy.

Wages in Hong Kong rose rapidly throughout the period; a 1993 report showed the per-capita annual income in Hong Kong to have risen above $18,000. That was a faster increase in a generation than any other country in Asia…and most of Western Europe. Despite the large number of immigrants that enter Hong Kong every year, there are chronic labor shortages. Entry-level office positions go unfilled because most people can find higher-paying jobs.

The material wealth of the immigrant upon arrival is not an important factor. Many poor immigrants become wealthy due to their pursuit of opportunities offered by a freer market economy. And *all* immigrants spend. Anyone who's spent a Saturday afternoon at a Best Buy in Los Angeles, Houston or Miami can attest to the fact that immigrants spend their earnings on consumer products.

Still, many statists argue that immigrants abuse America's welfare system. And this argument seems to resonate with Americans.

However, as Bill Clinton and Richard Nixon's election successes indicated, false things can ring true to voters. This argument is particularly false, though, because 1996 welfare reforms (championed by Clinton, no less) restricted immigrants from using welfare.

The most important economic factor to keep in mind about immigrants is that they're usually young and healthy when they arrive. Aside from times of war and massive dislocation, people who are sick, old or destitute—the main consumers of welfare services—tend to stay where they are.

Charges of welfare abuse by immigrants have long been a staple rhetorical trick used to stir political passions for kicking immigrants out of a country. That might work well in France, but it's not a traditionally American perspective.

Even if immigration did wrestle jobs away from native citizens, that's still no reason for closed borders. There is no right to a job or a wage rate. But there is a right to move from one country to another in search of a better life. That's part of the great natural rights tradition in America.

Political Opinions on Immigration

It's a great irony of politics that popular opinion and elite opinion split dramatically on hot-button topics like gun control, the death penalty and abortion. (Maybe the reason these topics are hot buttons is that the popular and elite opinions differ.)

Immigration shares some traits with the hot-button issues. Popular opinion seems to favor closed borders—under the false impression that they will save domestic jobs. Elite opinion tends to favor freer immigration policy.

Libertarians usually end up on the side of popular opinion when it splits with elite opinion. This isn't by cynical design—it's because popular opinion in America tends to be pretty libertarian. Immigration is an exception that proves this rule: It's one hot-button topic on which libertarians side with the elites against popular opinion.

Not being accustomed to this position, libertarians have bungled efforts to explain their opinions on immigration policy.

Perhaps the worst example of this bungling was when, shortly after the 9/11 attacks, the usually-savvy Stephen Moore, a senior fellow at the Cato Institute and president of the group Club for Growth, advised advocates of open borders to "lay low and don't talk about it a lot." Closed-borders statists made much political hay out of this quote—painting open-borders advocates as conspiratorial and vaguely unpatriotic.

In December 2002, the Chicago Council on Foreign Relations (CFR) published the results of an extensive poll it had conducted a few months earlier on immigration opinions.

The CFR poll was based on 2,800 telephone interviews from across the country. Then, the CFR interviewed nearly 400 "opinion leaders"—members of Congress, the Bush Administration, leaders of church groups, business executives, union leaders, journalists, academics and leaders of major interest groups.

Comparing the two sets of interviews, the CFR study concluded:

- About 60 percent of the public regarded immigration to be a "critical threat to the vital interests of the United States," compared to only 14 percent of the nation's leadership.

- There was no other foreign policy issue on which Americans and their leaders disagreed more than immigration. Even on such divisive issues as globalization or strengthening the United Nations, the public and the elite were closer together.

- Asked to rank the country's biggest foreign policy problems, the public ranked illegal immigration sixth, while elites ranked it 26th.

- George W. Bush's efforts to grant amnesty to illegal immigrants—a position he'd held from before he was president—appeared to hurt him politically. Nearly 70 percent of the public rated Bush as poor or fair on immigration—the lowest rating he received on any foreign policy issue.

Conclusion

Clearly, the 9/11 attacks—executed by foreign-born terrorists—increased the share of the public concerned about immigration. Even more clearly, libertarians and other open-borders advocates have done a poor job of expressing their positions to most of America.

Immigration may always be the toughest sell a libertarian has to make to middle America. For years, popular opinion has been drifting toward *laissez-faire* on issues like the War on Drugs and victimless crimes (prostitution and gambling). But open borders remain a menacing proposition to a clerk at Wal-Mart who's making $8 an hour.

Libertarians have to convince the Wal-Mart clerks that a vibrant immigrant population means more customers and bigger sales for her store. She needs to see immigrants as a sign that economy, in general, is on the rise and that a rising tide lifts everyone.

And, finally, she needs to see that America's commitment to natural liberty has always meant open arms for people seeking a better life. It's inscribed in bronze on the base of the Statue of Liberty:

"Keep, ancien lands, your storied pomp!" cries she
With silent lips. "Give me your tired, your poor,
your huddled masses yearning to breathe free."

This isn't just patriotic sentimentality. It's the immigration policy for a free state.

14 Foreign Policy

After the 9/11 attacks, Americans want decisive foreign policy. Libertarians talk mostly about domestic issues. Do they have any foreign policy beliefs?

Although George Washington is not usually considered one of the great libertarians from America's founding, his *Farewell Address* from September 1796 describes a pretty good philosophy that libertarians can bring to foreign policy and international diplomacy. Specifically, Washington said:

> ...nothing is more essential than that permanent inveterate antipathies against particular nations and passionate attachments for others should be excluded; and that in place of them just and amicable feelings towards all should be cultivated. The nation, which indulges towards another a habitual hatred or a habitual fondness, is in some degree a slave. It is a slave to its animosity or to its affection....
>
> Antipathy in one nation against another disposes each more readily to offer insult and injury...and to be haughty and intractable when accidental or trifling occasions of dispute occur. Hence frequent collisions,

> obstinate envenomed and bloody contests. ...The peace often, sometimes perhaps the liberty, of nations has been the victim.
>
> ...The great rule of conduct for us in regard to foreign nations is in extending our commercial relations to have with them as little political connection as possible.

In those few paragraphs, Washington anticipated many of the problems that America faces as a free nation struggling to fit in a largely unfree world. His words anticipated everything from dealing with China to the analyzing the motives of al Qaida terrorists.

For diplomats, the biggest problem with foreign policy in a free democracy is that it is inconsistent. In America, one president's administration will articulate different goals than the last president's...and the next president may choose others yet. Outside of the White House, various American citizens—and even various local governments—may disagree with the federal government...and act accordingly.

Career diplomats see all this change and unpredictability as bad things. Libertarians may not; a certain amount of institutional chaos is one of the prices of liberty.

Avoiding Entanglements

Many libertarians define their politics in opposition to what they call the "welfare-warfare state." But even the most committed libertarian will acknowledge that a rising threat of terrorism in the world makes special demands of the state.

Most rational libertarians admit that the social contract requires a limited form of government to regulate the interactions among citizens. They just want that government to remain as limited as possible. But should that limited government get involved in interactions with other governments? Forget international organizations and multinational military forces—which true libertarians find revolting—

should a limited government *have* a department dedicated to conducting foreign policy (what Americans call a State Department)?

Diplomacy is a standard responsibility of states. It's also been the mechanism by which statist ambitions—both international and domestic—are most often realized. Critics of international political and military actions are often ridiculed as know-nothings and (in the U.S.) "America First" bigots. But there are legitimate questions to be asked about any state's involvement in the affairs of another state.

As difficult and expensive as it is, sending in military troops is often the simplest part of an international engagement. The collection of tariffs, regulations, price controls and rationing that follow on the home front often have a longer-lasting effect.

The state's most powerful purpose is to protect the rights of citizens. Protecting these rights may occasionally mean using military forces to neutralize (and, perhaps, destroy) an external threat. But statist ambitions are often grander than that; they move into what statists call activism or interventionism…and libertarians call meddling.

The libertarian criticism of meddling is simple: If central planners lack the knowledge needed to allocate resources effectively for a national economy, can they rationally plan and execute foreign incursions in the international arena?

In the U.S., it has been a concern since the country's founding that the state not engage in what George Washington called "entangling alliances" that could ultimately undermine citizens' liberty.

In the Autumn 1997 issue of the political science journal *Formulations*, libertarian theorist Roderick T. Long described how a free nation might use international diplomacy to protect citizen liberties:

> It might be in the interest of a free nation to forswear
> the use of certain kinds of armament in exchange for
> verifiable assurances of the same by other countries.
> But the free nation would have no authority to hold
> its private citizenry to the same terms, so its treaties
> might not be taken very seriously. In any case, any

treaty negotiated by a free nation should be subject to
ratification by popular referendum.

These are not the sort of conditions that the statists drawn to
foreign service—and most people who work in foreign service do tend
to be statists—like to acknowledge.

Free Trade As the Foundation

Washington said it plainly in his *Farewell Address*. American for-
eign policy should focus on commerce as much as possible...and poli-
tics as little as possible. The America of the late 20th and early 21st
Centuries has strayed a long way from the simplicity of that senti-
ment. And the post-9/11 America, tempted to rid the world of im-
moral travesties committed in the name of fundamentalist Islam, would
do well to come home to Washington's words.

Free trade is firmly rooted in the American tradition of free enter-
prise and limited government. The Founding Fathers understood the
danger of trade restrictions. Benjamin Franklin famously remarked
that "no nation is ever ruined by free trade."

Invariably, opponents of free trade take the statist line. Since no
government can regulate every form of international trade, these stat-
ists end up arguing that the government should pick and choose win-
ners and losers among various types of businesses and various regions
of the world. Such choices are a fool's errand—and something con-
trary to the American ideal of individual liberty and free enterprise.

Tariffs, quotas and other tools of "managed trade" are all, effec-
tively, taxes. They artificially raise the cost of foreign goods and in-
crease the price that consumers must pay.

Better than any "managed trade" agreements negotiated by the
government—such as the North American Free Trade Agreement
(NAFTA) and the General Agreement on Tariffs and Trade (GATT)—
would be unilateral action by the United States to reduce or eliminate
tariffs, quotas and other non-tariff barriers against foreign goods.

Opponents of free trade usually argue that foreign competition harms American workers by moving jobs overseas. This movement was Ross Perot's famous "giant sucking sound" from the 1992 U.S. Presidential campaign.

Most evidence contradicts this concern. One oft-quoted 1989 study by the International Trade Commission showed that trade protection in the glassware industry preserved 2,500 U.S. jobs; but that protection cost U.S. consumers $185.8 million per year in the form of higher prices and reduced choice. That meant that every job saved cost U.S. consumers $74,320 per year. Similar calculations showed that the 400 ceramic tile jobs saved through protectionism each cost consumers $225,000 per year per job.

Why the bad bargains? Because states lack the clarity of purpose required to choose well in financial matters. Their collective natures warp their financial judgment. Again, tariffs and protectionism put states in the position of picking commercial winners...and they're very bad at that picking.

Democracy As a Foreign Policy Goal

Some people argue that an American foreign policy should do more than protect Americans' commercial interests abroad.

In fact, through the 1990s, Bill Clinton had a firm foreign policy goal of what he called "democratization"—encouraging other nations to become democratic and supporting newly democratic states. Clinton saw democracy as a path to peace and greater international cooperation; he often repeated the line:

> Democratic countries do not go to war with one another. They don't sponsor terrorism or threaten one another with weapons of mass destruction.

The problem with Clinton's democratization—and just about any other agenda for "doing more"—is that it tended to collapse into a muddle of multilateral diplomatic rhetoric.

During Clinton's time in office, the United Nations—a bastion of muddled multilateral rhetoric—embraced and expanded upon democratization. The U.N. set up an Electoral Assistance Unit that sent observers to all over the globe to make sure elections went smoothly and fairly. Throughout the 1990s, from Africa to the Americas, the observers observed; but, in many of these cases, the fair elections still managed to cause problems by voting in destabilizing leaders.

A difficult concept for most people to accept is that democracy is neither inherently good nor inherently bad.

Democratization and multi-lateralism contributed to the Clinton Administration's low point (fellatio aside): Turning a blind eye to the Balkans while Serbs tried to wipe out the neighboring Bosnians. The statist twits advising Bill Clinton on foreign policy reckoned that Slobodan Milosevic—a Hitler minus the impressive oratory—was fairly elected and could be further democratized.

U.S. policy toward the Balkans during the 1990s was one of those rare ironies when statist interference led to inaction…and flinty reserve might have led to some limited and much-needed action.

Does Liberty End at the Water's Edge?

Americans have long debated whether liberty can be—or should be—exported. Said simply, pure libertarians argue that America has no business exporting ideology; other countries' governments and political philosophies are their own affairs. Interventionist policies like Clinton's democratization invite only unintended consequences.

More pragmatic libertarians still dislike the presumptuousness of intervention. But they allow diplomacy—or military action—that protects the property rights and liberties of American citizens. The challenge is to keep the focus limited. Foreign policy has a way of expanding into the broadest strokes possible.

The guiding impulse of classical foreign policy is balancing power—creating an equilibrium of political interest and military re-

sources that discourages potential aggressors. The statists who call themselves "realists" (Henry Kissinger is the classic example of these) spend their careers at Ivy league colleges and Washington D.C.'s trendy neighborhoods studying the small nuances of balancing power.

And they still screw it up. As with enforcing tariffs, balancing power is something that states are inherently not good at doing. In the interest of balancing power in the Middle East, the United States supported Saddam Hussein's Iraq in its war against Iran during the 1980s; 10 years later, the U.S. was waging the first of its two wars against Saddam. The decision-makers in Washington, D.C., said ruefully that only hindsight is 20/20....

Like so many statists, foreign policy realists are cynical about liberty and democracy. They don't trust free states to band together during crises—even if they bicker at other times. And they're often repaid with distrust from their natural allies.

A libertarian would prefer to see the commercial markets lead their country's foreign policy. In statist terms, this means a focus on private-sector foreign direct investments. These are business dealings that give investors some control over their assets.

Ford Motor Company building a factory in Mexico to assemble automobiles for export is foreign direct investment. It's up to the executives at Ford to make the many decisions about Mexico's political stability, crime rates, currency value...and hundreds of other factors...before they invest their money in the first brick. If they screw it up, there will be accountability on the bottom line and in shareholder meetings.

And Ford isn't the only commercial entity looking for smart or cheap places to put their resources. The real power of the marketplace comes from hundreds and thousands of companies making decisions about plants in Mexico or anywhere else. This is what George Washington was talking about 220 years ago in his *Farewell Address*.

Direct investments are better than state aid in many ways. They transfer technological know-how to host countries; they provide jobs;

they train indigenous people in business. And, most importantly, they prove that value can be built independent of government. A state's foreign policy should be to encourage and protect these results.

To political activists who complain that the 2003 war in Iraq was all about oil money, the libertarian response is…of course it's about oil money. That's the *best* reason that exists for attacking someone.

One problem with counting on direct investment to lead foreign policy is that it tends to favor countries that are already wealthy and democratic. In 1987, the total worldwide flow of foreign direct investment was $188 billion—but only $25 billion went to developing countries. Investors will put their money where the most profit is possible with the least risk; investors fear uncertainty—especially when a coup, a rebellion or even the election of a radical group could mean the total loss of the direct investment.

Profit is more assured in developed and stable democracies, but costs are higher there and the steadier profit will usually be smaller. Developing countries are riskier—but cheaper and (usually) faster growing. In any event, these distinctions are made best by people or companies staking their own resources on the outcome.

At this point, the issue of multilateral "regional free trade" agreements logically comes up. People and companies doing business internationally are usually for these agreements. What should a pragmatic libertarian think of them? (The agreements, not the people and companies.)

Generally, regional free trade agreements like NAFTA and the European Union are good for individual property rights. They secure those rights clearly in a larger area—usually, the region in which citizens are most likely to do business and want their property rights protected. Proof of this: In the first half of 1994, when NAFTA was newly enacted, American and Canadian companies directly invested $2.4 billion in Mexico.

And any libertarian—pragmatic or purist—should certainly prefer agreements among countries in common-sense geographic regions

over statist monstrosities like GATT and its offspring, the World Trade Organization (WTO).

The problem with the regional free trade agreements is that the bureaucracies created to administer them sometimes begin to emphasize the regional over the free trade—and try to recreate themselves as...statist monstrosities like GATT and WTO. This trend has plagued the European Union more than it has NAFTA countries.

So, What About Iraq and Afghanistan?

Many critics of George W. Bush—in the U.S. and abroad—emphasize what they see as an imperial nature of his presidency. Especially in Europe, critics question the legitimacy of the successful U.S. campaigns to oust the Taliban regime in Afghanistan (which had given direct support to al Qaida) and Saddam Hussein in Iraq.

One irony of these criticisms is that they were a sort of intramural statist dispute. George W. Bush has a high pedigree in the statist wing of the Republican Party. Most of his critics hailed from the left wing of the more-thoroughly-statist Democratic Party. To a libertarian, there's not so very much difference between Bush and his critics.

Legally, Bush was within his presidential rights to launch the attacks against Afghanistan and Iraq. But that's largely because the laws controlling how a U.S. president engages in war are such a mess.

The U.S. Constitution is clear enough. The legislative branch of government has the power "to declare War...to raise and support Armies...to provide and maintain a Navy." But the president is the Commander-in-Chief of the military—the person who gives the orders to engage. In the second half of the 20th Century—after World War II—the drift in American government was certainly toward giving the president more discretion to send in troops first and seek Congress's support afterward.

The War Powers Act—passed during the Vietnam War—requires congressional approval for military actions after 60 days. This Act was

intended to restrict a president's military options. But, in fact, it has had the opposite effect; it gives the president nearly-complete, legal prerogative to send U.S. military forces anywhere he wishes for 60 days. Before the War Power Act, it could at least be argued that the president was supposed to get legislative support first.

Advancing technology has made the 60-day presidential prerogative even more powerful. All but the most cataclysmic military engagements (call them *wars, surgical strikes, police actions*—whatever you wish) can be completed within 60 days anymore; and, in the rare case that they can't be, enough progress can be made that Congress would seem peevish not to support the completion of a military task.

George W. Bush played this game with his invasion of Afghanistan. Polling showed it to be a popular act in the U.S.; strategically, it made sense, because the Afghani Taliban regime had supported the terrorist group that flew planes into the World Trade Center and the Pentagon. The invasion was over quickly…but, even within, the 60-day period described by the War Powers Act.

The Iraq invasion, which followed about two years after the 9/11 attacks, was more questionable strategically (the ties between Saddam Hussein's regime and the terrorists weren't clear); but it was less questionable legally. Bush actually proceeded in the pre-War Powers Act manner, securing in advance congressional votes that allowed him to "use the armed forces of the United States as he determines to be necessary and appropriate in order to defend the national security of the United States against the continuing threat posed by Iraq."

In the end, American troops were successful in ousting Saddam Hussein—by all accounts a brutal murderer with contempt for any notion of liberty. However, a connection between Saddam and the suicide terrorists of 9/11 was never firmly made. Nor was Bush's next-best defense for invading Iraq—that Saddam Hussein was developing chemical, biological and/or nuclear "weapons of mass destruction."

Bush's critics made much of this uncertainty. They called his military attack on Iraq "illegal" and "immoral." The first claim was false;

the congressional approval of Bush's Iraq actions wasn't contingent on any connections. The second claim was only relevant to someone who assumes that some military actions—some wars—are moral.

To a libertarian, war is the ultimately statist power-grab. War makes the state nearly omnipotent...on the battlefield and on the home front. Moral or immoral, war is never good for liberty in the short-run.

The only libertarian defense of war is that, while it restricts or suspends liberty in the short-run, a particular war will protect liberty and property interests in the long-run.

This is a slippery slope. A manipulative statist can use such a justification to suspend liberty while he builds a totalitarian regime. For this reason, libertarian purists can be the most philosophically consistent anti-war activists. They oppose all wars because of their bad effects of liberty both at home and abroad, even though many wars have been fought to protect (or to create) property rights.

Conclusion

After the 9/11 attacks, such philosophical purity seems misplaced. Bush—and other politicians—are right when they say that al Qaida's suicide terrorists are a new kind of enemy. They don't represent a country; and they have contempt for the political philosophy that allows Western democracies to exist. They certainly have contempt for libertarian notions of property rights and liberty.

Libertarian purists are wrong to argue that all foreign military intervention is analogous to statist intervention in domestic markets. The case against statist control of domestic markets rests on the fact that equilibrating mechanisms keep those markets in peak efficiency. By contrast, as numerous economists have admitted, "there is no invisible hand in foreign affairs."

Foreign policy is a difficult thing to privatize. Relations among states are best managed by states. In this arena, a libertarian's prefer-

ence is for a state that will follow its free markets and take only actions necessary to protect its citizen's liberty and property rights.

Still, troubling questions remain. Since the 9/11 terrorists didn't represent a traditional state, are states the right mechanisms for responding? Maybe the best free-market response would be to place huge bounties on the heads of all al Qaida leaders and let bounty hunters search the mountains between Afghanistan and Pakistan...instead of U.S. Army soldiers.

There's historical precedent for this. In the 18th Century, England's deals with privateers like Francis Drake created a version of a privatized navy.

Some people say that al Qaida is just a group of angry nihilists who want to destroy everything. That may be true. But the group's rhetoric calls for an Islamic Fundamentalist state that will rule over the entire Middle East...and perhaps the entire world. Theocracies are statism of the most extreme kind.

And, like the manipulative statist who uses the cover of war and patriotism to expand the grasp of government, al Qaida seems to be using the liberties that Western democracies provide to kill those democracies. If any group deserves harsh military attack, this group—and the states that harbor its factions—would be it.

A pragmatic libertarian can support such military action. American liberals believe that all libertarians care about is money and utility; American conservatives believe that all libertarians want is to satisfy appetites. Neither belief is true. To value liberty is an inherently moral practice: Libertarians judge morally and hate evil. They just define *evil* differently than either American liberals or conservatives.

Libertarianism isn't a suicide pact. One of the state's few, legitimate purposes is to assure a basic level of safety for its citizens. That basic level of safety doesn't mean a risk-free existence; but it does mean taking steps to neutralize groups that have stated—and shown—that they will destroy the citizens of a free state if they can.

And, again, foreign policy is a hard thing to privatize.

Part Four:
Politics

15 Liberty and the Libertarian Party

To the degree they recognize it at all, most Americans equate libertarian political philosophy with the Libertarian Party. This is unfortunate. Why?

In February 2003, an odd political dispute came to an absurd point in New York City.

City officials condemned a Manhattan Libertarian Party member who organized what he called a "Guns-for-Tots toy drive" outside a public school. The incident showed that the Libertarian Party is better at grabbing cheap headlines than influencing public policy. The Libertarian Party member—Jim Lesczynski—handed out toy guns in front of P.S. 72 in East Harlem to protest a proposed city ordinance that would ban sale or possession of the toys. But his tactics seemed to draw more attention to his outlandishness than the outlandish proposal.

"Water pistols, noise makers and other plastic gun-shaped novelties are the stuff of any red-blooded American childhood," Lesczynski said. He claimed that the Libertarian Party had collected toy guns from concerned citizens around the country and was "giving them away to the children of our borough."

Education department spokesman Kevin Ortiz said Lesczynski didn't hand out the toys on the school's grounds because it had already closed when he showed up. School officials were aware of the drive and had notified parents. "They showed up late; the kids were gone," Ortiz said. "So it was more of a community issue, not a school issue."

Manhattan Borough President C. Virginia Fields said she was outraged by the stunt.

"Our children should never be used as pawns in a political fight," she said in a news release. "This strategy is morally bankrupt on a number of levels, and the members of the Manhattan Libertarian Party should be ashamed of themselves."

David Weprin, the sponsor of the bill, said toy guns should be banned because they are increasingly being used to commit real crimes. He mentioned the case of a 17-year-old boy who'd recently been shot and killed by a detective who said he came upon the teenager holding what turned out to be a pellet gun to another detective's head. "Our issue is not whether the young man was guilty or innocent of a crime," Weprin said. "Our issue is these imitation weapons are being sold in stores and ultimately creating an unsafe environment for city residents."

Existing city law already restricted the sale of toy guns to brightly colored models constructed of transparent material. But some concerned New Yorkers argued that it is easy to paint the guns black or cover them in black tape to make them look real. And police officials admitted that some hardened criminals used toy guns because they knew that if they were caught the penalties would be less severe.

But Weprin's bill still struck many as foolish excess. Too bad the Libertarian Party made a bigger spectacle of itself than the bill it meant to satirize. "This is silly legislation," Lesczynski said, "and I urge you to salvage respect for the law and the credibility of the City Council by voting against it."

"Big L" Versus "Little L"

It would be strange to write a book about libertarian politics and philosophy without mentioning the Libertarian Party. The politics, philosophy and Party should all be closely related.

But they aren't.

In terms of both registered members and number of elected posts held, the Libertarian Party (in its own shorthand, the LP) is usually the largest third party...and third-largest party...in America. For short periods, the Reform Party (at its Ross Perot-led height) and the Green Party have rivaled the Libertarian Party for that narrow claim—but the LP has had the most consistent success from the 1970s to the early 2000s.

The LP's best marketing hook is the frustration that people have with condescension that statists have for ordinary citizens.

Its pitch goes something like this: The government believes it must act as a parental figure, telling us what we can and cannot do. It believes that without governmental regulation in all aspects of life, American society would fall into laziness, destruction and waste. And these beliefs are wrong.

More specifically, the Web site www.lp.org defines the main ideology of the party:

> We the members of the Libertarian Party, challenge
> the cult of the omnipotent state and defend the rights
> of the individual. We hold that all individuals have
> the right to exercise sole dominion over their own
> lives, and have the right to live in whatever manner
> they choose, so long as they do not forcibly interfere
> with the equal right of others to live in whatever
> manner they choose.

According to the LP platform, the government's role should be to protect our personal rights. If a person or company infringes upon another's rights, the government should be there to step in. So, local

police and federal enforcement agencies such as the Security and Exchange Commission (SEC) should be preserved.

However, the state shouldn't enact laws to protect us from ourselves. Laws banning possession of drugs or guns are examples of laws that should be thrown out. These laws merely try to outlaw a material to prevent the possibility of crimes. This isn't the best way to battle crime. Punish crime once it has been committed. Jail all people who hurt, steal and kill. But do so after the crime has been committed.

Ending the current levels of taxation and governmental spending is another central idea for the LP. Many of the services that the government currently provides would no longer be in its hands, but in the hands of private businesses. Responsibilities for paving roads and mail delivery would be given to private firms.

Programs such as Social Security, welfare and unemployment insurance would be gone. People would have to be responsible for their own lives and not rely on the state to pay for their bills.

In practice, however, the Libertarian Party is just that...a political party. It doesn't reflect libertarian beliefs (the primacy of property rights, the necessity of the smallest-possible government) consistently or well. What it does do well—for a small political party in the United States—is attract candidates, money and votes. Usually in that order.

The problem with any political party in America that isn't Republican or Democrat is that it has to resort to gimmicks to attract enough media attention and voter focus so that its candidates get some benefit from having a party affiliation. For libertarians, this means that what benefits the "big L" next to candidates' names may cheapen or contradict what the "little L" loyalists believe.

Perhaps that's justice. People who find political or philosophical meaning in "little L" libertarianism often find political parties nauseating. So, it may be fitting that the party that presumes to use the "big L" name has trouble keeping its natural constituents.

The practical problem is that too many LP candidates trivialize themselves and their campaigns to the level of weekend TV weather-

men. Notoriously, in 1994, shock radio personality Howard Stern won the LP's nomination for governor of New York. Stern brought his celebrity circus to the LP state convention in Albany, where he swore he was serious about his campaign. But, once the cheap publicity was had, Stern decided that he didn't want to run after all—it would mean disclosing personal financial information he preferred to keep private. The New York LP was left looking foolish.

It would be easier to identify with the LP if it didn't have so many leaders who are willful eccentrics, happy to live on the fringes of politics. As a result, the other parties—including the two main ones as well as upstarts like the Reform Party—have been able to co-opt some of the common-sense appeal of libertarian philosophy.

How often have you heard a focus-grouped politician or self-impressed pundit say "I'm libertarian on some issues." That familiar statement is an indictment of how poorly the LP has been able to knit together a functional political base.

The result of no close-knit political base: Freelance eccentrics who generate all sorts of knavish behavior in the name of the Party.

Party First, Libertarian When Feasible

In the fall of 2002, Rick Stanley swore off all political handlers and opinion polls in his campaign for the U.S. Senate from Colorado. All he needed to win, he said, was a gun.

The 48-year-old Libertarian Party candidate carried a .357 Magnum at all times. As a result, he had been arrested on weapons charges twice—in the few months since announcing his candidacy in May 2001. Both times, police confiscated the pistols. The arrests and confiscations could have been avoided if Stanley had been reasonable about honoring local ordinances and neighborhood policies.

But that didn't dissuade Stanley. He was more serious about being right than being Senator.

Professional campaign managers love having opponents like Rick Stanley. The results are often humorous and wins, easy.

With the 2002 elections little more than a month away, Stanley called a press conference to announce that he was stocking up on two new handguns—one to wear and the other as a backup in case of another arrest. He said the weapons would help make his case for gun rights, the cornerstone of his platform.

Stanley told reporters that he'd spent most of his adult life as an independent who vacillated between the Republican and Democratic Parties, depending on the candidates they nominated. Then, in 2000, a friend lent him a pamphlet arguing that, as soon as people start trusting their government, "someone will come to power who is not benevolent."

The aphorism gave Stanley some political vision. "I realized I'd been a Libertarian all my life and didn't know it," he said—a refrain that's common to politically-active libertarians.

Most days—sometimes several times a day—Stanley e-mailed libertarian columns that he called *The Stanley Scoop* to a list of what he claimed were 100,000 people nationwide. "People say I'm a loose cannon. But...there are a lot of people who think this. I'm running to represent them," he said.

Stanley's tactics raised the ire of fellow libertarians, who in August 2002 tried to oust him from the party's ticket. One detractor called Stanley "a bomb-throwing anarchist nut case" for distributing an e-mail calling for Colorado's U.S. Senator Wayne Allard to be hanged for treason. Another said, "He's not a Libertarian. He doesn't have a clue what Libertarianism is all about."

Stanley dismissed the rest of the LP as a bunch of geeks "and unattractive women." He sneered, "They tend to lack certain social skills. Their thoughts are grounded in the way things should be rather than how they are."

That criticism didn't prevent Stanley from painting in his own broad strokes. He wanted to abolish the IRS and all income and prop-

erty taxes, which he called "servitude" to a cartel of financiers that control the Federal Reserve and run the world. In the next breath, he claimed to have modeled his life on his favorite book, Ayn Rand's *Atlas Shrugged*, in which society collapses when "men of ability" go on strike against a statist bureaucracy. (This was a bit of an irony, since the Chairman of the Federal Reserve—by Stanley's reckoning a lackey for multinational banks—was well-known as a devoted follower of Ayn Rand's writings.)

Stanley's beliefs were a quilt of different philosophies. He wanted to privatize Social Security by returning retirement savings to workers; he saw the United Nations as a socialist group whose headquarters should be booted from the country. He said a smaller federal government should rely only on money from gas taxes, excise taxes and duties; he wanted a constitutional amendment banning desecration of the U.S. flag. His position on abortion was hedged to the point of incoherence by alternating references to "personal privacy" and his evangelical Christian belief.

On the campaign trail, Stanley urged voters to carry weapons to protest gun laws. He encouraged people to rise up against government tyranny—a revolution he anticipated coming within a decade. And he said he expected "bloodshed. ...If the government won't leave, we'll have to remove them physically."

He spoke grandly about his plans for exploiting the balance of power between Democrats and Republicans in the Senate, and said he would seize the opportunity to broker deals with both parties to push his agenda: "A freshman Libertarian could have a huge amount of power. In an odd way, I'd be running the country."

According to one veteran of Colorado politics: "Rick's got great potential and really seems normal in person. But, as a candidate, he gets over the top and sometimes goes off the deep end."

After polling less than 2 percent of Colorado voters in the November 2002 general election, Stanley left the LP to start his own political party.

Defying a Consistent Political Party

In defense of the LP, libertarian philosophy may defy an effective traditional political party. Political parties operate on an assumption of communal interest that's inimical to the aggressive individuality of liberty's logical extensions.

In the wake of 9/11, the LP had to reconsider its foreign policy positions. The party had been blissfully isolationist in foreign policy matters before; the attacks proved that even the most philosophically consistent group had to account for specific national security risks.

The LP position had been that it would support military action only if the United States itself were physically attacked. Since the LP was a relatively new party, it never had to deal with that "if" in the concrete. After 9/11, its position was tested.

And the party's conclusion was that its strict standards for justified war had been met. It supported the Bush Administration's invasion of Afghanistan; but it hedged this position by not supporting the overthrow of the Taliban. To many outsiders, this split position seemed like more silliness from a fringe party.

The LP tried to clarify its position by emphasizing that it wanted America's response to the 9/11 attacks to be "appropriate and measured." Various spokesmen made the point—cautiously—that America's interventionist foreign policies had provoked enemies. They argued that isolationism...or what the LP called *nonintervention*..."will reduce the chance that terrorists will want to strike [again] at America."

Some LP leaders took this argument even farther. Harry Browne—who'd been the LP's presidential candidate in 1996 and 2000—made several caustic remarks in the immediate aftermath of the attacks. He said: "When will we learn that we can't allow our politicians to bully the world without someone bullying back eventually?" Later, Browne said that in Afghanistan the U.S. had "attacked an innocent nation" and "slaughtered a lot of innocent people." He characterized the Bush Administration as "a threat to the world."

Some groups affiliated with the LP took these arguments even farther than Browne did:

- The group that runs the Web site Lewrockwell.com wrote that Bush Administration officials Richard Perle and Paul Wolfowitz—as well as Madeleine Albright, the previous administration's Secretary of State—were "war criminals." Their Web site repeated Saddam Hussein propaganda as fact; it seriously considered the similarities between 21st Century America and Nazi Germany.

- The Independent Institute, a Bay Area libertarian think-tank, hosted a seminar in early 2003 on the War on Terrorism. One participant described the United States as a "terrorist state." Author Gore Vidal, better known for his reflexive anti-Americanism than a commitment to libertarian philosophy, made the familiar criticism that America was fighting in Afghanistan because war was good for corporate America and because the Bush Administration wanted to control central Asian oil.

- Other radical libertarians—or, in their own jargon, "zero state libertarians"—castigated the Bush Administration for statist overreach. (This point isn't inherently ridiculous.) But the quality of discourse among these groups varied. The best of them argued that all America should have done in response to 9/11 was put a huge bounty on Osama bin Laden's head; the worst indulged in personal attacks on Bush Administration officials.

In some cases, the pacifism of these groups spilled into anti-Americanism and, frankly, anti-semitism (several of George W. Bush's highest-profile pro-military-intervention advisors were Jews). And, even if they weren't ranting about Paul Wolfowitz, these absolutists turned vicious when they described more pragmatic libertarians as sellouts.

Of course, the LP isn't responsible for the sophomoric anti-semitism of literary guests at seminars sponsored by loosely-affiliated think tanks. But the party's awkward position as the common link among some frivolous and some reckless groups reflects the inherent problems in its mission.

A big part of libertarianism's appeal is its tolerance—even encouragement—of idiosyncratic thinking. This is one of the areas in which libertarianism shares values with the benign versions of anarchism. But encouraging idiosyncracy and building a consistent political front are probably mutually-exclusive goals.

Conclusion

The LP, the Cato Institute, the Independent Institute, *Reason* magazine and the best-known libertarian pundits (many of whom write on Internet weblogs) had different opinions about the Bush Administration's military responses in Afghanistan and Iraq after 9/11. They were divided roughly into three groups: antiwar absolutists, pro-military hawks and a nuanced middle group that endorsed action in Afghanistan but opposed war with Iraq.

These various groups could turn vicious in their criticisms of one another—as various members of tight philosophical niches often do.

The main challenge facing the LP is whether it seeks to represent all of the groups, or merely be one forceful voice among them. Representing everyone in the niche will require some pragmatism on the party's part; that idea is repugnant to some of its core activists.

But I started this chapter by asking why it was unfortunate that many American equate libertarian philosophy with the Libertarian Party. The short answer is that the Party is too often overwhelmed by grandstanding buffoons like Jim Lesczynski and Rick Stanley.

16 Liberty Makes Strange Bedfellows

I'm starting to get the picture. When it comes to critiquing statist measures like the Patriot Act, some traditional political enemies support each other. What does this strange bedfellowship mean for America?

In November 2002, the American Civil Liberties Union announced an unusual alliance. Retiring Congressman Dick Armey of Texas—who'd been one of the Republican Party's conservative leaders for nearly 20 years—was signing on as a consultant on privacy issues, starting in the new year of 2003.

Armey was an unlikely ally. The ACLU had given him a very low rating of 7—out of a possible 100—for supporting its definition of civil liberties votes during his last congressional session.

A spokesman for Armey said that the congressman had been a champion of individual rights and against government intrusion; most recently, he'd led the successful campaign to eliminate the Justice Department's TIPS program, which would have encouraged individuals to snoop on each other, from the Homeland Security Act.

In the last few years of his time in Congress, Armey had become increasingly concerned about what he called "Big Brother" issues. He'd been a critic of local police forces using surveillance cameras to

give tickets to drivers whose cars ran red lights; and he'd been a dedicated opponent to any form of national identification system—arguing that a national ID "is not consistent with a free society."

Armey had first found common cause with the ACLU during the summer of 2001, over the issue of state use of facial-recognition computer programs. The ACLU has supported Armey's request that the General Accounting Office study the extent to which federal law enforcement agencies were funding—and using—facial-recognition technologies. He was concerned that the government was subsidizing a technology of dubious reliability. And he was equally concerned about the privacy effects if the technology *did* work.

Laura Murphy, the ACLU's legislative director said, "We are truly excited that the majority leader would choose the ACLU as an ally with whom to work as he continues his important fight for privacy...." This was putting a positive spin on a unlikely alliance.

Bush: Conservative or Corporate Statist?

Conservatives have been conflicted since 9/11. Most advocate the maintenance and use of strong military, so the effective ousting of the Taliban and the capture of Saddam Hussein are a point of pride.

But the post-9/11 military actions—even if justifiable in the wake of the attacks—are part of a generally troubling trend. America has entered a succession of foreign interventions since the 1960s that have little to do with protecting its shores, as the founders of the U.S. Constitution clearly intended the nation's war-making to be.

The greatest threat to American liberty is not from the likes of al Qaida but from government trampling on fundamental freedoms. Chipping away at liberty under pretense of war is not conservatism; it's an old statist trick.

This moves quickly to the common debate over the differences between "libertarian" and "conservative." The well-read weblogger Jim Kalb wrote:

From a theoretical standpoint, ideological libertarianism is just another form of rationalism and not at all conservative. As a practical matter, though, it's mostly an ally of tradition because it opposes the main current enemy, the PC social-services state.

Libertarians share the conservative emphasis on just desserts, hence the immense popularity of Ayn Rand in the libertarian movement. It is for this reason that alliances between libertarians and conservatives are often possible—they share a key value.

This gets to some key questions about George W. Bush: Is he a conservative (on the campaign stump, he calls himself a "compassionate conservative") or a statist? Is it possible to be both at the same time? *Yes.*

According to the conventional wisdom resulting from constant polling of the president's actions, it seems that many Americans support the military steps Bush took in the wake of the 9/11 attacks. Ironically, for a president whose foreign policy expertise was a question mark when he took office, Bush's approval ratings on foreign policy matters are higher than on domestic policy matters.

Of course, the fact that actions are popular doesn't mean that they're good for people's liberty interests.

From the libertarian perspective, George W. Bush has three major strikes against him—the Patriot Act, an aggressive growth of the federal government's size and a general air of secretiveness in his administration. All three seem to run against the spirit—if not the tactical politics—of what most Americans think of as "conservative."

Our phones can be tapped, our e-mails read, our library books monitored, our financial and medical records and religious and political affiliations scrutinized by government with little, if any, oversight—all in the name of security.

A free state offers its citizens liberty and opportunity, with a modicum of security. People around the world claim they want this—but, given the chance to vote, they often choose security over liberty.

And ambitious statists give a very broad meaning to the word security; they stretch it to cover concepts most reasonable people wouldn't see. One left-wing outfit described "security" in four parts:

- *national security*, or freedom from the fear of military conflict;

- *community security*, or freedom from the fear of violence, with law and order and a decent justice system;

- *personal security*, or freedom from the fear of want, with income and employment, housing, health and educational opportunity; and

- *environmental security*, or freedom to enjoy decent physical conditions in which to live and work and play.

Freedom from fear of want? There are millionaires who don't have that "security." Statists never tire of making fools of themselves by insisting on imaginary "rights" to things like housing and health care.

No libertarian—no person with any understanding of the U.S. Constitution—can agree with such a definition of security. The surprising part is not that some flaky liberal group looks at security that way; it's that George W. Bush, a self-professed conservative, has agreed with a lot of that flakiness.

Bush is not a proponent of limited government and restrained social agendas. Instead, he's a statist with a corporate leaning. This explains many things about Bush: his choice of vice president, a number of the appointments to his cabinet, his trade policies (heavier on protectionist tariffs than most supporters expected) and his support of the Patriot Act.

Partisanship Is a Boon to Statism

If George W. Bush is a statist president, why does he engender such passionate—negative—reaction from the Democratic Party? After all, in traditional American politics, the Democrats are the statists.

Shouldn't they have something like a grudging admiration for a man from the other side who has absorbed some of their values?

Bush may be suffering from an increased partisanship in American politics—something that started as far back as Ronald Reagan and hit its stride with Bill Clinton. Following this line of thought, loyal Democrats despise Bush because he's not one of them and is fairly popular to the general public; just as loyal Republicans despised Bill Clinton.

This increasingly intense partisanship is part of what historian Richard Hofstadter called "the paranoid style in American politics" in an oft-quoted essay of the same name. Hofstadter wrote:

> Since the enemy is thought of as being totally evil and totally unappeasable, he must be totally eliminated—if not from the world, at least from the theatre of operations to which the paranoid directs his attention. ... [The paranoid person] does not see social conflict as something to be mediated and compromised, in the manner of the working politician.

Hofstadter's essay was written in the 1960s. But it essentially predicted American political discourse in the 1990s and 2000s.

One basic symptom of paranoid politics is the exaggerated comparison to current people and things to historical paragons. In the wake of the 9/11 attacks, the two most common paragons were Adolf Hitler and Joseph McCarthy. In different contexts, Saddam Hussein and George W. Bush were both compared to Hitler; the Patriot Act, security checkpoints at airports and legitimate questions about Saudi involvement in al Qaida were a few of the things labeled new McCarthyism.

Neither Saddam Hussein nor George W. Bush is anything like Hitler. Adolf Hitler was one of history's greatest villains; he murdered millions and would have killed most of the human population in a massive eugenics experiment. Saddam was a ruthless dictator who— like others of his sort—caused thousands of his own people to die; but

he never posed anything like the threat that Hitler did to the world. George W. Bush is the leader of a country ruled by law and dedicated to lawful democracy at home and abroad.

Joseph McCarthy was the center of a brief period in American politics when incivility and paranoia—as well as statism—ran amok. A senator from Wisconsin, McCarthy led an overzealous effort to identify communists in government employ and remove them from their jobs. In the course of the effort, McCarthy seemed to forget his initial focus on government and a reasonable remedy...and lost himself in an effort to identify American communists wherever they might be.

In the decades since, "McCarthyism" has come to mean anything statists or American liberals consider unfair, unjust...or simply not nice. It's a modern example of the phenomenon described by George Orwell in his great essay "Politics and the English Language":

> The word *Fascism* has now no meaning except in so
> far as it signifies "something not desirable."

It's difficult for any libertarian to defend the excesses of the McCarthy era. The government has no business asking citizens about their political beliefs. It is every American's right to be a communist, if that's what he or she believes; it's every American's right to hate America. It's just not every American's right to kill a bunch of other Americans or destroy those others' property to express his or her points.

In a sentiment not far off from the contemporary mess of "hate crimes," McCarthy—at his worst—seemed determined to modify the beliefs of whole groups of Americans.

Pols Come to Terms With Statist Measures

McCarthyism is relevant to a discussion of liberty for another reason. McCarthy led his inquisition at the height of the Cold War. Since the collapse of the Soviet Union, and the retreat of communism to the dust-bin of history, politicians (and political theorists) have been flailing about, reaching for a new international political framework.

The 9/11 attacks provided that new framework. Some pundits describe this framework as a conflict of religious or cultural values. But it's not. It's a conflict between those who value personal liberty and those who do not.

The supposed religious fundamentalism of al Qaida is not its core identity. As many experts on Islam point out, violence against innocents is as repugnant to Islam as it is to Christianity or Judaism. The hatred that is implicit in Osama bin Laden's actions is not against religious infidels—it's against what he considers excessive liberty.

One of al Qaida's main goals—it's reason for being, really—is to recreate Saladin's caliphate. This was an Islamic kingdom of totalitarian detail. It had no place for personal liberty. In this way, al Qaida may be like the Bolshevik revolutionaries who helped create the Soviet Union. They talk some about ideology, but that's just camouflage for what they really want: Totalitarian statist authority.

When John Walker Lindh—the "America Taliban"—was captured during the Afghan intervention, the mainstream press published a lot of psychological analysis about how Lindh's dissolute upbringing had left his simple mind rudderless and drawn to harsh authority figures. The same could be said of Osama bin Laden.

This is the implicit connection between the nominally religious bin Laden and the nominally secular Saddam Hussein (even if an explicit connection never emerges): They are both totalitarian statists.

In the weeks immediately after the 9/11 attacks, American politicians struggled to define where they stood in relation to the new threat. As Congress was passing the Patriot Act and taking other actions—symbolic and tactical—to respond, key lawmakers acknowledged that some erosion of civil liberties was inevitable. Mississippi Senator Trent Lott, then Senate Minority leader, told reporters:

> ...when you're at war, civil liberties are treated differently. We've been having an academic discussion and holding our breath in this area for several years. We can't do that anymore.

History suggests that Congress would put security in front of liberty. During World War I, it passed the Espionage and Sedition Acts, which were used to arrest well over 1,500 people, many of whom were deported. In 1996, after the bombing of the federal building in Oklahoma City, it passed anti-terrorism and immigration control legislation that severely curtailed the ability of defendants in death penalty cases to appeal their sentences and that allowed federal officials to use secret evidence in deportation cases.

With the Cold War framework of communist/capitalist and left/right conflict gone, groups formed in that era were free to align themselves in non-traditional ways. So, the American Civil Liberties Union and the Cato Institute both cautioned against actions that might erode on the liberties that so offend al Qaida. And so, the ACLU and Dick Armey align to lobby for privacy rights.

Liberty Versus Democracy

While American political groups realign, some are pointing out another difficult complexity: personal liberty and democracy may not always be compatible. Indeed, al Qaida may be most dangerous not because it drops bombs, but because it is popular in central Asia, east Asia and other developing locations.

If American-style democracy were suddenly transplanted to most of the Middle East, Malaysia and the Philippines in 2004, it might well put in power precisely the totalitarian theocrats who pose the biggest threat to America.

This point is ironic, but essential to understanding world politics: Democracy isn't the opposite of tyranny. In fact, the triumph of democracy around the world in the 1990s and 2000s coincided with outbreaks of ethnic nationalism, civil war and genocide.

The liberty that America has mastered relies on several structures: an independent judiciary, constitutional guarantees of minority rights, a free press and autonomous universities. And, perhaps more impor-

tantly, America has benefited from a set of informal institutions that the French political writer Alexis de Tocqueville called "intermediate institutions"—everything from political parties to rotary clubs to choral societies to bowling leagues.

These institutions are essential to liberty's success; if they fade, they're often replaced by a kind of polarized populism in which each side angles to capture government power by any means. Without those structures in place, democracy can collapse into chaos.

James Madison wrote in *Federalist No. 51* that, when constructing a government, you have to do two things. First, the government has to control the governed; then it has to control itself. It's best to construct a system when you don't know whether you're going to be the ruler or the ruled, because you have incentive to create fairly.

California is a poster child for democracy run amok. By 2004, a state that had once been among the best-run in the country was on the verge of collapse. The educational system was a mess, its electricity grid didn't work, it couldn't pay its bills—all of this because it embraced a system of government where everything was done by initiative and plebiscite. The state legislature was impotent; and the voters elected a charismatic movie actor governor. Again.

A pragmatic libertarian has to be open to the idea that government by plebiscite can be as inefficient as government by bureaucracy.

Why? Because people often pick the prospect of security over liberty when they get scared.

The ACLU

That brings us back to the start of this chapter, and the unlikely alliance between Dick Armey and the ACLU.

In a whorehouse full of strange bedfellows, the American Civil Liberties Union remains the strangest of all. It's stated mission—an apolitical and even amoral defense of the logical extensions of the U.S. Constitution—is appealing. But the group doesn't come from such a

philosophically clean point; and it doesn't proceed in such a philosophically clear way.

The ACLU's founder, Roger Baldwin, wrote in 1935 that "Communism is the goal." In an essay written for *Soviet Russia Today*, then one of the Kremlin's major propaganda organs, Baldwin stated:

> Those of us who champion civil liberties in the United
> States and who at the same time support the proletarian dictatorship of the Soviet Union are charged with
> inconsistency and insincerity. If I aid the reactionaries
> to get free speech now and then, if I go outside the
> class struggle, it is only because those liberties help
> create a more hospitable atmosphere for working-class
> liberties. We want also to look like patriots in everything we do.

Josef Stalin was calling the shots in the Kremlin at that point.

Baldwin's defenders insist that his words have to be understood in a historical context that allows for some overheated socialist rhetoric. Even so considered, Baldwin's words are pretty damning stuff.

In the 1930s, the ACLU published a pamphlet that lumped the American Federation of Labor with "proto-fascism." The AFL, proto-fascist? What are the politics of an outfit that writes *that*?

During World War II, the United States was so uniformly behind the war effort that an idealistic constitutional gadfly would have welcomed the chance to defend dissenters of all stripes—including the wretched few who were for the fascists. But, when 30 union leaders of Trotskyist persuasion were convicted under a shaky anti-treason law, the ACLU applauded; it followed the Bolshevik line. It said nothing in defense of Japanese-Americans sent to internment camps (at that point, the Empire of Japan was the Soviet Union's enemy), although it launched steady attacks against U.S. businesses.

Even columnist Walter Lippman—a left-wing icon—complained that "the directors of the [ACLU] have missed one opportunity after another to show that they really stand for what they profess, that they

care for civil liberty as such [and] not merely because it is a convenience for communists."

Flash forward 60 years.

In the 18 months after the 9/11 attacks, the ACLU saw its membership increase by 15 percent, to an all-time high of about 380,000. Many newcomers signed up because they were concerned about the Bush Administration's anti-terrorism measures. And the group enjoyed support from what it called "the libertarian right." This included Dick Armey and Bob Barr, another former Republican congressman with conservative bona fides.

"People tend to join at a time when they really see a threat," said Emily Whitfield, a national ACLU spokeswoman.

Starting in late 2002, the ACLU hired organizers to help cities and towns pass resolutions saying they wouldn't cooperate with anti-terrorism measures that they considered too intrusive. Such resolutions have passed in 29 communities, from San Francisco to Amherst, Massachusetts. This was, in every sense but the legal, partisan politics against the Bush Administration. The ACLU—a tax-exempt organization—is supposed to avoid partisan politics.

According to John Eastman, a law professor at Chapman University in California:

> ...It's important to understand that the ACLU's historic mission is to defend our civil liberties against overreaching government. And it's such a critical mission that I wish they would do so in a more neutral and sensible way...for example, their opposition to President Bush's order on military tribunals—that we have to try every prisoner captured in the field of battle in a court of law—is something unknown in human history, particularly in wartime. And I think that over-reaching has undermined their credibility when they speak out against things that are intrusive into our liberties.

Conclusion

Republican-versus-Democrat partisanship in the U.S. has become an ongoing slap-fight. It's best avoided. In his September 1796 *Farewell Address*, George Washington anticipated all of this. He wrote:

> ...The alternate domination of one faction over another, sharpened by the spirit of revenge natural to party dissention, which in different ages and countries has perpetrated the most horrid enormities, is itself a frightful despotism. But this leads at length to a more formal and permanent despotism.

Washington warned that partisanship agitates the community with "ill-founded jealousies and false alarms, kindles the animosity of one part against another, foments occasionally riot and insurrection."

The familiar lines of American political partisanship—Republican-versus-Democrat, conservative-versus-liberal—were shattered by the 9/11 attacks. The general prospects of a new debate will be good for libertarians.

In the meantime, as the lines change, odd pairings like the ACLU and Dick Armey will continue.

CHAPTER

17 Quibbling Among Statists

Much of what passes for political debate since 9/11 sounds like sophomoric sniping among undergraduates. The attacks were supposed to end all that. What's happened?

On November 14, 2002, *New York Times* columnist William Safire showed some libertarian colors by lambasting a Pentagon program:

> Every purchase you make with a credit card, every magazine subscription you buy and medical prescription you fill, every Web site you visit and e-mail you send or receive, every academic grade you receive, every bank deposit you make, every trip you book and every event you attend—all these transactions and communications will go into what the Defense Department describes as "a virtual, centralized grand database."
>
> ...This is not some far-out Orwellian scenario.

Safire had been tipped off when the Defense Department solicited proposals some months earlier for private technology companies to bid on helping to develop the program.

Bush Administration apologists and establishment hacks of various political stripes dismissed Safire's outrage as "heavy breathing"

and overreaction. But the columnist accomplished at least one of his goals: He highlighted a program that had been quietly gathering momentum in the 14-odd months after the 9/11 attacks.

The program—called Total Information Awareness (TIA)—was an egregious statist power-grab cloaking itself in national security.

TIA's goal was to mine through vast amounts of data and predict brewing terrorist attacks from their requisite parts—airplane tickets, cash withdrawals, long-distance calls and purchases of things like chemicals or weapons. The program was developed by the Defense Advanced Research Projects Agency (DARPA), which had helped develop the Internet and stealth aircraft technology.

As Safire noted, the head of TIA was John Poindexter, the former U.S. Navy admiral who'd overseen the Iran-Contra project during the Reagan Administration. Poindexter—who'd been convicted of lying to Congress (the conviction was overturned on appeal)—was an odd selection to head a politically-charged project. His presence reflected the Bush Administration's right-of-center statist roots.

And Poindexter didn't seem recognize his own inappropriateness. He was an establishment partisan, back in the game of politics.

His involvement was like catnip to left-of-center statist activists. They hated him almost gleefully—and cranked up the outrage that a Reagan-era villain was back inside the Beltway making mischief.

Poindexter played to the paranoid passions of his enemies. Designing a logo for TIA, he'd picked the old Masonic image of an omniscient winged eye raised above a pyramid base. But Poindexter's Masonic imagery isn't what enflamed his critics. His brand of statism—a reflection of their own—did the trick.

What TIA Meant to Do...and How

According to DARPA's Information Awareness Office (IAO):
...the TIA objective is to create a counter-terrorism information system that:

1) increases information coverage by an order of magnitude and affords easy future scaling;

2) provides focused warnings within an hour after a triggering event occurs or an evidence threshold is passed;

3) can automatically queue analysts based on partial pattern matches and has patterns that cover 90 percent of all previously known foreign terrorist attacks; and

4) supports collaboration, analytical reasoning and information-sharing so that…decision-makers can effectively evaluate the impact of current or future policies and prospective courses of action.

When Safire started paying attention in late 2002, TIA was a small, experimental program operating far behind the bureaucratic walls of the Pentagon. It didn't have the tools to search personal data as effectively as critics feared; but it was working on them.

The critics had it slightly wrong when they claimed that TIA would build electronic dossiers on the personal lives of all Americans. The project engineers were more interested in writing software algorithms that could scan dossiers that *other* entities—banks, credit card companies, grocery stores—kept. They considered keeping databases an inelegant waste of time and computer memory.

The Pentagon's official line was that TIA was "an experimental prototype in the works that will determine the feasibility of searching vast quantities of data to determine links and patterns indicating terrorist activity."

Libertarians, privacy advocates, gun-rights groups and others worried that even experimenting with such a system risked transfer of unprecedented power to an unaccountable—and often incompetent—central government.

Political Hurdles Go Up

In February 2003, a group of stubborn (and largely Democratic) lawmakers negotiated a freeze of TIA's budget until Congress could review the technology's effect on privacy rights and civil liberties. Some grumbled that they weren't going to rubber-stamp "another Patriot Act."

The Bush Administration had 90 days after the freeze was enacted to submit a report to Congress on the internal workings of TIA or lose funding permanently. (The freeze was later modified to permit intelligence gathering on non-U.S. citizens only.)

Unless that report was filed, all further research on the project would have to stop immediately. However, Bush could keep the project alive by certifying to Congress that a halt "would endanger the national security of the United States."

TIA opponents were especially passionate because they believed the project was not a matter of tracking known or suspected terrorists. They felt it was a massive fishing expedition that would effectively put all citizens under scrutiny. And this was exactly what they'd expected from someone like Poindexter.

The Defense Department proceeded with the formation of two panels to oversee TIA. The result was a who's-who of establishment statists. Edward "Pete" Aldridge, undersecretary of Defense for acquisition, technology and logistics, would head the first panel—an "internal oversight board" created within the Defense Department whose members would be senior Pentagon officials.

Aldridge said an advisory committee established outside the Pentagon would be headed by Newton Minow, a professor of communications law at Northwestern University. Other members of the outside board included: Floyd Abrams of the New York law firm Cahill & Gordon; former Attorney General Griffin Bell; Gerhard Casper, president emeritus of Stanford University; William T. Coleman of the Los Angeles law firm O'Melveny & Myers; and former White House Counsel Lloyd Cutler.

According to Pentagon, the boards would help ensure that TIA developed in a manner consistent with "U.S. Constitutional law, U.S. statutory law and American values related to privacy." With so many insiders involved, most doubters still doubted.

In June 2003, the DARPA IAO released its report.

It reported that TIA was a five-year project to develop and integrate computer technologies that would "sift through public and private databases to find patterns and associations that suggest terrorist activity." The databases would include financial, medical, communications and biometric data (fingerprints, gait, iris). The technologies would be used by intelligence, counterintelligence, law enforcement and homeland security agencies.

As Poindexter noted, "If terrorist organizations are going to plan and execute attacks against the United States, their people must engage in transactions, and they will leave signatures in information space." His Masonic eye would be watching.

Sensing political trouble, the Defense Department emphasized that it had expressed "its full commitment to planning, executing and overseeing the TIA program in a manner that protects privacy and civil liberties."

The congressmen didn't buy the argument. They voted to slash TIA's budget. John Poindexter was soon out of a job. Having borne the brunt of outrage and criticism directed at TIA, he resigned in the summer of 2003.

"Activism" and "Activists"

About the same time DARPA was scrambling its report to Congress on TIA, U.S. armed forces were preparing to oust Saddam Hussein's dictatorial regime in Iraq. A reasonable libertarian might question both efforts. They seemed like an example of plodding, big-government ambition clouding the ruthless self-interest that *should* mark a free state's foreign policy.

Evidence connecting Hussein—by all accounts, a bloody tyrant—to al Qaida and the 9/11 attacks was weak. And there was the lingering sense that George W. Bush's administration was, even if subtly, motivated to finish a geopolitical job that Bush's father hadn't.

But the political criticisms that took center stage weren't so rational. Many "anti-war activists" were too excited to analyze; after years of holding their tongues for the nominal left-of-center Bill Clinton, they finally had something against which to protest.

At an anti-war "teach-in" in New York, a Columbia University sociology teacher thirsty for recognition leapt into the rhetorical excess. Nicholas DeGenova told the crowd that he wished U.S. soldiers in Iraq would suffer "a million Mogadishus." He also said:

> U.S. patriotism is inseparable from imperial warfare and white supremacy. U.S. flags are the emblem of the invading war machine in Iraq today. They are the emblem of the occupying power. The only true heroes are those who find ways that help defeat the U.S. military.

The "million Mogadishus" comment was most likely a reference to the film *Black Hawk Down* that had been released recently. That movie focused on a failed military exercise in the capital city of Somalia during U.S. attempts to end a civil war in that country during the early 1990s. However, the tight dramatic focus of the film failed to explain that the Somali civil war had been far more fatal to Somalis than to U.S. soldiers.

DeGenova's remarks weren't well thought out; some people who witnessed them suggested that the junior professor was just trying to grab some cheap support from what he assumed was a like-minded crowd. He failed even on this count.

The well-known historian Alan Brinkley, who also spoke at the teach-in, later said: "I had never met or even heard of Prof. DeGenova until he spoke that night, and I was appalled by what he said, and ashamed to be on the same platform with him."

A fierce backlash of criticism buzzed through the Internet and then through the major media. Columbia was ridiculed for giving an injudicious fool professional cover. Alumni were complaining to president Lee Bollinger, who took the unusual step of condemning DeGenova's remarks.

DeGenova seemed to lack any sense that the outrage was the result of his poor judgment. In a March 2003 letter to the Columbia *Daily Spectator*, he complained:

> *Spectator*, now for the second time in less than a year, has succeeded to quote me in a remarkably decontextualized and inflammatory manner. ... I am quoted as wishing for a million Mogadishus but with no indication whatsoever of the perspective that framed that remark. ... In my brief presentation, I outlined a long history of U.S. invasions, wars of conquest, military occupations and colonization in order to establish that imperialism and white supremacy have been constitutive of U.S. nation-state formation and U.S. nationalism. In that context, I stressed the necessity of repudiating all forms of U.S. patriotism.

This sounds like something out of *The Simpsons*.

The whole episode played into the hands of those who *supported* the invasion of Iraq. They were able to portray critics as witless and reflexively anti-American.

A common mistake that third-rate minds make about politics is that "activism" is—in and of itself—a good thing.

What exactly *is* activism? In the first half of the 20th Century, political activism in the United States usually meant taking some form of politically-motivated action—organizing workers, registering voters, confronting corrupt officials or even vandalizing property. However, in the last decades of the 20th Century, the actions grew less...active. Strikes and registration drives gave way to nuisance law-

suits quickly abandoned. Confrontation with bigoted law enforcement gave way to badly-written press releases.

By the early 21st Century, political activism often consisted of press conferences and teach-ins. Why this oxymoron "talk as activism?" Because the general sense of apathy is so strong that anything passionate—even passionate talk—seems active.

The beauty of liberty is that it allows people to think anything they want…even if that means thinking nothing at all. But apathy creates a void that blockhead celebrities, professional protesters and minor academics will happily fill. These sorts make up a motley class of passionate opinion-holders who believe that their brand of activism is an end in itself.

When activism is an end in itself, solipsism and circular-thinking are sure to follow. The problem with a blockhead celebrity spouting off some inane—but strongly-held—political belief isn't the inanity; it's the self-referential circle of ego that surrounds the stupidity. He or she is wise because he or she takes a stand—no matter how stupid that stand may be.

The United States is not alone in this mistake. The anti-Americanism that runs through some parts of the world is usually the same, solipsistic hot air. The hatred that cultural fanatics like Osama bin Laden show for America fits the pattern. It's passion looking for an outlet…and not too particular about where that outlet leads.

Empty Activism by the Bay

Over several days around March 20, 2003, some 1,400 "activists" were arrested as they attempted to shut down San Francisco's Financial District. Some of their activities were flamboyant—one group staged what it called a "vomit-in" near San Francisco's Federal building—but most of the anti-war activists were content to block traffic.

Some fellow activists criticized the vomiters for inviting ridicule of the anti-war movement. The critics carped that flamboyant protest

is "leftist infantilism." However, one of the striking aspects of the 2003 anti-war protesters is that *most* of them seemed infantile.

Many of the protesters carried signs. One, in the shape of a tombstone, read: "Here lies American Democracy: July 1776 to November 2000. It was a great run." It betrayed the politically partisan nature of the protests—November 2000 had little to do with the military action in Iraq. It was the month of the close and controversial presidential election that resulted in George W. Bush's inauguration.

Many of the anti-war protesters also showed a childish aversion to criticism or consequences. Various groups in San Francisco and other big cities sued—or threatened to sue—the law enforcement agencies that arrested protesters.

In Washington, D.C., the local chapter of the American Civil Liberties Union filed a lawsuit charging that Police Chief Charles Ramsey and local authorities violated the civil rights of anti-war demonstrators by trapping and arresting them for failure to disperse.

Even though the D.C. protesters had failed to get a permit for their march—and even though the police had repeatedly warned them to disperse—the protesters insisted that the police tactic they called "trap and arrest" was illegal.

Separately, protesters in Chicago sued the city, claiming that police had violated their constitutional rights by detaining and arresting hundreds of them without legal justification during a rally at the start of the Iraq war.

The class-action lawsuit charged the police herded thousands of peaceful demonstrators into a crowded space between Michigan Avenue and inner Lake Shore Drive and then blockaded them there "illegally" for two to three hours on March 20.

Weak Philosophical Foundation

A major problem with activism for its own sake is that it lacks ideological consistency. Any blockhead with enough passion to get

involved will be welcomed into the ranks of activists—no matter how loathsome his beliefs.

One of the groups central to the organizing of the various anti-war rallies that took place around the U.S. in early 2003 was a unit of International ANSWER—a bizarre organization with Stalinist ideological origins.

At different points, International ANSWER has supported North Korean dictator Kim Jong Il, alleged Yugoslav war criminal Slobodan Milosevic and convicted murderer Mumia Abu-Jamal.

International ANSWER is the political activist arm of the extreme left-wing Workers World Party.

The WWP was founded in the early 1960s by Sam Marcy, an obscure communist thinker who lived in the San Francisco area. To call the Party's politics statist would be an insult to statism; in a pathetic update of '60s radicalism, it actually embraces totalitarian dictatorships. WWP leaders have defended Kim, Milosevic, Saddam Hussein's regime in Iraq and Chinese leaders who put down the 1989 uprising in Tiananmen Square. The WWP also opposes Israel as it currently exists; in fact, its anti-Israel slant is so strong that it often sounds like anti-Semitism.

The WWP and International ANSWER could only exist in a wealthy society that gives broad freedom of speech. The groups are— in their rhetoric and demeanor—like angry children rebelling against their affluent, permissive parents.

And the people that the WWP and International ANSWER attract are often—literally—angry children rebelling against their affluent, permissive parents.

While other members of the left denounced International ANSWER, Michael Lerner—a high-profile Bay Area rabbi and editor of the liberal Jewish magazine *Tikkun*—defended the group. When members of his congregation complained about the anti-Israel rhetoric at demonstrations sponsored by International ANSWER, Lerner urged them to participate anyway.

But Lerner should have listened to his congregation. In early 2003, he was banned from speaking at a San Francisco anti-war rally sponsored by International ANSWER.

Why? Because Lerner, a steadfast critic of conservative Israeli governments, supported Israel's right to exist and condemned Palestinian terrorism. An International ANSWER spokesman told WNYC radio host Brian Lehrer that the group wouldn't allow a "pro-Israel" speaker at its demonstrations.

Conclusion

Michael Berube, a Penn State professor who was well-known in anti-war circles, and Marc Cooper, a contributing editor at the liberal *Nation* magazine, drafted a petition that read in part:

> At a time when the anti-war movement needs as broad a platform and as broad an appeal as possible, AN-SWER has chosen instead to put the interests of sectarianism ahead of the interests of all those who oppose this foolish and unnecessary war. We believe this is a serious mistake…and that it exemplifies ANSWER's unfitness to lead mass mobilizations against war in Iraq.

Among the antiwar activists who signed the petition, there was a consistent belief that a principled, intellectually consistent movement was needed—and that ANSWER wasn't it.

But the intramural dispute was damaging. And it was one more example of how anti-war activists and anti-Bush partisans were fighting an obsolete political battle along outdated political lines.

The post-9/11 world of statism-versus-individual liberty has made traditional American political lines irrelevant. The Masonic right-wing cold warriors and Stalinist left-wing political "activists" are abandoned to fight meaningless battles about pointless issues. They don't matter as much as they once did.

Their scratches in the sand will continue for a while. The mainstream media and, frankly, many citizens take comfort in the familiar debates. But these are little more than ritual performance among people and groups more alike than they'd like to admit. They're all statists, of slightly different stripes.

Times have left them behind.

Part Five:
Problems

18 The Patriot Act

A lot of people oppose the USA Patriot Act. What's the libertarian position on the law?

In February 2003, Oregon federal judge Ancer Haggerty heard arguments about whether the government should have to reveal its justification for 36 secret warrants the FBI used to watch and listen to a group of Portland-area people suspected of having ties to al Qaida.

The FBI had arrested Patrice Lumumba Ford, Jeffrey Leon Battle, October Martinique Lewis and brothers Ahmed Ibrahim Bilal and Muhammad Ibrahim Bilal in October 2002. These were the people implicated with Maher Hawash (who was tried separately in California—and whose case appears in Chapter 10). A sixth suspect, Jordanian native Habis Abdu al Saoub—who was believed to be the group's leader—remained at large.

Ford and his fellows—Americans who'd converted to Islam—were accused of trying to travel to Afghanistan in the fall of 2001 to join the fight against American forces there. Evidence against them had been collected under power granted by the newly-enacted U.S. Patriot Act and special warrants issued by the Foreign Intelligence Surveillance court. Without the new guidelines, the investigators wouldn't have been able to use their evidence.

The FBI had started watching the Ford group a few weeks after 9/11, when a sheriff's deputy from a Portland suburb spotted some members firing guns for target practice in a gravel pit. In late 2001, the group tried to get to Afghanistan; they made it as far as China before they were turned back...or changed their minds...and returned to Portland.

Secret warrants in hand, the FBI—assisted by state and local police—began round-the-clock surveillance in early 2002. Investigators tapped the suspects' telephones and monitored their banking, e-mails and Internet use. They pieced together a tale of misdirected, angry people who wanted to hurt the U.S. but weren't clear on the best way to do it.

Ford's defense lawyers admitted that their strategy was to challenge the Patriot Act. So, any decision by Haggerty on the warrants would likely be appealed to the Federal Appeals Circuit in San Francisco...and then to the U.S. Supreme Court.

"Civil liberties for the defendants, and all citizens, certainly are at stake here," said Whitney Boise, Ford's main attorney.

How the Law Was Passed

On October 1, 2001—while the rubble of the World Trade Center was, literally, still smoldering—the House Judiciary Committee voted unanimously to approve a bill that had been drafted by the Bush Administration's Justice Department. The vote, like the bill, was a political act meant to show that the federal government was taking action. In other words, to send a message. Even the bill's name— Uniting and Strengthening America by Providing Appropriate Tools Required to Intercept and Obstruct Terrorism (USA Patriot) Act— smacked of opportunism.

But Justice Department head John Ashcroft was not satisfied with the Judiciary Committee's vote. The committee had modified the language that Ashcroft's staff had drafted. The approved version had

removed language that allowed federal agents to search private homes or businesses secretly. It had cut out language that allowed the government to detain an immigrant indefinitely by declaring it suspected he was involved in terrorism; and it had cut back on the latitude Ashcroft had sought to monitor e-mail correspondence.

The changes reflected concerns voiced by members of the Judiciary Committee from both major political parties. But the main editor of Ashcroft's designs was the committee's chairman, James Sensenbrenner. The chairman wasn't a likely opponent of the Bush Administration; he was a fairly conservative Wisconsin Republican. But Sensenbrenner found a lot to dislike in Ashcroft's plan, starting with the fact that Ashcroft had gone on television to talk about it before contacting the Judiciary Committee.

Ashcroft—who'd been a congressman and senator from Missouri before being appointed Attorney General—knew a thing or two about parliamentary tactics. In the days after the Judiciary Committee vote, he worked with House Speaker Dennis Hastert to step around the changes Sensenbrenner had made.

In mid-October, Hastert replaced the Judiciary Committee's version of the bill with a new version that restored most of what Ashcroft had originally wanted. That version of the bill passed the House on October 24 by a vote of 356 to 66. It passed the Senate the next day by a vote of 98 to 1. George W. Bush signed it into law on the morning of October 26, 2001.

"This bill was carefully drafted and considered," Bush said—anticipating criticisms that the bill had been rushed through Congress without usual debate. The president said the new law was "essential not only to pursuing and punishing terrorists, but also preventing more atrocities in the hands of the evil ones."

Not everyone agreed.

Conservative Texas Congressman Ron Paul—perhaps the closest thing to a libertarian in the U.S. Congress—noted ruefully, "The bill wasn't even printed before the vote." So, the few congressmen who might have wanted to read the text of the thing couldn't.

On the other end of the political spectrum, liberal Senator Russ Feingold—the Senate's lone dissenter against the Patriot Act—was particularly concerned that the Act allowed law enforcement agencies to search a home or an office without notifying a suspect beforehand. Such notifications are important to protect a suspect's rights against illegal search and seizure, Feingold argued.

On the floor of the Senate, Feingold compared the Patriot Act to other legislative misjudgments made in the name of national security, including "the Alien and Sedition Acts, the suspension of habeas corpus during the Civil War, the internment of Japanese-Americans, German-Americans and Italian-Americans during World War II...."

What the Patriot Act Does

The Patriot Act does give law enforcement officials broader authority to conduct electronic surveillance and wiretaps—and it allows wiretaps to be focused on a person rather than a specific phone. It also tightens oversight of financial activities to prevent money laundering and diminish bank secrecy in an effort to disrupt terrorist finances. It permits subpoenas of e-mail records and expands the amount of materials government agencies can share with one another.

These changes don't seem objectionable in principal, especially considering the damage inflicted by the 9/11 attacks. But the details of the changes consistently bring the widest discretion possible to investigating agencies. Of course, this shouldn't be surprising, since the investigative agencies drafted the law.

Other parts of the act are more troubling to anyone who values liberty. One part allows the president, in the wake of a terrorist attack, to seize the personal property of anyone suspected of involvement. The act also allows federal agents to erode attorney-client privilege in some cases by eavesdropping on conversations between lawyers and their clients held in federal custody.

The main thing to know about the Patriot Act is that it spends a lot of time modifying the terms of another law—the Foreign Intelligence Surveillance Act (FISA). Created in the late 1970s as a compromise solution for battling foreign terrorists, the FISA allows federal agents to use looser legal standards in searches whose "primary purpose" is to gather foreign intelligence.

FISA warrants don't require evidence or probable cause; they only require a statement from the government about its intent for the search. And the judge—usually, a federal court judge on special assignment to the FISA court—has no authority to reject an application for a warrant. Federal investigators call the application "seeking a court order," but that's misleading. FISA search warrants don't receive as much scrutiny as traditional ones.

The main limit on FISA was that its looser rules could only be used in investigations of "foreign powers or their agents." The Patriot Act got rid of this limit.

Some constitutional scholars worried that the Patriot Act's many references to FISA could function as a kind of Trojan Horse, slipping dramatic constitutional changes by in the language of legal technicality. But the Bush Administration defended—effectively, in most cases—the Patriot Act as a needed security tool and dismissed criticisms as political exaggerations.

A quick look at the Act's controversial parts can separate the hype from the legitimate concern. For example:

- Section 206 authorizes roving wiretaps. These are taps specific to no single phone or computer, but to every phone or computer a suspect may use. If the government decides that a suspect uses a computer at a Kinko's for e-mail, it can tap that computer—and see any e-mail coming or going to it.

- Section 207 lengthens the durations of FISA warrants to as long as 120 days. It also broadens their use. Under FISA, results of secret search warrants could be used only for in-

formation-gathering, not for prosecution. Under the Patriot Act, intelligence information obtained using secret warrants could be passed along for prosecution purposes.

- Section 213 extends so-called "sneak-and-peek" warrants (in which the target of the search is not informed of the search) from FISA searches to any criminal search. And it allows the Attorney General to issue "emergency authorization" of a Section 213 warrant without court review.

- Section 214 broadens the use of the FISA pen register and trap-and-trace surveillance to both criminal and foreign intelligence investigations, so long as the government certifies that the information obtained would be "relevant to an ongoing investigation."

Pen registers record phone numbers dialed from a suspect's telephone; trap-and-trace devices monitor the sources of incoming calls. Neither reveals the content of communication.

- Section 215 modifies the rules on records searches. Third-party holders of financial, library, travel, telephone, medical, religious records—or "any tangible thing"—can be searched without a suspect's knowledge or consent, as long as the government tells a FISA judge that it's trying to protect against terrorism.

- Section 216 clarifies that pen register/trap-and-trace warrants apply to Internet surveillance. The original language of FISA contemplated only telephone surveillance—so Internet use was a gray area determined by judges on a case-by-case basis. Wiretaps may not be used to intercept "the content" of Internet communications, although the Act doesn't specify what "content" means.

During May 2003 congressional testimony, a Justice Department spokesman said, "We consider non-content to be the 'to' and the 'from.' The subject line is content."

- Section 218 expands the scope of FISA generally. FISA required that the "primary purpose" of a secret search or wire tap was to gather foreign intelligence; this section changes that requisite to "a significant purpose." The target of the search need not be connected to foreign espionage anymore; it's enough that the government might learn something about a terror investigation.

When asked by the House Judiciary Committee in 2002 how many of its warrants met the "significant purpose" standard but would have failed to meet the "primary purpose" standard, the Justice Department said it didn't keep statistics on the distinction.

- Section 314 allows federal investigators to obtain information from any financial institution regarding the accounts of people "engaged in or reasonably suspected, based on credible evidence, of engaging in terrorist acts or money-laundering activities."

Note that "or." The suspect doesn't have to be connected to terrorism.

- Section 505 authorizes the attorney general to compel third-party holders of personal records to turn them over to the government, simply by writing so-called "national security" letters. The records that can be obtained through the letters include telephone logs, e-mail logs, certain financial and bank records, and credit reports. FISA limited use of these letters to investigations of people who were reasonably suspected of espionage. Section 505 widens the application to anyone-including U.S. citizens not suspected of espionage or criminal activity (as long as the records are "relevant" to a terrorist investigation).

So, you can see the way that the Patriot Act works. Many of its controversial changes do work by changing the pre-existing FISA. And, even then, they chip away at the small details of constitutional

protections against illegal search and seizure. It's a crafty approach to changes that many Americans—and most libertarians—find objectionable.

How the Act Is Being Implemented

Federal investigators wasted little time using the broader investigative powers that the Patriot Act allowed.

The FBI particularly stepped up its use of national security letters. Ashcroft signed off on 170 emergency Section 505 letters in the months after 9/11. This was three times the number authorized in the previous 23 years.

Beyond these basic outlines, details of how the Patriot Act was being used were hard to find. The Feds draped themselves in a cloak of national security secrecy.

The Patriot Act requires semiannual reporting by the Attorney General to Congress, but the only thing he must report is the number of applications sought and granted. When asked by the House Committee on the Judiciary to detail whether and how many times Section 215 had been used "to obtain records from a public library, bookstore or newspaper," a Justice Department spokesman said the department would send classified answers to the House Permanent Select Committee on Intelligence. The judiciary committee had what it called "reasonable limited access" to those responses, and it reported in October 2002 that its review had "not given any rise to concern that the authority is being misused or abused."

Even Freedom of Information Act (FOIA) requests don't do much good when it comes to the Patriot Act. FOIA includes a broad "national security" exception; and the Patriot Act defines almost every government action that it allows as a national security matter.

Otherwise, Americans have to count on the odd crack in the state's bureaucracy to discover details about use of the Patriot Act.

One such crack came in 2002, when the FISA court ruled against Ashcroft on at least one application, saying he had misinterpreted the

Patriot Act in regard to the use of secret wiretaps. This ruling became public because Ashcroft had to appeal the decision to the Foreign Intelligence Surveillance Court of Review—also provided for in FISA but rarely convened. It was; and it upheld Ashcroft's version of things.

That small bit of daylight into the workings of the FISA courts led to an appeal to the U.S. Supreme Court by the American Civil Liberties Union, the National Association of Criminal Defense lawyers and Arab-American groups. But the appeal was a long shot because there was no aggrieved party claiming a specific infringement of his or her rights. Instead, the ACLU filed its appeal on behalf of individuals who might not know they were being monitored.

In March 2003, the U.S. Supreme Court refused to hear the case.

Later during congressional testimony in May 2003, Assistant Attorney General Viet Dinh allowed a little more daylight. He said that in "an informal survey of the field offices," his office had learned "that libraries have been contacted approximately 50 times, based on articulable suspicion or voluntary calls from librarians regarding suspicious activity." He didn't give any further specifics.

Although details about the use of Patriot Act provisions are kept quiet, John Ashcroft speaks often and generally about it. In congressional testimony during the spring of 2003, he said that courts across the country had issued some 18,000 terrorism-related subpoenas and search warrants in the 18 months following 9/11.

He insists that the Act was needed because the separation between intelligence gathering and criminal prosecutions was a barrier to pursuing terrorists hatching criminal plots. But, even if a libertarian agrees with that end, the tools that Ashcroft prefers—sweeping surveillance of the unsuspecting—is a classic example of state interference.

Because so much of how the Patriot Act is being used remains secret, there's little chance to hold government accountable for abuses. This was probably what the FISA court was trying to do when it ruled against Ashcroft in 2002; but no one can be sure precisely what the court meant, because its proceeding remains sealed.

A Case Study of Patriot Act Use

In October 2003, law enforcement authorities in the Las Vegas area confirmed that the FBI had used the Patriot Act to subpoena financial information in an investigation of strip club owner Michael Galardi and his alleged bribery of politicians in southern Nevada in exchange for favorable zoning treatment for his clubs. There was no apparent connection between the Galardi investigation and any terrorist act.

A special agent with the FBI's Las Vegas field office told a local newspaper that the Patriot Act "was used appropriately by the FBI and was clearly within the legal parameters of the statute."

Apparently, the FBI sought the records under the Patriot Act's Section 314—which focuses on money laundering activities.

According to one published report, two Las Vegas stockbrokers were faxed subpoenas in late October, asking for records for many of those identified as either a target or subject of the FBI's investigation. That list included Galardi, owner of the Jaguars and Cheetah's strip clubs, as well as four current and former county commissioners and two Las Vegas city councilmen.

The Section 314 subpoena appeared to be a search for hidden proceeds that could be used as evidence of bribery.

Las Vegas attorney Dominic Gentile, who was representing one of the alleged bribe-takers, said he planned to mount a legal challenge to any use of the Patriot Act. Gentile told a local newspaper: "My research indicates that this is the first time the government has used Section 314 in a purely white-collar criminal investigation."

Mark Corallo, the Justice Department spokesman handling questions related to the Galardi investigation, said federal law enforcement officials had no qualms about using the Patriot Act to pursue criminal investigations that have nothing to do with terrorism—such as child pornography, drug trafficking and money laundering. Corallo told one newspaper:

> I think most of the American people think the Pa-
> triot Act is a good thing and it's not affecting their
> civil liberties at all, and that the government should
> use any constitutional and legal tools it can, whether
> it's going after garden-variety criminals or terrorists.

This was a presumptuous statement—and certainly the kind of statist arrogance that bothers libertarians. In fact, it bothered two of Nevada's senior politicians.

When asked about the Galardi investigation, Harry Reid—one of the state's U.S. Senators and a conservative Democrat—said that Congress had intended the Patriot Act to help federal authorities prosecute terrorists. Reid scoffed that, "The law was intended for activities related to terrorism and not to naked women.... More activity like this is going to cause us to take a close look at what was passed."

Congresswoman Shelley Berkley, also a conservative Democrat, said she was preparing a letter for the FBI, asking about its guidelines for using the Patriot Act in cases that didn't involve terrorism. "It was never my intention that the Patriot Act be used for garden-variety crimes and investigations," she said.

Backlash to the Patriot Act

Congressional skepticism about the uses of the Patriot Act had been brewing almost since the act was passed.

In 2002, House Judiciary Chairman James Sensenbrenner and his Democratic counterpart John Conyers had asked the Justice Department to provide the committee with basic statistical information about its use of Patriot Act tools. The department stalled so long that Sensenbrenner eventually threatened to issue subpoenas and to vote against renewal of the Act when it expired in 2005.

Sensenbrenner said he told Ashcroft: "If you want to play 'I've got a secret' good luck getting the Patriot Act extended. Because, if you've got bipartisan anger in the Congress, the sunset will come and the Patriot Act disappears."

Shortly afterward, the Justice Department provided answers to the committee's questions. In April 2003, Sensenbrenner and Conyers released the information. Among the interesting points:

- The Department had used the Patriot Act for non-terrorism cases (drug violations, credit card fraud, theft from a bank account, a lawyer who defrauded his clients).

- The Department had sought and the courts had authorized delayed notification of "sneak and peak" search warrants 47 times.

- The Attorney General had made emergency authorizations 113 times for FISA electronic surveillance and/or physical searches (that means, without court review) in a one-year period.

After receiving—and releasing—the answers from Ashcroft, Sensenbrenner said that he would fight any effort now to make the Patriot Act's expanded police powers permanent.

Not everyone in Washington shared this opinion. In the spring of 2003, Utah Senator Orrin Hatch proposed removing the 2005 expiration date for Patriot Act powers. Hatch said he didn't want the Act to sunset "until terrorism does."

But Hatch's proposal backfired. A critical mass of opinion among lawmakers across the ideological spectrum was emerging to rein the Patriot Act in, not expand it. Sensenbrenner said repealing the sunset provision was a "non-starter" with his committee. The sunset provision had been the only leverage lawmakers had in overseeing the law and getting Ashcroft and his staff to answer questions about how they were using it.

The Backlash Culminates with "Patriot II"

With conventional wisdom turning against the Patriot Act, early 2003 was not the best time for suggestions about expanding or en-

larging the scope of the Act. But that's precisely when one such suggestion leaked out.

In February, the Center for Public Integrity—a partisan lobbying group, very critical of the Bush Administration—released the draft of a new bill developed by Ashcroft's staff.

The bill, titled the Domestic Security Enhancement Act of 2003, had not been officially released by the Justice Department, although rumors had been circulating about it for months. Capitol staffers and lobbyists called it "Patriot II."

The proposed bill turned the expanded police and investigative powers squarely on American citizens. It was a blueprint for statist interference and coercion.

Under the bill's provisions, the government could:

- wiretap any person for 15 days without a judge's approval;

- demand personal information such as credit records without judicial review;

- keep arrests secret until criminal charges were brought, no matter how long that took; and

- strip Americans of their citizenship if they even unwittingly helped any group the Justice Department determined to be terrorist-related.

Patriot II also made other disturbing changes in an already-disturbing law. It expanded the Attorney General's authority to invoke emergency FISA warrants without judicial review; and it changed the definition of a "foreign power" to include individuals (Beltway types called this the "Moussaoui Fix," because the FBI's investigation of alleged 9/11 accomplice Zacarias Moussaoui was hampered by the "foreign power" definition).

The Patriot II bill was statism at its worst. It was specific legal gamesmanship pretending to be public policy. It added indefensible tools of interference and coercion to a government that already had more than it should.

By the fall of 2003, as the second anniversary of the 9/11 attacks approached, popular opinion had turned squarely against the Patriot Act. Some 152 local communities had passed resolutions denouncing the Patriot Act as an assault on civil liberties. Of course, these resolutions were only symbolic; but they reflected a growing objection.

In the late summer, the so-called "Otter Amendment"—which prohibited federal funds to be used in support of the Act's "sneak-and-peek" warrants—had passed in the House by a vote of 309 to 118. Introduced by C.L. Otter, a conservative Republican from Idaho, the amendment revealed the extent to which the Patriot Act had lost congressional support.

Ashcroft responded by making a series of public appearances in which he denounced the contention that the FBI was using the Patriot Act to snoop into Americans' reading habits as "hysteria." In one such speech—to the American Restaurant Association—Ashcroft said people were being led to believe that libraries had been "surrounded by the FBI," with agents interrogating patrons.

Ashcroft insisted that subpoenas of library records were closely scrutinized by federal judges. He said that the main reason an FBI agent would want library records would be to track use of its publicly available computers, which terrorists have been known to use. "The hysteria is ridiculous. Our job is not," Ashcroft concluded.

Fair enough. But his turf battles with James Sensenbrenner had made Ashcroft look like a statist with something to hide.

Conclusion

The Patriot Act is a bad law. One proof: The best argument its defenders can make is that it isn't used as often as people think it is.

Every political system produces some bad law. One of America's great strengths is that its system is pretty good at fixing its bad laws quickly.

The see-saw dynamic between liberty and security is an eternal truth of any state. A pragmatic libertarian should accept the back-and-forth nature of liberty and security as a normal tension of democracy. It's unlikely that either goal can absolutely prevail over the other. The goals are mutually exclusive...and public sentiment shifts its support from one to the other, shaped by circumstances.

In the immediate aftermath of the 9/11 attacks, Americans wanted their government to do something. John Ashcroft's Justice Department was very savvy at producing that "something." As time moves away from 9/11, the need for "something" diminishes...and the Patriot Act should, too. Libertarians need to keep their eye on the law to make sure that it does.

Maybe the worst effect of the Patriot Act is that it gave state agencies one more excuse to be secretive. It has encouraged the Attorney General to be childishly uncooperative with the head of the House Judiciary Committee.

A few parts of the Patriot Act are important tools for fighting terrorism—the ability to use roving wiretaps and the increased flexibility in using evidence gained from FISA search warrants in domestic prosecutions are reasonable changes. But, in 2005, the rest should fade into the sunset.

19 The Department of Homeland Security

In the wake of the 9/11 attacks, the U.S. Government did what governments do best—it created more bureaucracy to respond. Is there any libertarian defense for the Department of Homeland Security?

In the summer of 2002, George W. Bush signed into law the Homeland Security Act, creating the Department of Homeland Security (DHS). The new department would involve the largest reorganization of the U.S. federal government in 50 years.

The DHS swallowed more than 20 federal agencies, including the Coast Guard, Customs Department and perennially mismanaged Immigration and Naturalization Service (INS).

Bush named former Pennsylvania governor and personal friend Tom Ridge to head DHS (Ridge had held an analogous position in the Bush White House before DHS became its own department). Like Bush, Ridge was a statist Republican—the type who talks about the virtues of small government but, in practice, expands government institutions as aggressively as his Democrat rivals.

Also like Bush (and maybe more so), Ridge comes across as a common-sense fellow who seeks only the best results for taxpayers.

But his responsibilities as head of DHS would test this image. The challenge came in two parts:

1) from a managerial perspective, the transfer of 20-plus agencies (each with its own bureaucracy and quirks) to DHS was extremely difficult. Failure or mediocrity would result in massive ineffectiveness, with each agency an isolated bureaucratic fiefdom;

2) from a policy perspective, even if the DHS could be whipped into managerial shape, the responsibilities assigned to it included many of the biggest threats a state can make to individual liberty; anyone short of a committed libertarian would run the risk of trampling on important liberties.

Ridge's first moves focused on the first part. That might have made sense, from a managerial perspective. But libertarians worried that it meant all Ridge would have left for the policy matters was talk.

Ridge Describes His Vision for DHS

At a meeting of the Association of American Universities in April 2003, Tom Ridge laid out his vision of how the DHS would operate:

> [Terrorism is] a permanent part of our environment now, whether it's bin Laden and al Qaida or any successor leadership or successor organization.
>
> ...We must secure our free republic from those who seek to destroy it, who threaten not just our liberties, but also our lives.
>
> After the terrorist attacks of September 11th, there were calls to share information between intelligence and law enforcement, to enforce our immigration laws and accurately determine who is visiting our country and why, to protect sensitive information, such as Web sites describing how to make a biological or chemical

weapon from anonymous persons and their unknown purposes.

America has rightly answered those calls, but we need to still be searching with the precise response that makes all of us content with how we're dealing with those challenges.

...We will not, as Franklin once warned, trade our essential liberties to purchase temporary safety.

This all sounded good—Ridge seemed to understand the liberty concerns raised by his department's mission. He acknowledged that fear of government abuse of private information was real—though he insisted Americans shouldn't let it stop the government "from doing what is right and responsible."

Ridge said that the antidote to privacy fears was an open and transparent process that guaranteed the protection and privacy of that data. In addition to the federal privacy safeguards already on the books, he said, the DHS would name its own privacy officer to review policies and practices.

Since he was talking to university heads, Ridge discussed several issues related to the treatment of sensitive information resulting from government-funded university research. This topic had particular importance to biological and chemical research; in the DHS's eyes, such research was a testing ground (sometimes literally) for biological or chemical weapons. Ridge said:

National Security Decision Directive 189...states in part that the products of fundamental research should remain unrestricted. The mechanism for control of information generated during federally-funded fundamental research is classification.

That remains the policy of the administration to this day, although it has been related to me that it is applied from your point of view inconsistently and sometimes differently, even within a civil agency. If noth-

ing else, we'd like to see a consistent application in-
tra-agency and then work on perhaps an interagency
approach across the board.

Ridge concluded by promoting his agency as a source for research
funding:

Just as Americans built an arsenal of democracy to
win World War II, the challenge now is to design a
shield of science for the war on terrorism. To that end,
this year nearly half-a-billion dollars will be transferred
to our department's new Science and Technology Di-
rectorate. And I should tell you we've asked for a 43
percent budget increase for science and technology
programs for the next fiscal year as well.

Clearly, Ridge understood how to use big-government dollars to
influence his audiences—and potential critics.

Infrastructure Risks

As the two-year anniversary of the 9/11 attacks approached, the
DHS noted that the United States remained full of vulnerability points.
In the summer and fall of 2003, a lot of expert attention turned to the
various commercial chemical and hazardous-materials plants scattered
around the country. Bureaucrats and government contractors sensed
big money in identifying—and protecting—those plants.

The Environmental Protection Agency pointed out that more than
7,700 of these plants were located in places where a thousand or more
people could be injured in an accident or attack. The DHS issued
policy papers on how to secure these plants; and the Bush White
House promised to draft legislation formalizing a plan.

These exposures fit, generally, in the category "infrastructure risks."
More specifically, the U.S. has:

- nearly 66,000 chemical and hazardous-materials plants, in
 all;

- some 5,000 public airports;

- more than 2,800 power plants, of which 104 are nuclear;

- 80,000 dams;

- 120,000 miles of major railroads;

- 2 million miles of pipelines;

- 590,000 highway bridges;

- 500 major public transit operations;

- more than 300 seaports; and

- 1,800 federal reservoirs—never mind the municipal ones.

That makes several million targets for al Qaida or other terrorists; and most of these targets are much easier to access than a commercial jet. To secure even some of them is a complex task.

Most of these targets are located in restricted areas, places where no one except authorized personnel (maintenance or security staff, for example) should ever be. The problem is how to watch everything effectively. Terrorists could go wherever patrols or monitors weren't looking.

The best response? Decentralized systems for observing sites and analyzing the images. Instead of bringing guards to the critical infrastructure, bring the infrastructure to the guards.

In 2002 and 2003, a number of for-profit start-up companies appeared—with business models based on building non-traditional systems for security infrastructure. These start-ups were a kind of antidote to the stated bureaucracy of the U.S. And they held strong appeal to libertarians.

The mechanics of the systems usually followed similar lines. Digital cameras are placed at regular intervals along the periphery of a secure site. The cameras are motion-sensitive; they take still digital pictures when they detect something moving.

Placing the cameras is the easy part; in fact, most sites already have them in place. The hard part is reviewing the pictures. Most of the systems connect the cameras to data centers that screen out all photos in which no change or movement has occurred. This eliminates most of the images; but it still leaves a lot—thousands an hours, during peak periods.

At this point, most of the systems circulate pictures to a group of freelance "spotters," and asks whether a person or vehicle is visible.

These freelance spotters sign up online and can work whenever they choose.

Sitting at home or anywhere else with Internet access, they might log on to the site and look at pictures—replying (by clicking a button on the screen) only if and when they see a person or vehicle. Usually, they have no idea what they're looking at—and this was an important feature. The systems would randomly order the images so no one gets too familiar with any location. If one or more spotters see a person or vehicle, the system sends the same picture to a dozen or more other spotters. If those spotters confirm the presence of a person or car, the professionals take over.

None of the spotters would need to do anything complicated or risky.

"We've modeled this system on the human brain," said spokesman for Connecticut-based Walker Digital, which developed a system. Each spotter is like a neuron, making a simple response. "The neuron doesn't know what the brain is thinking."

In the human brain, the intelligence is in the system.

These systems were an appealing alternative to DHS directorates for any libertarian. They used the power of the marketplace and individual enterprise to accomplish large, institutional goals. And—since most use the Internet for their data gathering and analysis—they seemed to employ the new medium to change business as go-go types raved it would during the dot.com bubble.

The Threat of Bureaucracy

In fact, the DHS was such a leviathan that even big-government Democrats in Washington worried about its statist excess. In a March 2003 congressional hearing, a number of politicians voiced concerns about the DHS's effectiveness. Oregon Congressman Peter Defazio expressed this concern clearly:

> ...that the creation of a 170,000 person bureaucracy with some very important and previously high functioning agencies like the Coast Guard with totally dysfunctional agencies, like INS may not enhance our nation's security and better protect the American people. But that's done. And now we've got to make sense out of the hash that's been served to us here.

Ridge's challenge was to do that without getting bogged down by the inertia of a huge bureaucracy. Even Massachusetts Congressman Ed Markey, a left-wing statist of long standing, understood the importance of pressing against this inertia:

> ...Many observers believe that we cannot expect to see the new department working smoothly for at least two years given the nature of the forced merger of 22 federal agencies. We must do everything we can to sharply reduce those estimates because the timing of another al Qaida attack could be tied directly to any confusion or lack of clear lines of authority within the department.

But Markey couldn't resist slipping in some partisan, statist—and particularly anti-business—slights:

> ...Homeland security will also require sacrifices from the private sector. For example, the nuclear industry must stop resisting all legislative and administrative efforts to beef up the security of nuclear reactors, which we know is at the very top of the target list of al Qaida.

The chemical industry must take all necessary steps to prevent a catastrophic release of toxic materials. And the owners and operators of this nation's infrastructure, from the Internet to financial institutions to oil pipelines must do what they have to do.

Libertarians—and all taxpayers—should be wary when statists invoke the favorite tautology "do what you have to do." That usually means you have to give up liberties...or money.

Conclusion

Some security experts worry that the DHS would focus so much on public opinion and managing its own bureaucracy that it will forget the simple things it could do to make security work more smoothly. In early 2003, some state security officials claimed that it was more difficult to get information and feedback from federal agencies after DHS was formed than before. If this remained true, it would presage trouble.

To use a business metaphor, DHS may be spending too much time trying to manage the "retail" end of security (with its color-scheme warnings and multi-variable organization charts) and ignore the "wholesale" end...where it can probably do the most good.

What is the "wholesale" end of security? It is—primarily—a matter of coordinating communications among government agencies and thousands of local agencies. The local agencies are the sheriff, police and fire departments who are the "first responders" to disasters of just about any sort.

DHS could do the most good in preventing terrorism by coordinating America's intelligence analysis and sharing information among federal, state and local authorities. Beyond preventing terror attacks, another use of intelligence is to inform decisions on how best to secure our ports, borders and airports, and how to protect critical infrastructure. Even DHS Secretary Ridge acknowledged this:

The key to this effort is information. Terrorists hide among us and use our freedoms against us, but they will find fewer places to hide if we provide accurate, verifiable and timely information to the people charged with protecting us.

But this coordinating is a tough job.

Ridge—a statist by temperament—seems to offer to buy his way out of any problems in coordinating communication. This Daddy Warbucks approach, which Ridge made in terms of research funding to the university heads, gives pause to any libertarian who prefers to see government remain as small as possible.

Ridge—a former governor of Pennsylvania—is a politician. Like most politicians, he is used to being an appropriator, doling out state resources to groups that want it. He does his job well when he appropriates effectively, not when he doesn't appropriate. And head of DHS is a high-profile job. If he does it well, he may be able to seek a higher elected office.

And that's exactly the problem.

There's no libertarian defense for a statist leviathan like DHS. Its best role should be coordinating the efforts of private-sector firms developing security systems that mimic the human brain.

20 Racial Profiling, Identity Politics and Hate Crimes

The 9/11 terrorists were all Arabs. Is anyone going to admit this? And, if so, what does this mean for American presumptions about liberty?

In September 2002, six young men from the Buffalo, New York, suburb of Lackawanna were arrested and...eventually...charged with providing material support to al Qaida terrorists. According to the government, the men—all U.S. citizens (five native-born) and all Muslims—had traveled to Afghanistan just before the 9/11 attacks and received training from al Qaida military operatives.

In the spring of 2001, the six traveled to Pakistan for a spiritual retreat under the auspices of Tablighi Jamaat, a Pakistani missionary group. Then, according to the federal prosecutors, they moved on to Afghanistan. They allegedly went to a camp where they assembled and disassembled rifles, learned to shoot and climb mountains, watched explosives go off, slept in tents, wore uniforms and were ordered to avoid small-talk. One day they saw Osama bin Laden, who made a speech "espousing anti-United States and anti-Israeli sentiments." Then, they were sent home to Lackawanna to await orders.

One of the men was a burgeoning identity thief—he had numerous Social Security numbers and credit cards in several names. The

government also found ominous e-mail messages. "The next meal will be very huge," one e-mail message said, an allusion to an upcoming attack. "No one will be able to withstand it, except those with faith."

Perhaps the most damning part of the case was that there had been, at one point, more than six men in the group of defendants. Kamal Derwish had traveled to Yemen after the 9/11 attacks. (Derwish, an American who'd lived briefly in Lackawanna, had allegedly arranged the other men's journey to Afghanistan.) He was killed in late 2002, when a U.S. Predator drone fired a missile at a car in Yemen, killing everyone inside—including an alleged high-ranking al Qaida figure.

At their arraignments, the six men gave contradictory accounts of where they had traveled. Some admitted that they'd gone to Afghanistan; others insisted they'd only gone to Pakistan. At least one seemed to have engineered the loss of his passport in a poorly thought out attempt to avoid suspicion.

The men fit a reasonable profile for al Qaida operatives—with one exception. They were all under 30 years old, most were unmarried, most were of Yemeni heritage, all were devout Muslims—but they were U.S. citizens. *That* was unusual.

Government investigators, as well as local Buffalo-area law enforcement officers, noted that the Yemeni community in Lackawanna was insular. Locals said that, for most of the Yemeni immigrants, assimilation with American culture took a backseat to the self-conscious retention of traditional ways.

Perhaps it would be rational for law enforcement officials to profile young men from such a cloistered immigrant community as potential al Qaida sleeper agents. But it does seem somehow...un-American...to brand a whole immigrant community as suspect.

Government prosecutors argued that the Lackawanna case presented a special twist, because a "conspiracy of silence" was central to the defendants' alleged violation of U.S. anti-terrorism laws. After the 9/11 attacks, the six men said nothing.

"While the defendants have roots in the Yemeni community of Lackawanna," the government argued, by their silence "the defendants failed to demonstrate [their] ties to the American community, let alone their allegiance to the American community."

This wasn't a particularly strong case. The entire "conspiracy of silence" argument seemed to support the worst impressions of ethnic suspicion.

But evidently the charges had *some* merit. Various members of the group started accepting plea bargains with the Feds. One admitted that he'd had transactions with al Qaida—he paid for a uniform, stood guard duty at the camp and received the training that the Feds described. He agreed to a 10-year sentence, which could be reduced to seven. His relatives said his attorney had suggested he cut his losses.

The Mechanics of Profiling

The case for ethnic profiling in security and law enforcement is made by the pictures of the 9/11 terrorists. All Arab; all male; all under 40 years old.

The case against ethnic profiling is Timothy McVeigh, who killed dozens of pre-school children when he blew up the Alfred P. Murrah federal building in Oklahoma City on April 19, 1995. In the immediate aftermath of that bombing, law enforcement agents were looking for people more like the 9/11 crew. They were wrong.

Security professionals have the unenviable task of poring through mountains of data, looking for the handful of bits of intelligence that can help prevent terrorist violence. Prevention is labor-intensive. Round-the-clock surveillance of one suspect can tie up a dozen agents.

When they're being candid, these people admit that profiling is an inevitable aspect of sorting through the volumes of information and prioritizing manpower. Ethnic profiling is a fact of life. But, before a libertarian cheers or despairs, one key question needs to be answered: What—exactly—*is* ethnic profiling?

Profiling is the use of general descriptions to help law enforcement officers direct their attention to most-likely perpetrators.

When it's done well, profiling means giving officers a series of detailed descriptions, including age, gender, race, dress, demeanor, behavior, etc. based on supportable facts from arrest records—and encouraging them to look twice when they observe someone who matches.

One example: El Al Airlines, often lauded for profiling passengers, doesn't simply rely on race or ethnicity: Its profile of potential terrorists reportedly includes "young single women traveling alone."

When it's done badly, profiling can mean discrimination. In late February 2003, the California Highway Patrol settled a class-action lawsuit related to discriminatory profiling by extending a ban on some searches and requiring officers to specify with "specific and articulable facts" the reason for each drug-related traffic stop. According to the settlement, "A mere suspicion or *hunch* is not sufficient."

The lawsuit had originated in 1999 with a single plaintiff—San Jose lawyer Curtis Rodriguez. Rodriguez said that, in 1998, he was driving near San Jose when he noticed CHP troopers pulling over Hispanic drivers. He decided to take photographs of the stops, to establish that the drivers were all Hispanic. The CHP troopers noticed Rodriguez taking the pictures and pulled him over. Although his driver's license and insurance papers were in order, Rodriguez was detained while a drug-sniffing dog checked his car. The troopers and their dog found nothing illegal.

There is no specific law against ethnic profiling. The legal theories behind lawsuits like Rodriguez's are usually based on the 14th Amendment, the Civil Rights Act of 1964 (and its several updates) or local anti-discrimination laws. But the real theory behind lawsuits like the one against the CHP is politics: They are a mild form of extortion, racially-charged shakedowns of public institutions.

The ACLU—which has been involved in many such cases, including Rodriguez'—has a cynical nickname for profiling cases: DWB lawsuits. *DWB* stands for "driving while black."

It's hard for a libertarian to support either side in a case like the CHP profiling lawsuit: the overzealous troopers or the extortionist "civil rights activists."

The CHP, like many law enforcement agencies, seems to attract employees who are overzealous by nature. But the ACLU's position seems to be more hypocritical. In most of its lawsuits, the group demands a large, activist state that measures people and institutions by racial and ethnic quotas—then, when a law enforcement agency uses the same standards, the ACLU objects.

Muslims and Profiling

In the wake of the CHP settlement, ACLU lawyers said the settlement was particularly important given the targeting of Arab and Muslim Americans by terrorism investigators.

Some Arab and Muslim groups confirmed the concern. James Zogby, executive director of the Arab-American Institute, noted that—according to the U.S. Justice Department's own reports—more than 1,100 men of Middle Eastern origin were arrested, detained and, in many cases, deported after 9/11 (though none was charged as a terrorist). The Feds also required visa holders from 25 mostly Muslim countries to be fingerprinted and photographed.

"All we've seen so far is that these powers have been used more in the form of persecution than prosecution," Zogby said. "They have not been devoted to dealing with specific crimes, but they've been used in a crude form of profiling against visible individuals from very specific communities, the only specificity here being Arabs and Muslims. I find that very troubling."

These concerns were rational; others were not. Throughout 2002 and 2003, various political advocacy groups—including some local ACLU spokesmen—compared ethnic profiling of Arab nationals living or visiting in the United States to the internment of Japanese Americans in World War II. The comparison was absurd. Detaining

Middle Eastern visitors, many in violation of their visas, was not equivalent to putting American citizens in prison camps.

Besides, some of the FBI's experiences in the months before 9/11 made the case *for* more aggressive ethnic profiling. The Bureau had intelligence that several of the hijackers were behaving suspiciously (moving around a lot, not enrolled in school, as their visas required).

More specifically, the FBI's Phoenix, Arizona, office had noted that an unusual number of Arab immigrants were taking flight training there—and elsewhere. The Phoenix office asked FBI headquarters for permission to investigate the Arabs-in-flight-training scenario more closely. The bureaucrats hesitated to give permission, largely because they were afraid of appearing to condone ethnic profiling.

After 9/11, the FBI had to tread a narrow path between profiling the Arab community in America and defending it against ignorant efforts at revenge for the attacks. Several times during the year after the attacks, the FBI issued statements saying that violence against Americans of Arab extraction would not be tolerated.

However, it had been questioning immigrants from Arab countries consistently since 9/11. And, in early 2003, it widened the questioning to include some 11,000 Iraqi nationals about possible terrorist attacks related to the U.S. military action in Iraq. At the same time, it moved to apprehend any Iraqi immigrants who were in the U.S. illegally (overstaying their visas, for example, which had been a common tactic of the 9/11 terrorists).

Arab-American and civil liberties groups denounced the new round of FBI questioning as ethnic profiling. But the complaints fell on deaf ears in the media and general population. The political/extortion element to ethnic profiling complaints requires an institutional insecurity or guilt over racism or bigotry. When it comes to post-9/11 security matters, that guilt doesn't stack up high enough.

Complaints and Hypocrisy

The mechanisms of state are powerful and inexact things. That's why they shouldn't be used casually. If you demand that the state measure race and ethnicity by millimeters in one context, you have to expect it will use the same measurements in other contexts.

A libertarian may grudgingly allow the law enforcement efficiency of ethnic profiling to combat a security threat that has a clear ethnic component. That grudging allowance follows from the fundamental compromise of the social contract.

Complaints from statists about ethnic profiling follow from opportunism and hypocrisy.

This opportunism and hypocrisy get their political cover from the fact that America remains culturally dysfunctional on the matter of race. This dysfunction undoubtedly traces back in U.S. history to the economy's early dependence on (predominantly black) slave labor. Wise cultural critics have likened slavery and race to America's "original sin." And that metaphor, unlike many cultural ones, seems to work.

Original sin—the spiritual flaw that makes later, greater spiritual development possible—is an interesting metaphysical concept. Its application to cultural identity is an artful one. But artful cultural criticism has a hard time working with the specific, material concerns of the daily interaction between citizens and their state. The resulting trouble makes for statist solutions that libertarians loathe.

The compromise that makes up the fundamental social contract between free citizens and their state leads to many other compromises in the way the state enforces its laws and standards. None of these compromises results in rousing examples of liberty.

The best a pragmatic libertarian can hope for is that a basic level of security results from the reasonable enforcement of laws.

Hate Crime Laws

In June 2002, Jeffrey Owen was stabbed during a late-night argument in the parking lot of a bar called The Menagerie, near Riverside, California. He bled to death the following morning, after he was given an overdose of an anti-clotting medicine at Riverside County Regional Medical Center.

The Menagerie was a well-known gay bar. People who'd witnessed the crime said that a group of young Hispanic men had approached Owen and several acquaintances and provoked a fight. The Hispanics allegedly made some gay slurs.

It didn't take detectives long to locate the likely suspects: A group of six men in their late teens and early 20s who affected gang behavior. County prosecutors argued that Owen was targeted by the young men because he was gay, making the attack a hate crime.

The addition of the hate crime to the murder charges increased the sentence the alleged attackers faced. For example, 19-year-old Dorian Gutierrez—allegedly the one who stabbed Owen—would face a no-parole life term if convicted of murder and a hate crime.

Lawyers for the young men made a consistent argument against the hate crime charge. They all claimed that the altercation was a fair fight between two evenly matched groups of inebriated men...and that Owen's death was an unfortunate accident. In all, they argued, the fight had nothing to do with Owen's sexual orientation.

Following California's long criminal trial process, the alleged attackers finally faced a judge in early January 2003. Judge Patrick Magers ordered all six to stand trial in connection with Owen's death. But he did them a big favor by dismissing the hate crime charges from the start.

In his ruling, Magers agreed with the defense lawyers that the fight had been "more of a mutual combat situation" between the defendants and Owens and his friends. For that reason, chief among several, he didn't think there was enough evidence to find that the attack was a hate crime.

Magers's decision resulted in a protest that dogged the rest of the trial. The protest, in turn, illustrated how little most people—even lawyers and activists—understand how hate crimes work.

In typical political rhetoric, the head of Riverside's Human Relations Commission said during the protest that Owen's death and Magers's ruling "challenged the community to demonstrate" that hate crimes would not be tolerated.

But the question of what constitutes a hate crime was another matter. Under hate crime laws, *hate* is usually defined in a thicket of legalistic and bureaucratic jargon.

Subjectivity Based on Subjectivity

Hate crime laws are an example of bureaucratic statism run amok. They are, at best, an example of unintended consequence—well-meaning efforts to outlaw destructive behavior that become wooly-headed exercises in social engineering. At worst, they are the tool of an elite trying to force their beliefs on the public.

And, perhaps most insidious, hate crimes create a false impression on political groups that consider themselves aggrieved; these groups often assume that hate laws prohibit more than they do and protect "rights" that they don't. The result is political expectations that are raised artificially—only to be dashed, inevitably, at some point.

Hate crime laws are designed to add punishment to certain crimes if those crimes can be shown to have been committed against a person because of his or her membership in a minority group. In other words, they are intended to punish felons who are bigots more severely than felons who are...just felons. So, the simplest and most compelling conclusion to draw about hate crime laws is that they're unnecessary.

Hate crime laws would not have added any meaningful condemnation of the felons who killed Matthew Shepard—who was gay—in Wyoming or James Byrd—who was black—in Texas. In fact, from a philosophical perspective, hate crime prosecutions would only have detracted from the clarity of the charges against those killers.

Murder is a felony because it's an intentional act. The hatreds that inform the intention aren't relevant; the act is damnable enough.

On the subject of subjectivity, why should hate be singled out for criminalization? Sadness, fear, anger, despair and greed are all human emotions that can rival hate in their destructiveness. Like hate, they may be connected to a political belief system...or, like hate, they may not. Why aren't those negative emotions outlawed? Because hate is subjective...or more measurable? It's not.

Even the most solid hate crime cases often involve some elements that come disturbingly close to Orwellian thought crime.

Hate Is Hard to Locate, Precisely

On a Saturday afternoon in January 2003, Jesse Goodmonson was being dropped off by some friends in a parking lot near his duplex apartment in Vancouver, Washington.

Goodmonson, a 17-year-old of mixed-race background (he considered himself black), was saying goodbye to his friends when he noticed a guest of one of his neighbors staring at him. Goodmonson said the man's shaved head and tattoos caught his attention.

"What the fuck are you looking at?" another guest asked.

Goodmonson noticed that the neighbor and his guests—who were leaving for a concert—were standing on the Goodmonson family's lot. He later told police that he answered, "Get off my property, bitch."

That didn't go over well.

The neighbor—32-year-old Matthew Schmoyer—led 10 or 12 of his friends in a rush on Goodmonson. The teenager took at least one punch to the face and numerous kicks to the back and head. "I just covered up and took the blows," he said later.

While they attacked Goodmonson, Schmoyer's crew screamed obscenities and the predictable racial epithets. Goodmonson's friends—as well as a few neighbors—witnessed the attack. A couple of his friends managed to scramble out of their car and tried to separate him from the attackers; but Schmoyer's guests held them back.

Dorothe Goodmonson, Jesse's mother, heard the commotion and rushed out to see her son being beaten. She jumped on the back of one of the attackers and yelled for the neighbors to call the police. That prompted Schmoyer's crew to break off and flee the scene.

Goodmonson was bruised and sore…but not seriously injured.

When the Clark County sheriff's deputies arrived, they talked to the Goodmonsons and various witnesses. The deputies concluded that there had been a hate crime. They spent most of that evening investigating and eventually searched Schmoyer's apartment.

The apartment was full of racist material. Investigators found a computer with a "White Pride, World Wide" screen saver. There also was a CD titled *Angry Aryans, White Law* and a black shirt with the insignia of a World War II-era German SS unit in plain sight.

The investigators also found an e-mail that promoted the concert Schmoyer's crew had left to attend. It featured several skinhead rock bands, including the Volksfront, Aggressive Force and Cut Throat.

Police and sheriff's deputies were disappointed in the attack because, they said, Vancouver had not had much trouble with overt white-supremacist activity. Indeed, most of Goodmonson's attackers weren't from Vancouver. Only Schmoyer was a local—the rest had driven from Idaho for the concert.

A few hours after the attack, just before midnight, a deputy spotted a car matching a description given by the witnesses to the attack on Goodmonson. He arrested Schmoyer and four of his guests. The four from Idaho had tattoos that indicated they were part of a group that called itself the Hammerskin Nation skinheads.

There's little doubt that the attack on Jesse Goodmonson was about as clear-cut a hate crime as you could find—complete with skinhead bluster, racial epithets, aggressive violence and plenty of witnesses. Schmoyer and his guests were more a testament to impotent losers drifting toward radicalism (only one of the five had a job and was able to post bail) than a growing social menace.

But the ease with which the Clark County sheriff's deputies got into Schmoyer's apartment (apparently, his wife was home and let

them in) and the almost smug way in which they reported his screen saver and CDs are troubling. No political belief—even one as odious as white supremacy—should be corroboration of a crime.

"Sending a Message" and "Taking a Stand"

Perhaps the most disturbing aspect of hate crime laws for a libertarian is the nearly-universal desire that advocates of the laws have for "sending a message" and "taking a stand."

Using state laws and law enforcement agencies to send political or social messages is an extreme abuse of powers granted the state in the social contract. And it's a practice that begs a backlash of unintended consequences.

As the Hollywood producer Sam Goldwyn said, "If you want to send a message, go to Western Union." Few statists heed that advice.

In March 2003, New Mexico passed its first version of a hate crime law. The statute was based on those in place in most Western states—it allowed additional prison time if a state court determined that a crime was motivated by hatred of a victim's "actual or perceived race, religion, color, national origin, ancestry, gender, sexual orientation or gender identity."

"We need to send a message that this type of behavior isn't going to be tolerated in 2003," Robin Phillips—an Albuquerque security company owner who identified herself as a transgendered female—told a local news service.

Not everyone in New Mexico agreed. One state senator noted disapprovingly: "If it's a crime to hate somebody, it should be a crime to hate anybody." And several other state politicians complained that the law sought to criminalize unpopular thought.

The best way for the state to "send a message" against bigotry and prejudice is for its laws to apply equally to everyone, without regard to identity or identity politics. If crime victims are treated differently because of their race, religion or sexual orientation—and if criminals

are treated differently for bad beliefs—the message being sent is that bigotry, when used in an approved manner, is good.

False Reports

Hate crime laws are promoted under the theory that, even if they simply recriminalize already-criminal conduct, they send a message to law enforcement, school administrators and the public that such crimes are especially heinous, and should be taken very seriously.

Precisely the same can be said about hate crime hoaxes—which are sometimes treated quite offhandedly by the authorities.

At the University of Mississippi in the Fall of 2002, the entire campus went through an uproar lasting for weeks when it was reported that a group of black students had been victimized by racist graffiti scrawled around their rooms.

A University investigation quickly discovered that the perpetrators were black, and were trying to use a hate crime hoax to draw attention to what they perceived as indirect racism in the school.

Hate crime laws are promoted as a means of teaching the public that tolerance regarding race and sexual orientation is an especially important value. Precisely for this reason, hate crime hoaxes ought to be punished with special severity, because they are deliberately intended to create an atmosphere of intolerance.

Conclusion

There's a lot for a libertarian to dislike about hate crime laws. They're unnecessary restatements of the criminality of crimes. They involve concepts so subjective as to defy consistent analysis and application. They raise hate above other dark emotions that are natural parts of the human condition. They drift into prohibition of unpopular thoughts—even though their authors try to include language to prevent this. They're often intended to "send a message" to groups

that the social elite consider unenlightened. And they breed an inordinate number of false claims.

There's no justification for the state meddling in the beliefs and private thoughts of its citizens. The liberal social contract allows for certain damaging acts to be prohibited—but not even the *most* damaging thoughts. A free citizen must be allowed to struggle with his or her demons in his or her own manner. Efforts to ban certain demons...certain bad thoughts...trivializes this righteous struggle.

And it makes a free state scarcely better than the totalitarian states that tell their citizens what to think.

Part Six:
Lifestyle

21 Sex and Marriage... and Gay Marriage

What should a libertarian make of gay marriage? In some ways, it seems a logical conclusion of self-ownership and freedom of contract; in others, it seems like an unhealthy political desire for state recognition.

In February 2004, the city of San Francisco started issuing marriage certificates to same-sex couples willing to recite civil laws before a duly deputized city official. These "marriages" directly contradicted California state law that stated marriage was an agreement between a man and a woman.

Scores of homosexual rights advocates flew to San Francisco—to swap vows in what the smartest among them considered an act of civil disobedience. Mayor Gavin Newsome encouraged the flouting of state law. Some libertarians applauded the San Francisco weddings as a knowing indictment of the state's hypocrisy on the morality of marriage; more scoffed at the episode as a publicity stunt performed by one more identity-politics constituency.

A few noted ruefully that the whole gay marriage debate would fuel anti-American groups like al Qaida that considered the U.S. depraved.

The notion of gay marriage—even as a civil disobedience stunt—was born some months earlier in a U.S. Supreme Court decision.

The Predicate Legal Matter

On September 17, 1998, the Harris County (Texas) sheriff's office got a complaint about a gunman loose in a Houston building. When the sheriff's deputies arrived at the scene, residents pointed them to a specific apartment from which loud noises had been coming. The deputies pushed open the unlocked door and found two men having sex with each other.

The two men—John Lawrence and Tyrone Garner—both went to jail for the night and were each ordered to pay fines for violating section 21.06 of the Texas criminal code, which banned sodomy between people of the same gender. More specifically, the law defined sodomy or "deviate sexual intercourse" as:

> any contact between any part of the genitals of one
> person and the mouth or anus of another person; or
> the penetration of the genitals or the anus of another
> person with an object.

Such anti-sodomy laws had once been common in the United States. They started to fade away in the 1970s. But, by the late 1990s, about a dozen states still had anti-sodomy laws on their books.

At trial, Lawrence and Gardner challenged the Texas statute as a violation of the Equal Protection Clause of the 14th Amendment to the U.S. Constitution and a similar provision of the Texas Constitution. The trial court rejected their argument. So, they pled *nolo contendere* to the charges and were each fined $200 plus court costs. They appealed the fines—and challenged the Texas law—to the federal appeals court and, ultimately, to the U.S. Supreme Court.

In June 2003, the Supreme Court surprised many observers by ruling in favor of Lawrence and Gardner and overturning the Texas sex law. In ruling this way, the Court—through a decision written by

Associate Justice Anthony Kennedy—overturned its own relatively recent precedent, that had upheld the right of individual states to pass and enforce anti-sodomy laws.

Kennedy's decision in *Lawrence et al. v. Texas* was, by Supreme Court standards, a libertarian statement. Rather than drilling into the mechanical details of Texas criminal code and the 14th Amendment (a piece of writing so vague that it can be interpreted to mean just about anything), Kennedy wrote in broad strokes:

> Liberty protects the person from unwarranted government intrusions into a dwelling or other private places. In our tradition, the State is not omnipresent in the home. And there are other spheres of our lives and existence, outside the home, where the State should not be a dominant presence. Freedom extends beyond spatial bounds.

> Liberty presumes an autonomy of self that includes freedom of thought, belief, expression and certain intimate conduct. The [present] case involves liberty of the person both in its spatial and more transcendent dimensions.

This writing, especially the phrase "autonomy of self," could have come from the pen of a libertarian writer like Robert Nozick or Ayn Rand. The fact that it comes from the U.S. Supreme Court should give anyone who values liberty some hope that the government can recognize its own limits.

But broad strokes sometimes make for bad legal interpretation. And the *Lawrence* decision involved the most controversial of human affairs: sex. Outrage was bound to follow—and it did, starting on the Supreme Court itself.

A problem with Kennedy's decision was that it contradicted an earlier Supreme Court decision, 1986's *Bowers v. Hardwick*, which had involved similar facts and law. In that decision, the Court had ruled that Georgia's version of an anti-sodomy law could stand.

One difference between the two cases was that the Georgia law prohibited deviate sexual conduct whether or not the participants were of the same sex, while the Texas statute applied only to participants of the same sex. In other words, the Texas law singled out homosexual acts while the Georgia law didn't.

In the *Bowers* decision, the Court stumbled over this point. Near the beginning of the decision, it wrote:

> The issue presented is whether the Federal Constitu-
> tion confers a fundamental right upon homosexuals
> to engage in sodomy and hence invalidates the laws
> of the many States that still make such conduct ille-
> gal....

But that wasn't the issue—or shouldn't have been.

In *Lawrence*, Kennedy stated plainly that the *Bowers* decision had been wrong and should be reversed. In fact, he cited one of the dissenting opinions in *Bowers* for support of his libertarian analysis. In that dissent, Justice John Paul Stevens emphasized two points:

> First, the fact that the governing majority in a State
> has traditionally viewed a particular practice as im-
> moral is not a sufficient reason for upholding a law
> prohibiting the practice; neither history, nor tradi-
> tion could save a law prohibiting miscegenation from
> constitutional attack. Second, individual decisions by
> married persons, concerning the intimacies of their
> physical relationship, even when not intended to pro-
> duce offspring, are a form of "liberty" protected by
> the Due Process Clause of the 14th Amendment.
> Moreover, this protection extends to intimate choices
> by unmarried as well as married persons.

In some ways, Stevens's reasoning makes a better legal argument than Kennedy's broad strokes. In a passage that would be mocked by critics as pop psychology rather than legal analysis, Kennedy wrote:

[Lawrence and Gardiner] are entitled to respect for their private lives. The State cannot demean their existence or control their destiny by making their private sexual conduct a crime. Their right to liberty under the Due Process Clause gives them the full right to engage in their conduct without intervention of the government.

In defense of this argument, Kennedy mentioned another Supreme Court decision, 1992's *Planned Parenthood of Southeastern Pa. v. Casey* (which he had co-authored). That decision was nominally about a minor's right to get an abortion without parental consent; but it also dealt with what Kennedy called "the substantive force of the liberty" protected by the Due Process Clause. He quoted the *Planned Parenthood of Southeastern Pa.* case:

These matters, involving the most intimate and personal choices a person may make in a lifetime, choices central to personal dignity and autonomy, are central to the liberty protected by the 14th Amendment. At the heart of liberty is the right to define one's own concept of existence, of meaning, of the universe and of the mystery of human life. Beliefs about these matters could not define the attributes of personhood were they formed under compulsion of the State.

That may be the most important passage for libertarian thought in modern U.S. legal history.

Some legal experts might ridicule the phrases "personal dignity" and "attributes of personhood" as vague and politically-correct jargon. But they miss the importance of Kennedy's arguments.

Randy E. Barnett—a professor at the Boston University School of Law and a legal commentator of libertarian leanings—wrote about the *Lawrence* decision:

...Kennedy's opinion protects liberty without any finding that the liberty being restricted is a "funda-

mental right." Instead, having identified the conduct prohibited as liberty, he turns to the purported justification for the statute and finds it inadequate. This represents a rejection of fundamental rights jurisprudence as it has developed since *Griswold v. Connecticut* and the adoption of a "presumption of liberty."

The important point to take away from the decisions in *Lawrence* and *Casey* is that they are both strong rebukes to state interference in people's lives. This is a heartening trend for libertarians.

Justice Antonin Scalia wasted no time in thrashing Kennedy's decision. In a typically scalding dissent, Scalia wrote:

...nowhere does the Court's opinion declare that homosexual sodomy is a "fundamental right" under the Due Process Clause; nor does it subject the Texas law to the standard of review that would be appropriate if homosexual sodomy were a "fundamental right." ...Instead the Court simply describes petitioners' conduct as "an exercise of their liberty"—which it undoubtedly is—and proceeds to apply an unheard of form of rational-basis review that will have far-reaching implications beyond this case.

[The Texas anti-sodomy law] undoubtedly imposes constraints on liberty. So do laws prohibiting prostitution, recreational use of heroin and, for that matter, working more than 60 hours per week in a bakery.

This was Scalia's legal objection to Kennedy's decision. And it's an important one. The much-debated Due Process Clause of the 14th Amendment is the basis for many of the legal precedents that affect privacy and lifestyle issues in the U.S.—including the pro-abortion decision *Roe v. Wade*.

The doctrine known as "substantive due process" holds that the Due Process Clause prohibits states from infringing fundamental lib-

erty interests, unless the infringement is narrowly tailored to serve a compelling state interest. Only fundamental rights—rights that are "deeply rooted in this Nation's history and tradition"—qualify for this heightened scrutiny protection.

Kennedy's libertarian argument seems to broaden the heightened scrutiny protection to a wide-ranging definition of liberty. And this broader definition might become unwieldy in other situations.

But Scalia didn't stop with his legal objection. He proceeded to launch into a cultural criticism of Kennedy's decision.

> Today's opinion is the product of a Court that has largely signed on to the so-called homosexual agenda, by which I mean the agenda promoted by some homosexual activists directed at eliminating the moral opprobrium that has traditionally attached to homosexual conduct.

> ...It is clear from this that the Court has taken sides in the culture war, departing from its role of assuring, as neutral observer, that the democratic rules of engagement are observed. Many Americans do not want persons who openly engage in homosexual conduct as partners in their business, as scoutmasters for their children, as teachers in their children's schools or as boarders in their home.

And, Scalia implied, acting on such beliefs is every American's right. This is a notion that should resonate with anyone who loves liberty—the right to embrace or reject things or people as you see fit, and not have statists tell you whom you must accept.

So, who's the libertarian: Kennedy or Scalia? Probably not Scalia. Given the chance to claim a libertarian mantle, Scalia has consistently declined to do so.

Outside of the Supreme Court, reaction was dramatic. Homosexual advocacy groups cheered the decision as a cultural and political

validation. Cultural conservatives jeered Kennedy as an amoral libertarian. And both groups prepared to move the cultural battle to the issue of gay marriage.

A Quick History of Sex in America

The history of sex—as a liberty issue—in America is fuzzy because public records and court rulings all avoided discussing sex issues in blunt terms until fairly recently. But some general points are clear.

In colonial times, there were prohibitions of sodomy derived from English criminal law. American lawyers and judges read sodomy, buggery and crime-against-nature laws as criminalizing certain activities, regardless of the sex of the participants. The absence of legal prohibitions focusing on homosexual conduct followed from the lack of any concept of the "homosexual" as a distinct category of person.

The anti-sodomy laws of that era were generally not enforced against consenting adults acting in private. Surviving records suggest most prosecutions involved predatory acts against those who could not or did not consent, as in the case of a minor or a victim of assault. One purpose for these prohibitions was to ensure there would still be grounds for prosecution if a predator committed a sexual assault that didn't constitute rape.

This standard remained true through the early 1800s. Sodomy prosecutions usually involved relations between men and minor girls or minor boys, relations between adults involving force or relations between men and animals.

However, after the Civil War, the growth of large urban centers saw an increase in prosecutions on charges of vagrancy and sex in public places that modern legal scholars interpret as indicators of same-sex sodomy cases. It was also about this time that the notion of "homosexual" as a separate sexual identity began to emerge.

The public policy standard changed dramatically after World War II. The 1950s and 1960s saw technological advances in birth control

and economic advances across the population that made most Americans more permissive about the wide range of sexual activities.

There was backlash to these changes, of course. And, after a series of events in the late 1960s that marked the beginnings of the gay-rights movement, social conservatives began to look for legal or political methods for discouraging "homosexuals." The most popular of these methods: reviving and refining anti-sodomy laws to refer only to same-sex activities.

The legal justification of this scheming was that having anti-adultery and anti-sodomy laws on the books—even if they weren't often enforced—was a way that society could send the message that this kind of sexual activity was disfavored.

This issue comes up again and again. Laws are too potent—and their enforcement is too unpredictable—to be used to "send messages." Laws, by the nature of the social contract, restrict someone's liberty in some way, even if these limits are slight. The only justification for a law is that it protects more liberty than it limits.

Sex and the Public Sphere

Libertarians recognize that the immorality of an act doesn't necessarily mean it should be prohibited legally. Anthony Kennedy's arguments in *Lawrence v. Texas* about government limits and autonomy of self are compelling, philosophically. A libertarian should oppose anti-sodomy laws like the one in Texas, because they restrict more liberty than they protect.

But what about the logical extensions of that opposition? Should a libertarian support gay marriage? Or gay rights anti-discrimination issues that affect business and the workplace?

The autonomy of self argument cuts two ways. While it gives a person the freedom to engage in any sex activity he or she wishes—as long as any partner is willing—it also gives private employers the freedom to discriminate on the basis of sexual orientation. And it gives

private-sector businesses like hotels the right to refuse rooms to adulterers, threesomes or gay couples.

This private-sector stigmatization of certain sexual activities is the better way to send a message. And, when government acts well, it steps aside and lets private-sector stigmatization succeed or fail by market response...that is, how many people agree with it.

Of course, government doesn't always act well. The most common problem is that the body of federal law in the United States doesn't work even-handedly: While courts are careful to define protection from discrimination with great precision, legislatures prohibit discrimination broadly and crudely. This process turns the very notion of "protection" on its head.

The result: Detailed lists of protected groups and imprecise, unduly broad definitions of what "protected" means. The net effect is great cost and hardship for anyone—or any firm—accused of discrimination.

So, where is the line between protecting same-sex couples from the discrimination of the Texas anti-sodomy law and protecting other people and businesses from the political statement that sodomy is a constitutional right? Said another way: What is the difference between being forced to tolerate people who engage in homosexual sodomy (or adultery...or any other sexual activity) and being forced to approve of them?

For the sake of this distinction, *tolerate* means not to harm, undermine or resist actively and *approve* means to support actively and even prefer.

The liberty equation for tolerance is, generally, more positive than the liberty equation for approval. And this is especially true in matters of sex, because it's an intimate matter about which reasonable people feel very strongly.

Tolerating others—even others whose actions, practices or beliefs you detest—infringes on your liberty relatively little and can increase their liberty substantially. Approving of others can infringe a great

deal on your liberty—financial, intellectual or emotional—and doesn't necessarily add as much to theirs.

Americans appear to have ambivalent views about homosexuality. In numerous surveys and opinion polls, most Americans emerge as tolerant of homosexuality; but few seem to approve of it.

Tolerance Versus Approval

Still, many people end up tripping over the distinction between *toleration* and *approval*.

In April 2003, Rick Santorum—a U.S. Senator from Pennsylvania—gave an interview in which he discussed the *Lawrence* case (which was still being considered by the Supreme Court at that point). In attempting to make an even-handed criticism of the case, Santorum stumbled badly. Here's what he said:

> We have laws in states, like the one at the Supreme Court right now, that has sodomy laws and they were there for a purpose. Because, again, I would argue, they undermine the basic tenets of our society and the family. And if the Supreme Court says that you have the right to consensual sex within your home, then you have the right to bigamy, you have the right to polygamy, you have the right to incest, you have the right to adultery. You have the right to anything. Does that undermine the fabric of our society? I would argue yes, it does.

> Whether it's polygamy, whether it's adultery, whether it's sodomy, all of those things, are antithetical to a healthy, stable, traditional family.

> Every society in the history of man has upheld the institution of marriage as a bond between a man and a woman. Why? Because society is based on one thing:

> that society is based on the future of the society. And
> that's what? Children. Monogamous relationships.

Mind you, in addition to being one of the most powerful legislators in America, Santorum is a lawyer.

From these words and from statements he made later, it seems that Santorum was trying to make a liberty-equation distinction between tolerating and approving of various private sexual activities. He also mixed in a little communitarian analysis—the part about the well-being of children.

(Ironically, in sexual matters, communitarian and utilitarian philosophies—often considered "progressive" in American circles—are often downright moralistic. There is, generally, a correlation between permissive sexual behavior of any orientation and bad outcomes like broken families, higher disease rates and drug or alcohol abuse. Therefore, communitarians who stay true to their code—and some don't—advocate sexual restraint as a solution.)

The major media focused on Santorum's clumsy wording. And political organizations interested in sexual identity issues followed the media's lead. A spokesman for the New York-based Human Rights Campaign, a big gay rights organization, accused Santorum of "disparaging an entire group of Americans. The outrageous thing is he put being gay on the same legal and moral plane as a person who commits incest. That is repugnant in our view and not right."

Asked why the comparison was not right, the spokesman betrayed his ignorance of liberty, American law and—arguably—the inappropriateness of his organization's name. He told the online magazine *Slate* that his group had no problem with state bans on incest because "[t]here's a compelling interest for the state to ban that practice." Asked what that compelling interest was, the spokesman handed the interview off to his organization's legal counsel—who responded with tautological mumbling about constitutional rights.

So, though Santorum suffered bad press for weeks after his interview, his clumsy argument was closer to a coherent analysis of tolera-

tion versus approval than the arguments made by some self-proclaimed human rights advocates.

The Future of Marriage

While attacking the logic of Anthony Kennedy's *Lawrence v. Texas* decision, Antonin Scalia anticipated the next battle in the culture war over homosexual rights by raising the topic of gay marriage. Specifically, Scalia wrote:

> ...Today's opinion dismantles the structure of constitutional law that has permitted a distinction to be made between heterosexual and homosexual unions, insofar as formal recognition in marriage is concerned. If moral disapprobation of homosexual conduct is "no legitimate state interest" for purposes of proscribing that conduct; and if, as the Court coos, "[w]hen sexuality finds overt expression in intimate conduct with another person, the conduct can be but one element in a personal bond that is more enduring;" what justification could there possibly be for denying the benefits of marriage to homosexual couples...?

Most homosexual rights groups rose to Scalia's bait and proclaimed, in various specific ways, that the *Lawrence* decision made sexual identity a fundamental right under the Constitution. This was wrong. As Scalia pointed out—and Kennedy didn't deny—the decision was based on a different, more general presumption of liberty. It was precisely not based on any fundamental right to be gay.

Still, the debate over gay marriage followed familiar, faulty logic. A few months after the *Lawrence* decision, the Massachusetts Supreme Court wrote this argument into a decision that began a process intended to allow gay marriage in the Bay State. And in California the mayor of San Francisco didn't wait for *his* state's courts to create an opening. Like an ambitious statist, he just acted presumptuously.

Cultural conservatives worry the drift may not stop with gay marriage. The next step on the logical extension likely would be legalization of group marriage—in fashionable intellectual circles called "polyamory." And this scenario hijacks some libertarian concepts: Marriage becomes a matrix of so-called "relationship contracts," linking two, three or more people under various terms and conditions.

Polyamory purports to be an alternative to the loneliness of single-parenthood, the constraint on traditional marriage and the promiscuity of the sexual revolution. Its supporters tend to come from the ranks of radical feminists and lesbian academics, though-and writing on the subject is full of trendy jargon about "queer theory" and "deconstructing family structure."

University of Utah law professor Martha Ertman may be the least flaky proponent of group marriage. In the 1990s, she developed a legal template for a "relationship contract system" modeled on corporate law. Ertman wants state-sanctioned group marriage, legally organized on the model of limited liability companies.

To libertarians who value contract rights, this idea makes some sense. And, for single parents or people in troubled marriages, it promises to maintain some family connection while diluting the centrality of any one relationship.

Conclusion

But that last bit is the *problem* with Ertman's plan: It makes the most sense to older, world-weary single parents and people in troubled marriages. A series of Marriage, LLC operating agreements doesn't hold much appeal to people in happy marriages or young people looking forward to getting married—happily—and starting families.

Given the chaos of the potently illegal San Francisco marriages, Americans will either have to accept nontraditional marriage or end the public policy notion of marriage entirely—ending all reference to it in legal documents, the tax code, etc., and making it strictly a pri-

vate institution. This is a form of privatization that some self-described libertarians haven't expected. But it is the logical conclusion of libertarian notions of self-ownership and contract.

The hard point of this logical conclusion may be why the libertarian take on toleration versus approval doesn't work for so many people. They want to approve, and, by extension, disapprove of people and ideas. They desire passion...not abstract notions of liberty that come with all sorts of attendant responsibilities.

While libertarianism tolerates many things, it has a hard time operating in complete cultural and legal chaos.

Civil marriage is a governmental mechanism for encouraging—through direct and indirect subsidy—stable lives for citizens. Conventional nuclear families may not be the only way to provide these stable lives—but they are, historically, the surest way. A pragmatic libertarian should be able to admit that, in deference to eons of human nature, two-person couples tend to work best as the nucleus of nuclear families.

Statist experiments in replacing the nuclear family with government programs or collectives have only resulted in more government programs and bigger collectives.

The social contract promises to deliver stable markets to citizens. Civil marriages encourage this stability as long as they encourage nuclear families. Logic doesn't recognize gender in this manner.

So, in the end, what's the libertarian conclusion about marriage? Do away with it, as a civil institution. In the interest of encouraging stable nuclear families, offer civil unions to any couple whose partners qualify. Leave the granting of more metaphysical states of marriages to churches or other spiritual institutions—and leave the state out of the marriage business.

22 The War on Drugs and Legalization

The War on Drugs bothers libertarians because it blurs important distinctions between law enforcement and the military. But how do libertarians defend drug legalization?

In late May 2003, a Montana affiliate of the National Organization for the Reform of Marijuana Laws (NORML) scheduled a benefit concert in Billings to raise money in support of its public policy efforts. Since most of these efforts were focused on decriminalizing the use of recreational drugs (especially marijuana), it was a fairly safe guess that some pot would be smoked at the concert. A local Drug Enforcement Administration agent decided to preempt the event.

According to the Drug Reform Coordination Network, the agent "used threats of RAVE Act prosecutions to intimidate the owners" of the club where the concert was going to take place. According to employees, the agent—literally waving a copy of the recently-passed RAVE Act in one hand—warned that they could face a fine of up to $250,000 if someone smoked a joint during the benefit. And he focused particularly on the young woman who managed the club, insinuating that she'd face federal charges personally.

What is the RAVE Act? And why was it relevant to a rock concert in Billings, Montana?

The answer makes libertarians—who may have little sympathy for drug users—align with the potheads.

The main organizer of the concert was a local marijuana-decriminalization advocate named Adam Jones. Like many of his fellows, Jones had a long history of drug-related legal problems. In fact, his involvement in the concert was likely the reason the DEA agent showed up at the club in the first place.

A few days before the concert was supposed to take place, Jones had been arrested by his probation officer for switching work-study jobs at Montana State University at Billings without reporting in first. (His probation stemmed from a conviction for possession of psychedelic mushrooms.) And he was still in jail when the concert was canceled.

Apparently, Jones's probation officer had found out about the concert and contacted the DEA. According to the club manager, "the DEA guy kept talking about Adam Jones" while making his threats about fining the club owners.

Is it an effective use of government resources for a DEA agent to harass a group of college student hemp activists trying to organize a concert to raise money for their politics?

Few Americans—and certainly few parents of young children—want a free state to encourage psychedelic drug use. However, there's an undeniable thread of overreaction running throughout the U.S. government's treatment of illicit drug users. And the image of a bilious DEA agent making threats against a young woman who manages a Montana concert venue is only a small indicator of the overkill.

The Conflict Between Liberty and Prohibition

For more than two decades, American politicians and public policy thinkers have been enthralled by the War on Drugs. What started as a public relations campaign for Ronald Reagan's wife has morphed into a boondoggle for statists of all stripes.

From a libertarian perspective, the worst aspects of America's War on Drugs are related to the erosion of the Posse Comitatus Act—and the resulting use of federal military troops in law enforcement efforts.

But, moving beyond law enforcement issues, should a free state even have anti-drug laws? And, if so, how aggressively should that state prosecute them? Finally, has the War on Drugs contributed to a general cheapening of liberties in post-9/11 America?

There are three main problems that most people who value liberty have with the War on Drugs. Or any form of prohibition, for that matter.

First—and most practically—there is a steady consensus among American libertarians that the War on Drugs is a bad thing politically. At least, it's a misallocation of law enforcement resources; at worst, it's a sort of Trojan Horse that statists use to advance their authoritarian impulses.

Second, the classical liberal notion of personal liberty is inescapably tied to a notion of personal responsibility; and these two notions, taken together, result in a powerful belief in every individual as a laboratory for the effects of his or her own decisions. So, libertarians tend to believe strongly in every person's right to make bad choices...and to suffer the consequences.

The first part of that strong belief is what moralizers mean when they complain about libertarianism's "permissiveness."

Third, there is a hollow absolutism to prohibition. Key elements of the War on Drugs are so-called "Zero Tolerance" programs in courts, schools and other public venues. These programs target casual drug users, rather than dealers or suppliers. Under Zero Tolerance programs, police confiscate cars, homes, bank accounts and businesses without the ordinary due processes of arraignment and trial. These seizures— which can take place without search warrants or even probable cause— can pose a serious threat to property rights.

In many cases, this confiscated property is sold at public auction, with the proceeds used to hire more drug police. This kind of govern-

ment racket harkens back to the Colonial Days in America—when the British King could engage in similar, self-interested takings.

Under California's "Campaign Against Marijuana Planting," SWAT teams search Northern California fields by helicopter. If any marijuana plants (which sometimes grow wild) are found, homes and businesses are subject to immediate confiscation. The owner has 20 days to sue the government to get his property back.

This is a perversion—practically an inversion—of the privacy and property rights that frame the U.S. Constitution.

Economics and Politics

The production and sale of illegal drugs are perhaps the largest industry within America's shadow economy of activities that are illicit, unregulated and untaxed.

So, to some Americans, the enforcement of anti-drug laws looks like an economic matter—an effort to shut down a part of the economy that remains unregulated and untaxed.

Drug legalization activists argue hard that the reasons for the War on Drugs are economic. They argue that marijuana may be the largest cash crop in the United States, without any federal agricultural subsidies. Marijuana grows very well in the same conditions that corn does— but a bushel of corn sells for $2 and a bushel of marijuana sells for $70,000. They argue that the anti-drug laws drive up the price...and tempt otherwise law-abiding people to grow it or sell it.

But the reasons for the War on Drugs aren't economic. The stepped-up enforcement of anti-drug laws hasn't been effective at shutting down the druggy part of the shadow economy. While some studies suggest drug use has inched down, the estimated size of the illicit drug industry has remained roughly the same (as a percentage of total GNP) since the 1980s.

Fewer casual users may be experimenting with drugs; but addicts and dedicated users haven't turned away from their fixes.

So, why does the War on Drugs linger? Because it's a great tool for statists. Illicit drug use is clearly a bad thing—it stupefies the users and abets family breakdown, vagrancy, higher crime rates and other social ills. Honest citizens rightly feel that *something* should be done about all of this. But they aren't sure what the best response is (neither are the academics who study illicit drug use as a social phenomenon).

Of course, in political circles, the War on Drugs works well as rhetorical shorthand. In order to seem the right kind of tough, a politician can save a lot of words and time—and avoid confusion—by agreeing to keep the War on Drugs fully engaged. And fully funded.

The appeal of this political shortcut is bipartisan. In fact, it may be stronger to politicians from the left, who are afraid of being cast as soft on crime. More people were sent to prison for federal drug offenses under Democrat Bill Clinton than under any other presidential administration; maybe that's why it was so important to Clinton to make the bizarrely legalistic point that he'd smoked...but never inhaled... marijuana in his youth.

A similar thing happened with former New York Governor Mario Cuomo during the late 1980s and early 1990s. Because Cuomo opposed the death penalty on moral grounds, he made himself vulnerable to accusations that he was soft on crime. So, he signed on to the War on Drugs. And Cuomo ended up putting more people in prison—primarily for minor drug offenses—than any other governor in the history of New York.

Arguments for Legalization

On the other hand, some of the most coherent critics of the War on Drugs have come from the political right. A number of conservative Republicans—William F. Buckley, George Schultz, Milton Friedman—think that the War on Drugs is a waste of government time and money. And that it's rife with unintended consequences.

Poor, largely black, inner-city communities are particularly sad victims of the War on Drugs. Few poor teenagers will take entry-level

jobs at $5 or $6 an hour when they think they can make thousands a week selling drugs. Failing to acquire job skills early on, they end up as criminals or on welfare their entire adult lives.

The appeal of profitable crime can only be trumped by removing the huge profit margins from the crime.

The argument *for* legalizing drugs—at least marijuana—can be summed up in a few points:

- Criminalization results in huge black-market profits and the domination of the drug trade by criminal groups. As the criminals battle each other and the police for access to and control of their markets, violence invariably follows.

- Criminalization results in hugely inflated drug prices. The street price of heroin is often thousands of times the hospital cost of similar opiates. To support their artificially-expensive habits, addicts have little choice but to turn to dealing, prostitution and theft.

- Criminalization causes health problems. Lack of regulation causes many of the drug overdose deaths that occur each year. There is no (legal) means of taking action against people who sell adulterated drugs. Needles and other drug paraphernalia are illegal, which makes them expensive—and more likely to be shared unsafely among addicts.

- Criminalization creates a false distinction between recreational drugs, including alcohol and tobacco, that are tolerated and regulated by the state and others, starting with marijuana, that are not.

The strongest argument offered *against* legalization is that it would result in a massive increase in drug use. But there's little evidence to support that point. In Holland, Belgium and other European countries that have legalized or decriminalized use of marijuana and similar drugs, use has increased only slightly. However, crime, drug overdoses and drug-related deaths have fallen dramatically.

Legalization might even reduce use. In 1975, Alaska legalized private use of marijuana. A 1982 study by the University of Alaska showed that 4 percent of Alaskan high-school students used marijuana every day, compared to 6.3 percent of all American students.

The State's Rights Angle

Marijuana is an illegal drug under federal law. State law in California—as well as Alaska, Arizona, Colorado, Hawaii, Maine, Nevada, Oregon and Washington—allows marijuana to be grown and distributed to people with a doctor's prescription.

As a result, the Feds often clash with those states over their more permissive laws.

An example: City officials in Santa Cruz, California, filed a lawsuit in April 2003 demanding that federal agents stay away from a farm growing marijuana for sick and dying people.

The suit followed a Drug Enforcement Administration raid in September 2002 on a small pot farm about 15 miles north of Santa Cruz. Agents uprooted about 165 plants and arrested the owners, Valerie and Michael Corral.

After the raid, the Santa Cruz City Council sponsored a medical marijuana giveaway from the steps of City Hall. The Council also deputized the Corrals, allowing them to cultivate, distribute and possess medical marijuana under a city ordinance.

Santa Cruz is a college town, home to the University of California's least traditional campus, and—frankly—a hippie town. It has become a center for the application of California's so-called "Medical Marijuana" law (which allows the drug to be grown for and used by chronically-ill people). City police cooperate with medical marijuana growers and users to make sure the system works smoothly and...by California standards...legally. Several bed-and-breakfasts designed for medical marijuana users operate within the city limits.

The lawsuit claimed that seven patients had had their medical marijuana substantially decreased since the Santa Cruz DEA raids,

hastening some deaths (though it remained vague about any direct connection between the raids and the deaths).

A San Francisco-based DEA spokesman dismissed the Santa Cruz lawsuit, sneering that his agency's mission is very clear: "To enforce the Controlled Substances Act."

Bush Administration Attorney General John Ashcroft has shown his statist stripes in many ways, but most clearly in the way that he's pressed the federal government's powers over local power in the War on Drugs.

This strategy has used the weight of the Justice Department to reverse local government policies and generally impinged on the rights of states. And Ashcroft isn't alone. In 2002, White House drug policy chief John Walters actively campaigned—using taxpayer funds—in Nevada to encourage the defeat of a state referendum to partially decriminalize medical marijuana use.

There is a federal law banning such overt political activity by a public officeholder. Although the Marijuana Policy Project, a supporter of the Nevada referendum, filed complaints with federal and state officials, no action was taken against Walters. And some members of Congress suggested that federal law should be changed to allow—and expand—the "drug czar's" ability to get involved in politics as Walters did in Nevada.

Medical Marijuana

Voters—especially in the western part of the U.S.—continue to support efforts that allow so-called "palliative use" of drugs like marijuana for people with chronic health problems. Arizona voters approved marijuana for medical use; Nevada voters, who also legalized medical use, considered eliminating penalties for possession of small amounts and allowing the sale of the drug in licensed shops. And, in a local ordinance vote, Seattle voters considered directing police to make arrests for marijuana possession their lowest priority.

The popularity of these measures has forced some questions about the practicality of the federal government's drug prohibition policies.

In 2002, the California state Supreme Court upheld the state's Medical Marijuana law in the decision *California v. Myron C. Mower*. This ruling tacitly supported California's ongoing resistance to federal marijuana policy and law enforcement efforts. In a unanimous opinion, the court wrote:

> The possession and cultivation of marijuana is no more criminal—so long as its conditions are satisfied—than the possession and acquisition of any prescription drug with a physician's prescription.

Some critics decried the California court's decision as left-wing social engineering. But these critics were relatively few...and particularly shrill.

Again, the point isn't partisanship—it's creeping statism.

The California state Supreme Court (like many of the federal courts in California) does tend to be more liberal than the rest of the U.S. But a libertarian shouldn't care so much about the court's politics in this matter; what's important is that the court took stand for liberty by defending a state government's right to stand up to the Feds. Of course no decision in state court can overturn laws made in Washington, D.C.; but the *Mower* decision essentially left federal officials without allies in California as they seek to block AIDS and cancer patients from using marijuana to ease their pain.

There's even some sense of this issue among some politicians at the federal level. In 2002, Massachusetts Congressman Barney Frank introduced the States' Rights to Medical Marijuana Act, which would prohibit the federal government from opposing state efforts to allow the use of marijuana as medicine. Frank, a staunchly liberal Democrat on almost all political matters, was supported in this instance by two conservative Republican congressman—Dana Rohrabacher from California and Ron Paul from Texas. So, opposition to the federal policies was neither partisan nor regional.

The RAVE Act

In the early 2000s, there was some progress in limiting the ambitions of statists at the federal level to control states' drug laws. But the War on Drugs found other places to reallocate and expand those same ambitions. These other places have led to laws so bad that they may end up shifting popular opinion away from prohibition.

Chief among these: The RAVE Act, which the overzealous Montana DEA agent used to threaten the Billings nightclub manager.

In the spring of 2003, Congress passed the Reducing American's Vulnerability to Ecstasy Act, known widely by its too-cute acronym. The RAVE Act was designed to address problems the DEA and federal prosecutors had trying to use the so-called "Crackhouse Law" to thwart promoters of the druggy dance parties known as raves.

The Crackhouse Law was passed in the 1980s to hold property owners financially responsible if their buildings were used to sell and use crack cocaine—even if the owners had no knowledge of the illegal activities.

When the Feds charged a group of New Orleans-based rave promoters under the Crackhouse Law in 2001, it was the first time the law had been applied to anything but a crackhouse. The case didn't go well for the Feds and was eventually settled out of court on terms favorable to the property owners. In a later case, after more than a year of federal investigation, Crackhouse Law charges were brought against a club owner in Panama City Beach, Florida. It took a jury less than an hour to find the club owner not guilty.

Raves aren't like crackhouses. Not everyone who goes to a rave uses illicit drugs; many really do go to dance.

The law expanded the federal powers of prosecution as they relate to holding venue owners accountable for drug use and dealing on their properties.

The law allows prosecutions of people who "knowingly open, lease, rent, use or maintain a place for the purpose of manufacturing, distributing or using a controlled substance."

The law also allowed prosecutors to charge owners civilly, lowering the standard of proof for conviction. So, venue owners could take precautions and provide good security—and still be fined hundreds of thousands of dollars.

Critics of the RAVE Act usually offer two primary concerns. The first is that there's no need to expand the powers of prosecution. The second is that—while it's acceptable to arrest drug dealers and users—it's constitutionally dubious to single out a culture of music and dancing for special prosecution and liability.

The Act gives broad discretion to prosecutors, who may use it to target events they personally don't like. Aside from due process issues, this discretion raises some free speech issues. As the Montana case shows, the RAVE Act's broad language can apply to more than just electronic-music parties; it can apply to practically any public gathering, including theatrical productions, concerts, parties and—potentially—even political rallies.

More Shaky Foundations

Like many statist power grabs, the RAVE Act required some legislative chicanery to become law. Joseph Biden, a Democratic Senator from Delaware, had initially presented it as a stand-alone bill in 2002. Although the bill had significant support initially, it attracted a lot of angry response from various corners—including the ACLU and various groups related to the music industry. Co-sponsors started dropping off, so Biden withdrew the bill.

For a short time.

A year later, Biden changed the name and some of the text and—most importantly—attached the RAVE Act to another bill. Biden knew what he was doing. The bill to which he attached the RAVE Act was a hugely popular proposal to make national the "Amber Alert" system of publicizing child kidnapping cases.

Such parliamentary maneuvering is common enough in any capitol (and calls to mind Otto von Bismarck's observation that people

who like laws or sausage shouldn't ask how either is made). But Biden took the gamesmanship beyond the usual when he implied to fellow legislators that, with the minor changes he'd made, the ACLU had flipped its position and no longer opposed the RAVE Act.

In April 2003, the Amber Alert bill—which included the provisions of the RAVE Act—passed in the House by a vote of 425 to 2 and in the Senate 98 to 0. Even if he had problems with the proposals (and he didn't), George W. Bush would have been hesitant to veto something passed almost unanimously. The bill became law.

Some politicians did take note of Biden's tricks. On his official Web site, Vermont's U.S. Senator Patrick Leahy wrote:

> We've finally gotten a green light for a national AM-BER Alert program. The problem has never been winning enough support to pass it. The problem has been that our bill has garnered such strong support that it has been abused as a sweetener for highly controversial add-ons.
>
> ...I am also concerned about the inclusion of the [RAVE] Act in this conference report. This bill has drawn serious grass-roots opposition, and I know that I am not alone in hearing from many constituents about their serious and well-considered objections....

Unexpectedly, the establishment Democrat senator from Vermont finds himself on the side of liberty in this matter. The RAVE Act is genuinely a bad law. It makes it easier for the federal government to prosecute innocent business owners for the drug offenses of their customers—even if they take steps to stop such activity.

The original bill suggested that prosecutors should view the sale of water and the presence of glowsticks or massage oil as evidence of drug use.

Instead of restricting the application of the "crackhouse statute" to ongoing, continuous drug operations, the RAVE Act expanded the provisions making them applicable to temporary, one-time and

outdoor events. Also, civil provisions were added that lowered the burden of proof required to punish businesses and property owners that had no ties to the sale of illegal drugs.

The Act could be interpreted to mean that "knowingly" applies to a venue owner (who knowingly opens a place to the public) but that "for the purpose of" applies to someone else (who later uses the place to sell or use drugs). Both should relate to the owner; so that, to be liable, he or she would have to open the place for the specific purpose of selling drugs.

Generally, the RAVE Act's language was so vague as to render it impossible for anyone to know what specific conduct would actually make them liable. For example, unlike the Crackhouse Law, the RAVE Act said an owner was liable if his premises were "temporarily" used for drug purposes. That one word negated the entire purpose of the Crackhouse Law. A crackhouse was supposed to be a building or property whose purpose was to facilitate drug use. The purpose of a concert is to entertain people with musical performances. Under the RAVE Act, if even one person uses drugs at a concert, the venue owner could face civil and criminal liability.

Conclusion

Libertarians believe that prohibiting the behavior of reasonable adults is an erosion of self-ownership and a troubling proposition. And, if this behavior doesn't directly harm any other person, the troubling proposition becomes untenable.

Furthermore, libertarians do not believe in laws or other state acts designed to "send a message" to citizens. That's a redundancy and misuse of the state's considerable powers.

And, finally, libertarians believe that passing laws that won't be enforced results in a dangerous disregard for all law.

For all of these reasons, the state prohibitions against use of drugs like marijuana rest on shaky philosophical grounds. Leaving aside the

damnable effects of the War on Drugs, legalization and regulation of the use of recreation drugs would allow for a more efficient use of state resources.

This would be a considerable improvement over the current, erratically-enforced prohibition.

23 Liberty in Cyberspace

The Internet has always reflected the libertarian bent of its earliest users. As national security becomes a bigger issue in the developed world, will this remain so?

In February 2003, George W. Bush released his administration's *National Strategy to Secure Cyberspace*. This document was discussed and debated for months—before it was released. It was a topic of much speculation since the days after the 9/11 attacks, when reports buzzed that al Qaida's hijackers had coordinated their movements by e-mail, accessed through computers in libraries and other public places.

The *Strategy* quickly assumed the solemn tones of what hackers call *FUD*—an acronym for the *fear*, *uncertainty* and *doubt* that non-technical people tend to use when discussing cyberspace risks. And the hackers were right. Here are some excerpts from the introduction:

> Identified computer security vulnerabilities—faults in software and hardware that could permit unauthorized network access or allow an attacker to cause network damage—increased significantly from 2000 to 2002...from 1,090 to 4,129.
> ...Cyberattacks on United States information networks can have serious consequences such as disrupt-

ing critical operations, causing loss of revenue and intellectual property or loss of life. Countering such attacks requires the development of robust capabilities where they do not exist today if we are to reduce vulnerabilities and deter those with the capabilities and intent to harm our critical infrastructures.

...Looking inward, providing continuity of government requires ensuring the safety of its own cyber infrastructure and those assets required for supporting its essential missions and services.

The *Strategy* gave primary responsibility for Internet security to individuals and corporations, rather than the government. It called for a Cyberspace Network Operations Center to be established by Internet service providers (ISPs), computer hardware and software makers and the Information Sharing and Analysis Centers (ISACs).

However, the *Strategy* also called for law enforcement and national security agencies to create a system to detect a cyberterror attack leveled against the nation. The seeds of statism can hide in these seemingly harmless missions. Phrases like "continuity of government" can be euphemisms for statist interference with commercial markets.

The U.S. government has had some problems in its efforts to influence Internet security. In the 1990s, a Federal Intrusion Detection Network (FIDNet) was proposed—but was rejected when opponents raised fears that the privacy of U.S. citizens might be compromised.

Beyond the awkward suggestions for public- and private-sector solutions, the overall tone of the Bush *Strategy* was one of exaggerated risks. Hype. Many computer and Internet security experts scoffed at the "4,129 vulnerabilities"—pointing out that the number was too precise (as well as too low) and the term was not precise enough. The *Strategy* authors couldn't resist ponderous talk about "intrusions... targeted against those organizations that conduct advanced technical research on national security, including atmospheric and oceanographic topics as well as aircraft and cockpit design."

A lot of the FUD rhetoric in the Bush document was stale stuff to people who work in Internet security. Some of it was rehash of reports from the National Infrastructure Protection Center (NIPC)—a federal agency set up in the mid-1990s by Bill Clinton to combat the then-trendy threat of cyberterrorism.

The computer-security industry is experienced in hyping threats. Its experts and spokesmen often exaggerate estimates of cyberterrorism damage—such as the $1.2 billion supposedly inflicted by the February 2000 "Mafia Boy" denial-of-service attacks on several popular consumer Internet sites. (That number included the momentary stock market capitalization dips that some owners of the victim sites suffered.) In February 2002, the Microsoft-led Business Software Alliance published a survey claiming that a major cyberterror attack would be launched against the United States within 12 months and that Uncle Sam should be sure to stock up on new security products. The deadline passed without incident.

Through all this hype, one key question remains: Would a tightly regulated society really be more secure than an open one? If so, then maybe there is some merit to reconsidering the Internet's openness.

Open Systems Versus Closed Ones

The scientists who designed Internet Protocols—the language that lets computers talk to one another—made them open: No particular software was needed to work best with them. Nor was there any central control over who could access the Internet. Any software inventor with an application could turn it loose online. Many did, which is how e-mail, instant messaging, file sharing and Web browsers developed in a few years during the 1990s.

The Internet's lack of centralized control is crucial to its success. Internet Protocols created something analogous to a traditional "commons," a place everyone could use and which no one owned. Physical phone lines were owned by the telephone companies; servers were

owned by users; routers could be owned by either. But no one owned the Internet.

The decentralization produced some real benefits. The worm that Robert Morris unleashed in 1988—one of the first such programs—shut down close to 10 percent of all networked machines; but it was decompiled within 12 hours, thanks to spontaneous cooperation among computer scientists at MIT, Berkeley and elsewhere.

The result of this open distribution of information wasn't a meltdown of the Internet but improved security and responsiveness.

The general belief among early Internet enthusiasts was that an open society would be better equipped to deal with threats than even the most efficient regulatory (or police) apparatus. As Richard Clarke—the first head of the NIPC—famously said: "The government cannot dictate. The government cannot mandate. The government cannot alone secure cyberspace."

But the lack of ownership and centralized control bothers some security types, particularly some of those connected to the U.S. federal government and a number of larger corporations working in the entertainment and telecommunications industries.

These security types—statists of either government or corporate stripe—argue that access to the Internet needs to be controlled, just like access to a shopping mall or sports stadium. This makes sense, if you've never used the Internet.

Concerns about these claims were the focus of discussion in April 2003, at the annual Computers, Freedom and Privacy conference in New York City.

One of the speakers at the conference, whose perspective was typical of the attendees, said:

> ...the architecture of tomorrow is being embedded
> with the tools of a surveillance society: ubiquitous
> cameras; the creation and linking of all manner of
> databases; insecure networks; and policies that invite
> abuse. They are being put into place by an unholy, if

loose, alliance of government, private industry and just plain nosy regular folks.

Many attendees complained that—despite its talk of encouraging private-sector solutions to Internet security issues, the Bush Strategy actually advanced a strong statist regulatory agenda. A prevailing concern was that the government wanted to know absolutely everything about you and to have the option of violating your fundamental rights, as long as the cause was deemed worthy.

Security by Online Citizen Militia

The devotion to liberty and open systems doesn't mean chaos. Open system advocates argue that the model of the collaborative effort to decompile and patch the Robert Morris worm can work in many corners of the Internet.

A less technical example: The particularly active e-mail list used by the residents of the Boston suburb of Arlington, Massachusetts.

The Arlington list (www.arlingtonlist.org) generated a lot of media attention as proof that Internet security could look like a simple chat room. Participation was active; the number of postings usually exceeded 100 per day—mostly on topics of local business or politics.

The list was open to anyone who wanted to subscribe. Subscribers could read all posted messages, which included the sender's name and e-mail address, and could respond either individually or to the list itself. Its site was maintained by a small group of volunteers, most of whom worked in the information technology field.

Town officials also used the list on an informal basis. At least one school committee member, one town selectwoman and one state representative were regular contributors. Unlike many e-mail lists, the Arlington list was not moderated: members' submissions were uncensored. This was a big part of its appeal.

The Bush *National Cyberspace Security Strategy* tried to harness the local appeal of town e-mail lists:

Rapid identification, information exchange and remediation can often mitigate the damage caused by malicious cyberspace activity. For those activities to be effective at a national level, the United States needs a partnership between government and industry to perform analyses, issue warnings and coordinate response efforts.

Privacy and civil liberties must be protected in the process. Because no cybersecurity plan can be impervious to concerted and intelligent attack, information systems must be able to operate while under attack and have the resilience to restore full operations quickly.

The ultimate security application of a system like the Arlington list is a kind of surveillance in which many local citizens keep a collective eye on their neighborhoods...and their Web sites. In this model, decentralized surveillance becomes an institutional "self-knowledge" or "self-monitoring" that avoids the insidious tentacles of an ambitious state.

In some places, the foundations of this model are in place. Through the late 1990s, English law enforcement agencies began placing remote-control video cameras in crime trouble spots. These cameras were intended to serve several purposes—deterrence, as well as surveillance. One location in particular—the London suburb of King's Lynn—saw crime rates drop 98 percent after 60 remote-controlled video cameras were installed. By the end of 2000, over a million closed circuit cameras were operating in the U.K.

In 2000, the New York Police Department had grown its surveillance system to over 1,000 security cameras in public places such as parks, subway stations and public housing—up from a few hundred in 1998.

This wide use of surveillance cameras might seem like an invasion of privacy (though courts have held that they're not, as long as they are focused on public spaces). To a libertarian, the relevant question

isn't so much about privacy as it is about use. Who's using the information? What is the best way to assure that it's being used for the undeniable public good of reducing crime?

If the legitimate security requirements of the minimal state require surveillance, a system in which no group, agency or individual is privileged over any other seems to offer the best prospect for fair application. A local agency makes its surveillance available online to anyone who's interested. Interest will come mostly from locals…but the curious would be welcome.

Here the Internet can be a great security tool. Public surveillance streams are available to everyone…so you have no idea whether—or who—is watching a given location at a given time. A crime may be observed by the broadest possible section of the population.

It's better for all to watch one another than for elite authorities to monopolize this power, hoard information…and leave citizens with the feeling of being watched.

Internet Security Remains a Mystery to Most

There's a big hurdle to getting to the decentralized, citizen-militia model of Internet security, though. That model requires a fairly large degree of computer sophistication of a fairly large number of Americans.

Since the rise and fall of the music file-sharing service Napster, many people have strong beliefs about digital piracy on the Internet; but piracy is a relatively small threat in the Internet economy. The bigger threat is the spread of dangerous technologies, like computer viruses and hacker attacks.

A growing part of any business (and of many individuals' interests) on the Internet is intellectual property. This intellectual property can be a computer operating system worth billions of dollars or a personal Web page worth a few cents…to anyone other than its owner. It can be—and often is—digital files of hard-core pornography or an

educational game site that teaches children to read. The Internet is a democratic institution because its protocols don't discriminate with regard to content.

Those democratic protocols also pose risks evenly. People all over the world can wreak havoc more effectively than ever. They can launch denial-of-service attacks that overwhelm a Web site with so much bogus traffic that they shut sites down.

So, the security challenge for the Internet may go beyond even watching crime-riddled streets via remote control cameras. It may require people to think in decentralized terms about all matters of security—both personal and digital.

How do people who love liberty monitor the Internet's information networks to protect against fatal or destabilizing information—without turning the regulation into something from the megalomaniac dreams of Beijing's Central Committee?

There's no doubt that statists believe the dissemination of knowledge allowed by the Internet needs to be stopped—and the information bottled back up. As Sun Microsystems' chief scientist, Bill Joy, warned:

> We have yet to come to terms with the fact that the most compelling 21st Century technologies—robotics, genetic engineering and nanotechnology—pose a different threat than the technologies that have come before. Specifically, robots, engineered organisms and nanobots share a dangerous amplifying factor: They can self-replicate. A bomb is blown up only once—but one bot can become many, and quickly get out of control.

Joy called the new threats "knowledge-enabled mass destruction." In an information economy, dangerous knowledge can be copied and disseminated quickly and takes on tactile—even physical—effects.

Of course, not everyone who knows computer software believes this New Age crap.

Joy is a statist. He believes that governments should regulate—and individuals should relinquish "certain kinds of knowledge." He argues that the social contract requires that states reconsider the open, unrestrained pursuit of knowledge that has been the foundation of science for centuries.

But regulating knowledge is unreliable and full of unintended consequences. For example: In August 2000, the Motion Picture Association of America (MPAA) sued the magazine *2600* for posting links to a computer program called DeCSS on its Web site (www.2600.com) that would allow hackers to copy films from most standard DVDs. The motion picture group used the newly-enacted Digital Millennium Copyright Act (DMCA) as the basis for the lawsuit. It won, resulting in a court order that forbade *2600* "from linking their site to others that make DeCSS available." This was a far-ranging order. The magazine had not developed the program; it hadn't even used the program. It had merely shown readers where they could find it.

The magazine and editor Emmanuel Goldstein (whose *nom de plume* is a reference to the novel *1984*) were sued under a provision of the DMCA which states that "no person shall... offer to the public, provide or otherwise traffic in any technology...primarily designed or produced for the purpose of circumventing a technological measure that effectively controls access to a work protected under [the DMCA]."

The law forbids trafficking in the technology, which federal Judge Lewis Kaplan ruled includes providing a URL with "a desire to bring about the dissemination" of infringing technology. This is statism: fuzzily-worded regulatory theory that can create self-replicating government action—itself similar to a virus.

After Kaplan's ruling, Goldstein said:

> We can all laugh at such words but they represent something very sinister. We are now expected to believe that telling someone how to get a file with a link is the same as offering it yourself.

And even Kaplan, while ruling against the magazine, acknowledged a slippery legal slope between restricting access to computer code and limiting free speech:

> It cannot seriously be argued that any form of computer code may be regulated without reference to 1st Amendment doctrine. The path from idea to human language to source code to object code is a continuum.

He then distinguished between the "expressive" component of computer code, protected by the 1st Amendment, and the "functional" component—which can be restricted by the state and its laws. Finally, Kaplan made this analogy to clarify his distinction:

> Computer code is not purely expressive any more than the assassination of a political figure is purely a political statement.

Kaplan compared the DVD-copying code to which *2600* had published links to a "propagated outbreak epidemic" in which the disease is contagious—as opposed to a "common source epidemic," which could be halted at the source.

The Internet does enable certain knowledge-based threats to become what Kaplan called outbreak epidemics. In some cases these threats are, literally, computer viruses; in other cases, they are simply potentially-dangerous information that can travel like a computer virus. But are ham-fisted, statist efforts at regulating information the best way to respond? Despite the legal complexity of Kaplan's ruling, the DeCSS program still works—and it still available on the Internet.

The better way seems to be to combine the decentralized, communal watching that can work for street crimes with a similar approach to the actual, illegal use of programs like DeCSS.

Jurisdiction: The Waterloo for Statist Regulation

Judge Kaplan's complex—and sometimes convoluted—analysis in the MPAA decision is made even more complicated because there

was some question about whether his court was even the right place for the case to be held.

The *where a case is heard* issue is what lawyers and judges call jurisdiction. And the Internet makes a hash of convention standards for where activities occur...and, therefore, where legal disputes resulting from those activities should take place.

Ambitious statists refer to the 1993 U.S. Supreme Court decision *United States v. Smith*, which set up the broadest authority for federal courts to claim the authority to hear a case. That decision stated:

> Our courts have also developed a sixth basis for prescriptive jurisdiction, which is referred to as the objective territorial principle. This principle has been defined as including acts done outside a geographic jurisdiction, but which produce detrimental effects within it. Those circumstances support the proscription and punishment of the cause of the harm as if it had been physically present where the effect takes place.

This is dangerous stuff. It means that U.S. courts can apply their powers to actions that didn't take place in the U.S...and to people who may have never set foot in the country.

U.S. courts are supposed to consider various other points—which are intended to prevent them from overwhelming other countries' courts. These points include:

- the degree of conflict with foreign law or policy;

- the extent to which enforcement by either state can be expected to achieve compliance;

- the relative significance of effects on the United States as compared with those elsewhere;

- the extent to which there is explicit purpose to harm or affect American commerce; and

- the relative importance to the violations charged of conduct within the United States as compared with conduct abroad.

But the net effect of the *United States v. Smith* standard is that statists in the U.S. judicial system can claim jurisdiction over practically anyone, anywhere.

Other countries have applied similar theories to Internet cases. So, the overall trend seems to be toward a legal quagmire in which many countries can claim jurisdiction over Internet disputes...and few will cede jurisdiction to someone else. Some early examples of this trend:

- In *Gutnick v. Dow Jones*, an Australian court held that publication occurred on downloading an article from *The Wall Street Journal* Web site, rejecting Dow Jones's argument that publication of the article should be deemed to have taken place either in New York, where the article was uploaded, or in New Jersey, where the Web servers that made the article available on the Internet were located. The court also held that the law of the Australian state of Victoria should apply to the trial of the action. The High Court of Australia dismissed Dow Jones's appeal.

- A coalition of entertainment companies filed suit in U.S. District Court in Los Angeles, seeking to shut down Kazaa, an online file-swapping service whose software is downloaded from the Internet and used to trade music, TV shows and movies. Kazaa is a multinational creation. The software developers are from Estonia and were commissioned to do the work by a company in the Netherlands.

The Kazaa case may be the first example of how statists in various countries will battle each other over whose rule should prevail.

An Estonian court refused to enforce an order from the U.S. courts that demanded Kazaa's developers produce documents and provide testimony; an appeals court in the Netherlands ruled that local dis-

tributors of the software should not be responsible for piracy by its users.

Conclusion

The key question a pragmatic libertarian needs to ask about the Internet is: Will a tightly regulated, statist society really be more secure than an open one?

If so, there may be some merit to reconsidering whether American notions of liberty and free speech can work in a world of knowledge-enabled risks. It may be worth allowing an elite group of decision-makers to restrict the knowledge in knowledge-enabled risks.

And the trains running on time in Italy may have been worth Benito Mussolini.

The early results indicate that statism does not make a more secure Internet. It ends up with well-meaning but bizarre laws like the DMCA; and, more importantly, the jurisdictional issues raised by the notion of cyberspace make a mess of statist legal systems.

Increases in personal liberty that followed the print revolution catalyzed the ideals of freedom and individuality that define liberalism and libertarianism. The further increases in personal liberty allowed by the digital revolution have driven some statists to cry "enough." They see the Internet as a great excuse for government to put personal liberty in check.

Knowledge hierarchies exist in every society. The fundamental threat lurking behind plans to relinquish "certain kinds of knowledge" is broader than a potentially corrupt state agency. The threat is that public education itself will become more restricted.

Instead of regulating access to technical knowledge, people who value liberty should teach the languages to anyone who wants to learn. The alternative—mass technical illiteracy—will reduce most people to a herd of low-wage service providers. The statist might not mind this; uneducated retail clerks and baristas are easy to police by conven-

tional means. Resources for surveillance and regulation could be concentrated on the few people who have dangerous knowledge. This is the system that Aldous Huxley predicted in his novel *Brave New World*.

But it's not the America that Washington, Adams and Jefferson imaged.

24 Travel and Transportation

Is there any hope for relief from the invasive security practices adopted by the U.S. travel industry after 9/11?

In 2002, Rebecca Gordon and Janet Adams—self-described "peace activists" who helped run a publication called *War Times* that was harshly critical of the Bush Administration's anti-terrorism policies— were detained at San Francisco International Airport on their way to Boston. An American Trans Air employee told them their names appeared on a Transportation Security Administration (TSA) "no-fly list."

The TSA was still getting used to operating the security functions at U.S. airports in later 2002. The federal agency had been cobbled together from different bureaucratic pieces in the months after the 9/11 attacks; its rushed mission was to bring uniformity to airline security throughout America. There was speculation that one of the TSA's first steps had been to issue no-fly lists—groups of people who wouldn't be allowed on commercial flights because their behavior or background made them likely terrorists.

On the fringes of American politics—especially the left-wing fringes—there was also worry that the Bush Administration would harass "activists" by adding their names to the no-fly lists.

This was what Gordon and Adams suspected immediately, if ego-centrically.

Their bags were thoroughly searched and the women were questioned in detail about their travel plans. Eventually, they were allowed to board their flight. However, they were subjected to extra scrutiny on every leg of their travel. Even though they were allowed to fly, they were clearly on some sort of watch list.

So, when they got back to the Bay Area, Gordon and Adams contacted the American Civil Liberties Union, which happened to be researching the relatively large number of no-fly list episodes at San Francisco International. Getting little response from the TSA or other federal agencies, the ACLU decided to sue. It used Gordon and Adams as the lead plaintiffs in a lawsuit alleging violations of the federal Freedom of Information Act, the Privacy Act and other civil rights laws.

The ACLU argued that government officials had improperly withheld information about how people wind up on the "no fly" list, what steps are taken to ensure its accuracy and how people who are erroneously detained at airports can get their names off the list.

The FBI told the ACLU in a letter from December 2002 that it found "no records pertinent" to the no-fly issue. But ACLU officials said records from the San Francisco airport showed that the FBI was contacted about many of the airport detentions.

The ACLU (which, separately, was still opposed to use of metal detectors in airport terminals) said it had documented 339 cases since the 9/11 attacks in which people at San Francisco International had been stopped and questioned because they were thought to be on a no-fly list. Even though the lawsuit focused on one airport, the ACLU said the situation there offered a "window into what is happening at airports around the country."

TSA officials insisted they were making no effort to harass political critics of the Bush Administration. And, in response to the ACLU lawsuit, the agency went as far as commenting officially about Gordon and Adams. The TSA said that Adams's name was very close to

that of another person (apparently, a "J. Adams") who was on one of its watch lists for classified reasons.

In early 2003, the TSA advised airlines that it was creating a new "fly list," to include people who'd been chronically misidentified as watch list suspects.

Database Problems

When it comes to thinking about commercial airline security in the United States, the first thing you have to appreciate is that a lot of people fly. In 2001, about 640 million people passed through U.S. airports. It would be impossible to subject each of these people to a thorough check. It's also unnecessary, since the overwhelming majority of people flying are not terrorists.

The TSA has had problems throughout its short history. During a hiring binge following the 2001 attacks on the World Trade Center and Pentagon, class instructors in the New York area fed job applicants the answers to employment tests. The results followed as you would expect. In one battery of undercover tests, its screeners missed 24 percent of weapons and imitation bombs planted in carry-on bags. In other tests, screeners failed to detect over half of the potentially dangerous objects smuggled through. And these tests may understate failure rates, because they're structured to boost worker self-esteem.

To screen fliers, TSA set up a crude database called Computer Assisted Passenger Prescreening System. In statist fashion, TSA bureaucrats referred to this by an acronym—CAPPS. Like the TSA itself, CAPPS was sewn together hurriedly from several pre-9/11 pieces. Whatever the system was called, it wasn't very sophisticated.

The first part of CAPPS involved each commercial airline checking its own information about a passenger—particularly when and how the ticket had been purchased. "At the last minute" and "in cash" were answers that would raise further scrutiny—and move the passenger to the second stage of the system.

The second part of CAPPS involved the airline comparing—by computer—a suspect passenger's name with an online database kept by TSA.

The TSA database had two main watch categories, a "no-fly" list of people "to be denied transport" and a "selectee list" of people who would require "additional screening prior to boarding." The database was updated "almost daily" to add new names and clarify existing ones. In an internal memo from October 2002, Claudio Manno— TSA's acting associate undersecretary for intelligence—said that a person would be put on the watch list if one of several intelligence or law enforcement agencies asked the TSA to do so. Which agencies could make these requests? That was classified.

How would a name be removed from the watch list—if, for instance, it had been mistakenly added? The TSA was cryptic about that. A person would be removed when he or she was "no longer considered a risk" by the agency that had originally made the request.

The CAPPS database was prone to mistakes. For one thing, it usually relied on airline-reservation databases whose indexing software was based on a 19th Century system that mistook many similar-sounding names. This indexing system—called Soundex—had first been used by the U.S. Census Bureau for the 1880 national headcount. It gave each name a key using its first letter, dropping the vowels and giving number codes to similar-sounding consonants (like S and soft C). The system gave the same code to the surnames *Lydon*, *Lawton*, *Leedham* and one that might be greater interest to the Feds: *Laden*.

Soundex is one reason that many immigrants ended up with shortened versions of their complex ethnic names. It is particularly bad at categorizing Arabic, Asian and other names that—when translated from their native scripts to Roman letters—can have hundreds of different spellings

One example: In the early 1990s, a Pakistani terrorist known as *Mir Aimal Kansi* eluded government watch lists in place at the time

and entered the U.S. by using *Kasi*—a legitimate variation of his name—on his travel documents. (In 1993, he killed two CIA employees and wounded three other motorists on a busy roadway outside the spy agency's headquarters. And then he fled the country.)

Soundex and the CAPPS database were part of the reason that Janet Adams was detained at San Francisco International Airport. And she wasn't alone. The TSA was receiving hundreds of letters a week from innocent passengers who'd been mistaken for shady characters with similar-sounding names.

A High-Tech Solution

So, in early 2002, TSA turned to technology to assist.

It planned a computer-based identification system that would pull details on individual travelers from various commercial databases to confirm their identity. This new system—called CAPPS II—made sense to the TSA but posed problems for almost everyone else. For one thing: The "various commercial databases" would include banking and financial information that could drag personal matters like credit rating or medical history into the equation.

Word of CAPPS II first circulated to the public in February 2002, when defense contractor Lockheed-Martin was awarded a $12.8 million contract to administer the CAPPS II database and Access features in the first phase of what was projected to be a five-year program.

One executive with a rival information-technology firm complained: "Twelve million is a lot of money for an Access database, a couple of DSL lines and an online-access platform. My teenage daughter could build the same thing for under $1,000."

Of course, TSA insisted that CAPPS II was more than that. According to TSA spokesperson Heather Rosenker, the system would feed in your name, address, telephone number and date of birth—information that airlines already have about each passenger—into one of several commercial databases. This step would try to determine

whether "you are who you say you are." The computer could get from these databases the same sort of information that many businesses access—your known addresses, your employer, whether you own or rent your home, etc. Based on how much information matched, CAPPS II would assign a color code.

It would come back in less than five seconds with one of three responses: green, yellow, red. Most passengers would get a green rating and would proceed immediately. Those who got yellow would require further security checks. Those who got red couldn't board the plane. (The TSA insisted there were fewer than 1,000 names on the "no-fly" list.)

The TSA described CAPPS II as a progressive system: It would scan as few databases as it needed to determine that you checked out. According to Rosenker:

> If every commercial database says there's a Joe Smith
> with this address and this date of birth and this phone
> number, the system says you're OK. [But] if it comes
> up that this person has only been living here for four
> months and there's no sign of him before that, then
> we'd need to go to the next level of identification.

The next level would include checks with law-enforcement databases and, "if need be, [an examination of] your behavioral patterns."

The TSA wouldn't say what kind of behavioral patterns it would examine because, if terrorists knew what the agency was looking for, they would modify their behavior.

TSA was acutely aware of this behavior modification. In May 2002, two graduate students in computer science at MIT developed a series of algorithms that terrorists might use to beat a profiling system like CAPPS. After studying everything that was publicly known about TSA searches, the pair set up computer models to test imaginary passengers. Their conclusion: Any group with the will and a few members could get at least one person around the system.

The problem with selected searches is that law enforcement agencies show their standards when they pick out people considered likely to pose a threat. Every time someone is picked out by a profiling system, the scrutiny he's given—a bag search, for example—tips him off that he fits the profile. If this person is part of a terrorist group, he can use the information to develop a plan for a future attack. Determined terrorists can identify standards and avoid them.

The MIT students concluded that airlines would be safer if, instead of profiling, they selected a portion of fliers at random and subjected them to more thorough searches for weapons.

Some Bumps in the Tarmac

The problem with random searches, though, is that they end up subjecting a lot of people who don't fit any "profile" of likely terrorists to extra scrutiny. And this is not only an inconvenience to passengers, it's an infringement on their privacy and inefficient use of law enforcement time.

CAPPS II handled the behavior modification risk by dividing labor.

When commercial fliers checked in at the airport, their names would be punched into the system and their boarding passes encrypted with the ranking. But they might not find out what code they'd been assigned right away. TSA screeners would check the passes at checkpoints.

As to privacy issues, the TSA insisted that the CAPPS II system only drew on information that was already shared by banks and other institutions. It wouldn't add any new data about people. But many people remained skeptical about the possible misuse of a system that could access so much personal information.

And a high likelihood of mistakes bothered just about everyone.

A December 2002 study from the Consumer Federation of America and the National Credit Reporting Association found errors in names

and other identifying information in one out of every 10 credit reports—the tools that TSA hopes to use to confirm identities.

When asked how incorrect credit data might affect someone's CAPPS II rating, Heather Rosenker—the TSA spokesperson—said, "Well, first, the industry itself encourages the general public to make sure that [credit] information is correct, so that's something we should all be doing."

True enough. But that only fueled consumer skepticism.

More controversy bubbled up in early in 2003, when Delta Airlines agreed to test a pre-release version of CAPPS II. Longer check-in time and a steady flow of technical glitches followed. Angry Delta fliers started a Web site called *Boycott Delta*—which brought significant press attention to what the TSA and Delta had hoped would be a low-profile test run. Several media outlets, including *USA Today* and the *New York Times*, called for the TSA to change its plans.

And some of those skeptical people also worked for the government. In March 2003, Mark Forman—associate director of the Office of Management and Budget—said his office wouldn't let CAPPS II go forward until questions about its security and effectiveness had been answered. He said that the TSA hadn't been forthcoming with information about how the program or the technology would work. (A 1996 law allowed the OMB to cut funds for federal information technology projects that it didn't consider efficient or effective.)

Brian Roehrkasse, a Department of Homeland Security spokesman, told the media that a privacy officer will be assigned to safeguard civil liberties in CAPPS II cases. Also, an oversight panel that included a member of the public was being formed.

Again, with the expert panels....

The TSA issued a written statement in response to the various criticisms and stressed that CAPPS II would not use bank records, records indicating "creditworthiness" or medical records:

> The mission of the CAPPS II system has been and always will be aviation security. ...As part of this com-

mitment to keep the skies safe and defend the home-
land, we have an absolute obligation to prevent ter-
rorists and the most violent criminal fugitives from
gaining access to our commercial aviation system.
CAPPS II will ensure that passengers do not sit next
to known terrorists and wanted murderers.

But this argument was weak on its face. The TSA was using the
specter of al Qaida to rationalize its questionable executive decisions.

Bob Barr, a civil liberties advocate and former Republican con-
gressman from Georgia, slammed CAPPS II to its core when he said
that the program sought to "gather evidence on law-abiding citizens
in vain hopes this will somehow magically identify terrorists."

A Fundamental IT Problem

To a significant degree, CAPPS and CAPPS II were being asked
to compensate for the fact that government law enforcement agencies
didn't communicate effectively.

Federal agencies had long been hampered by what information
technology experts called "information silos." These silos were im-
mense databases of diverse information not connected, shared among
departments or analyzed. This lack of coordination limited the state's
ability to detect and prevent terrorist threats.

Rather than restructure and simplify lines of communications,
CAPPS II created a Rube Goldberg contraption to work around gov-
ernment dysfunction through credit card companies.

In the face of the CAPPS II mess, a few good government reform-
ers argued that the better solution would be to simplify incompatible
information systems, legal and privacy restrictions on information shar-
ing and organizational barriers between agencies. But, in this case,
"good" government was not the same as "small" government.

New systems like CAPPS II might not be necessary. Existing
systems could gather data from multiple sources and make it available

within a single agency's IT system, ultimately allowing multiple agencies to exchange information. This would provide agencies with a comprehensive view of all data related to a suspect or potential terrorist threat.

To get to this point, the Feds would have to build a decentralized computer system for tapping into information stored in multiple government and private-sector databases. To turn all that data into knowledge, the agencies would have to collaborate and filter information on a higher level than has ever been attempted before.

Government IT managers pointed to the fact that some agencies had several different databases. That reflected how the federal government usually operated—around projects rather than around agencies.

A corporation could address that problem by getting rid of its information silos and merging the data into a new, integrated system. But that option would be difficult for the government, which had lots of big, expensive legacy computer systems it could not afford to replace quickly.

The poor IT choices that have marked the U.S. federal government since the early 1980s are the biggest indictment of statism. Bureaucracies tend to make poor choices—especially in terms of advancing technology. Therefore, to expect a state to make good choices about cutting-edge technology is ridiculous.

Sky Marshals?

Some security experts point out that all of the fine points of passenger profiling and identity checks are not as effective at preventing terrorism as the tools available on commercial planes.

What are the best prevention tools? Federal sky marshals—armed agents flying undercover on commercial flights.

Having an armed federal marshal on every commercial flight would certainly seem to deter terrorists. But the market wouldn't bear that cost. One marshal per daily flight would require 35,000 officers—

more than twice the number of agents employed by the FBI, the Secret Service and U.S. Marshals Service...combined.

Sky marshals work better as a deterrent than an actual prevention of in-air crime.

Okay, the pragmatic libertarian thinks, but there are several bright university-graduates in the cockpit of every commercial flight. Why don't we just train them to carry guns?

The Department of Transportation, stripped of bureaucratic power by the Department of Homeland Security, resisted the idea of anyone but federal marshals carrying firearms on U.S. flights. It pressed hard to expand the federal air marshal program in 2002 and 2003. About 6,000 new marshals were hired in the 18 months after the 9/11 attacks. Basic market economics are going to force some hard reckonings in that situation: The rapid expansion reduced the quality of new hires and left the air marshal program in disarray. According to one disillusioned former marshal, the program has become "like security-guard training at the mall."

Again, the pragmatic libertarian thinks, there are good candidates for fire power and crisis decision-making in every plane. Instead of going on a federal hiring binge, why not rely on the talented people the airlines already have? Why not allow pilots to be armed?

The Airline Pilots Association supported the idea. With the overwhelming support of its members, the APA wanted armed pilots in commercial cockpits. So did the public. So did Congress. The airlines are opposed only because they fear the trial lawyers.

"Under the old model of hijackings," said an APA spokesman, the "strategy was to accommodate, negotiate and do not escalate. But that was before."

Post-9/11, the strategy had changed. The cockpit of a commercial flight had to be defended at all costs. In a crisis, a pilot's gun wouldn't leave the cockpit—because the *pilot* never would.

And, if a terrorist were able to penetrate the cockpit, shooting him within the cockpit's door frame wouldn't require a sniper's skill.

Sky marshals are a decent deterrent. But no employer—and especially not the state—should press a labor market so hard that it delivers inferior supply. Forget the mall-guard sky marshals. Put guns in the hands of the pilots.

Ridge's Defense of CAPPS II

In April 2003, with the OMB and other oversight groups piling atop CAPPS II's weaknesses, Department of Homeland Security Secretary Tom Ridge made his agency's best case to the Congressional Committee on Senate Commerce, Science and Transportation.

Ridge's best case was:

> CAPPS II will not degrade the civil liberties of Americans. TSA will rarely see the background information checked by the computer. TSA will have access to this information in the extremely rare instances that a particular traveler has been identified as having known links to terrorism. TSA will only see the aggregated threat assessment of the data used to determine whether, based on current information on foreign terrorist activities, the passenger is a possible terrorist threat to civil aviation security. This assessment will be synthesized into easily understood color codes—Green, Yellow and Red, which will be transmitted to TSA only shortly before the passenger's flight, and purged from the computer immediately after the passenger's flight is completed.

Sensing that CAPPS II was always going to be a loser, Ridge moved on to a broader argument. At the end of each day, commercial airlines represented a small part of all transportation miles traveled within the United States. Ridge rightly pointed out that other transportation channels posed a greater threat to U.S. citizens. He said:

> There are 3.9 million miles of public roads, which account for 2.7 trillion miles of travel by car and truck

each year. There are 11.2 million trucks and almost 2.4 million rail cars coming into the U.S. each year. Mass transit accounts for 9 billion commuter trips each year. The United States has 25,000 miles of commercial navigable waterways. ...there are 51,000 port calls made by 7,500 foreign flag ships to our 361 ports.

The Department has adopted a risk management approach as a cornerstone policy for developing risk-based regulatory standards for the various modes of transportation. Under this approach, there are three primary elements of good risk management: a threat assessment, a vulnerability assessment and a criticality assessment.

Conclusion

Before a pragmatic libertarian steps on a commercial jet liner, he or she should remember Ridge's argument. Most of the commercial transportation miles traveled each year go through places other than airports.

For the population at large, this means that the state should be paying attention to ports, freeways and train stations.

To the next person stepping on the next 767 bound for Washington, D.C., this means you're probably safer than the market—left to its own devices—would require.

Commercial transportation is an unusual market. It brings large numbers of people and things together in small spaces for relatively short periods of time. It's a unique combination of public and private interests...and resources. It should be no surprise that, in many countries, travel is a state-run enterprise.

As imperfect as U.S. transportation companies may be, they are as deregulated as any in the world. (And that's not saying much.) The al Qaida terrorists recognized this in their choice of venue for the 9/11 attacks.

The upshot here: Libertarians need to focus their small-government efforts in more productive areas. Commercial transportation—and the travel sector in general—is a risky business. It's bound to be regulated heavily in the future.

The answer to the question that started this chapter is: *No*.

Liberty Means
Responsibility

Okay. I've read it all, I've thought about everything. Libertarian politics just seems too much about money and things for me. Why should this greedy political philosophy have so much meaning for Americans after 9/11?

In November 2003, various groups of left-wing, anti-globalism activists organized in Miami to protest a meeting of regional trade ministers to discuss the Free Trade Area of the Americas (FTAA). The FTAA would be a larger version of NAFTA, reaching—as supporters like to say—"from Anchorage to Argentina."

Miami officials had a lot to prove to the visiting dignitaries; their city was one of several vying to become the home to the FTAA's administrative headquarters. So, they didn't want anything burning down or blowing up. To that end, the Miami police department clamped down on any political trouble.

The result: battling statists—the big-city police on one side and the left-wing protesters on the other. Both sides behaved badly.

As in other anti-globalism protests, the activists included organized labor groups, radical environmentalists and some self-appointed "anarchists" and "gadflys" looking for trouble. On Thursday, Novem-

ber 20, they mounted their main protest march along Biscayne Boulevard, one of Miami's signature streets. Nearly 10,000 protesters showed up.

The police had barricaded various side streets and buildings along the path of the march. And they had some 2,500 officers in riot gear standing guard.

As these things often do, the march started peacefully but turned ugly about the time it should have been ending. Some of the protesters' rhetoric was heated and not really on topic for the FTAA meetings. Chants of "Fuck Bush" and "Fuck the Police" echoed through the crowd. This wasn't exactly screaming "Fire!" in a crowded theater...but it was trouble-making. And it *did* make trouble.

While the precise details remain disputed, people on the scene said that several of the younger environmentalists "got in the face" of some of the riot police. Miami Police Department spokesmen later said that protesters started the violence by throwing "rocks, feces in plastic bags and bottles of urine" at officers stationed near the landmark Intercontinental Hotel. (Three officers were admitted to local hospitals for injuries sustained during the protests; and the Miami P.D. would claim that 18 were injured in all.)

The police near the Intercontinental struck back. A handful used their baseball-bat-sized riot clubs or Taser weapons to subdue protesters who were throwing things. This caused a larger push toward the police lines. Then, the police fired tear gas, rubber bullets and bean bags—regular staples of riot control—into the crowd.

Most of the protesters weren't throwing rocks or excrement; some didn't even see the trouble-makers doing that. To this majority, heavy with senior citizens and union working stiffs, the police actions were an unprovoked attack. The crowd broke from a somewhat-organized whole into several disorganized parts, and many people tried to cut through police lines to get away from the trouble. Police resisted. This only made the sense of menace worse.

For several hours, tear gas and pepper spray filled the air along Biscayne Boulevard. Despite this, the Miami police kept a pretty tight grip on the proceedings. The chaos remained focused to a limited area; only a few people were hurt badly enough to need hospitalization; and there was very little vandalism or property damage.

Law enforcement executives from other cities had come to Miami to watch its police handle protests; most came away positively impressed. When the tear gas cleared, fewer than 100 protesters had been arrested; this number was much lower than similar statistics from other big anti-globalism protest sites. Mayor Manny Diaz called his cops' performance "a model for homeland security."

The protesters howled another story. Their spokesmen complained bitterly about police abuse. The United Steelworkers of America called for a congressional investigation into how police turned Miami into "a massive police state." Amnesty International and the Sierra Club also called for government probes. The ACLU and the more-radical National Lawyers Guild both made noises about suing the city.

Somewhat suspiciously, almost all of the complaining people and groups used some variation of the phrase "this is not America" in their press conferences. The line occurred so often that it seemed to have been a bit of pre-arranged outrage.

Several journalists came forward to say that they'd been arrested along with protesters—even though they'd told police they were there as observers. And a few of these journalists had been treated roughly, doused with pepper spray or handcuffed for several hours.

The Miami P.D. pointed out in reply that it had offered embedded positions to journalists and warned those who declined that they might be treated as protesters in any crowd-control actions.

But the police weren't blameless. A number of protesters and a few journalists had the bruises to show that they'd been shot in the back with rubber bullets or bean bags. Evidently, some Miami P.D. officers had fired at people retreating from scenes of trouble. This undermined the clean image they were working hard to project.

More Miami-style tactics were likely to follow, though. In early 2004, Miami P.D. chief John Timoney was selected to handle security for the 2004 Democratic National Convention in Boston.

Which Side Do Libertarians Take?

No libertarian likes the image of riot police shooting citizens in the back—even with non-lethal beanbags. They represent the worst totalitarian aspects of statism, right down to their menacing (by design) uniforms and equipment.

But neither do most libertarians like the childishness of "activists" who scream "Fuck the Police" and throw rocks at cops...and then cry when the cops react.

There's little doubt that federal law enforcement agencies have used the fear generated by 9/11 attacks to expand their police powers. While this expansion has helped prevent any repeats of 9/11, that prevention has come at the cost of some of the fundamental liberties that make America great.

History suggests that those fundamental liberties will rebound. They did after the statist power grabs that produced Adams's Alien and Sedition Acts, Lincoln's suspension of habeas corpus and Roosevelt's imprisonment of Americans of Japanese extraction. Current laws like the Patriot Act will likely join those measures in the reject bin of U.S. legal history.

But every crisis produces its own specific issues; and the terrorized world of the 21st Century poses its own risks.

People who value liberty need to keep a few critical points in mind:

- It's important to keep a pragmatic mind about political philosophy. Purists may enjoy the clear conscience of intellectual consistency—but they make bad neighbors. Because libertarianism counts on individuals to resolve most of life's problems themselves, it must in-

clude a healthy dose of pragmatism. Getting along is as important as *getting over*.

- The social contract exists—and, managed well, provides value. But, like any contract, the social contract requires some compromises. So, a pragmatic libertarian should pay his taxes and obey posted speed limits...most of the time, anyway.

- Statist ambitions rely on politics and politics plays games with logic and language. Since 9/11, the Feds have been frantic to label every sort of societal ill "terrorism." But this becomes a meaningless exercise when anti-terrorism laws are used to prosecute Las Vegas strip club owners who've allegedly "greased" local officials for favorable zoning decisions.

- The overbroad definitions of words like terrorism in federal laws like the Patriot Act have a negative effect on other laws. Governments should avoid passing laws to send messages or make statements. Invariably, such laws are vaguely conceived and imprecisely enforced.

- Liberty isn't modular, even though most lawyers would like to believe it is. When you restrict some fundamental freedoms, you impact all. In the American system—as in most good ones—fundamental freedoms are protected by various specific points of law. Abortion may or may not be murder; but it definitely is a practical application of privacy...and privacy is keenly important.

The Problem: Being a Libertarian Is Tough

Being a statist is emotional. And it's easy.

To believe in—and to apply—libertarian philosophy is tough. It means you have to think rationally about the things you allow your

government to do. But it's worth the effort. Valuing liberty is like working out in Colorado; the altitude hurts...but it gets you in better shape in the end.

What Libertarianism Means for You

You may believe that crimes like murder and rape deserve death as a just punishment...but you have to realize that the state is a woefully inefficient arbiter of justice. It means well, but lumbers awkwardly through subtle legal and moral distinctions. It shouldn't be trusted with the just application of death.

You may think that the FBI, IRS and SEC are sneaky liars; but you have to realize that consistent law enforcement and some basic rules of fairness are essential to the efficient operation of any marketplace. Markets need minimal regulation, if only for the psychological effects.

Property rights and free speech are easy things to *say* you value. But supporting them can make you come to conclusions that aren't easy.

Defending property rights can make you sound like a heartless greedhead—but the record companies were right about Napster: It violated fair copyrights.

In the meantime, you have to tolerate the idiotic political opinions of Hollywood halfwits because they protect, ultimately, better-formed opinions. Protecting people's right to embrace ignorance and lies is the only way to protect the truth.

And exceptions prove this rule. The current predicament that American universities face with regard to lack of political diversity among their faculties is the direct result of their cowardly betrayal of free speech on their campuses through the 1980s and 1990s. They preferred statist speech—and thought—codes; and they endangered their legitimacy.

Free speech is the best proof of libertarianism's timeliness. Statists, swayed by their easy emotions, invariably hedge away from it as a hurdle to the quality of life they value. They make ridiculous arguments about how people are too fragile to tolerate hateful (or even impolite) words. Oliver Wendell Holmes Jr. pointed out the paradoxical nature of freedom of speech when he wrote that it's "not free thought for those who agree with us but freedom for the thought that we hate."

So, even though hate crimes may seem fair, libertarians understand that they're not.

Liberty Is a Hard Bargain that Makes You Strong

Liberty doesn't guarantee equality of circumstances among the people who live under it. In fact, it practically guarantees *inequality* of circumstances. Property rights combined with free markets lead—inexorably—to capitalism. And capital is restless.

Before 9/11, these paradoxes seemed like intellectual parlor tricks, best suited for cocktail party chatter. But the world's current terrorized tenor shows that it takes equanimity to protect liberty. It's an adult person's philosophy. It requires the maturity to understand that free speech—and all freedoms—operate within a complex marketplace of values, interests and ideas.

Terrorism won't waken wealthy Americans from their generations-long daydream of statist contentment. But the state's ham-fisted reaction to terrorism just might.

Whatever the alarm, Americans need to awake from the daydream. And, when they do, they'll find that liberty—real, mature and pragmatic liberty—will crush the angry statism of childish "activists" and suicidal terrorists.

Statism is an illusion. Liberty is real. It's a hard bargain that makes you stronger for believing.

Liberty in Troubled Times

The U.S. Bill of Rights

I. Freedom of Speech, Press, Religion and Petition

Congress shall make no law respecting an establishment of religion, or prohibiting the free exercise thereof; or abridging the freedom of speech, or of the press; or the right of the people peaceably to assemble, and to petition the Government for a redress of grievances.

II. Right to keep and bear arms

A well-regulated militia, being necessary to the security of a free State, the right of the people to keep and bear arms, shall not be infringed.

III. Conditions for quarters of soldiers

No soldier shall, in time of peace be quartered in any house, without the consent of the owner, nor in time of war, but in a manner to be prescribed by law.

IV. Right of search and seizure regulated

The right of the people to be secure in their persons, houses, papers, and effects, against unreasonable searches and seizures, shall not be violated, and no warrants shall issue, but upon probable cause,

supported by oath or affirmation, and particularly describing the place to be searched, and the persons or things to be seized.

V. Provisons concerning prosecution

No person shall be held to answer for a capital, or otherwise infamous crime, unless on a presentment or indictment of a Grand Jury, except in cases arising in the land or naval forces, or in the militia, when in actual service in time of war or public danger; nor shall any person be subject for the same offense to be twice put in jeopardy of life or limb; nor shall be compelled in any criminal case to be a witness against himself, nor be deprived of life, liberty, or property, without due process of law; nor shall private property be taken for public use without just compensation.

VI. Right to a speedy trial, witnesses, etc.

In all criminal prosecutions, the accused shall enjoy the right to a speedy and public trial, by an impartial jury of the State and district wherein the crime shall have been committed, which district shall have been previously ascertained by law, and to be informed of the nature and cause of the accusation; to be confronted with the witnesses against him; to have compulsory process for obtaining witnesses in his favor, and to have the assistance of counsel for his defense.

VII. Right to a trial by jury

In suits at common law, where the value in controversy shall exceed twenty dollars, the right of trial by jury shall be preserved, and no fact tried by a jury shall be otherwise reexamined in any court of the United States, than according to the rules of the common law.

VIII. Excessive bail, cruel punishment

Excessive bail shall not be required, nor excessive fines imposed, nor cruel and unusual punishments inflicted.

IX. Rule of construction of Constitution

The enumeration in the Constitution, of certain rights, shall not be construed to deny or disparage others retained by the people.

X. Rights of the States under Constitution

The powers not delegated to the United States by the Constitution, nor prohibited by it to the States, are reserved to the States respectively, or to the people.

Index